Bits and Pieces:

When I was seven years old I had two best girlfriends living in our neighborhood in Jackson, Mississippi. Betty Webb, Jeannine Wells and I would put our blankets under the oak tree outside our kitchen window to play with our dolls. We dressed them, strolled them in their little baby buggies, and pretended to be mothers. I would also take my "children" with me when I pretended to go to my job to be a doctor, teacher, plumber, or just to the office.

One day Jeannine told me I could not go off to work *because I was a girl.* I knew that wasn't true. Aunt Hermie and Aunt Lib went to work and so did Cousin Sophie. At the end of the day Mamma, Daddy and I were eating supper when I told them what Betty and Jeannine said, and what I said.

Mamma said, "Well, Aunt Hermie and Aunt Lib had to work because they weren't married and there wasn't a man to take care of them. And Cousin Sophie had to work because she was married to a man who was lazy and no good and didn't have a job."

"Well, I *am* going to get married and I *am **not*** going to marry a lazy man, and I *am* going to have babies and I *am* going to be a doctor."

Mamma sighed. "You can't be a doctor but you can be a nurse. You will have to have a job where you can stay home most of the time to take care of your children."

That was the first time I realized that some people thought girls were not supposed do the same things as boys. I wondered about it, but I never really believed it.

When Mamma talked like that Daddy always said, **"Ethel, leave her alone!"**

And so Christmases came and passed: one year I got a train and a doll; one year a wagon and a doll; one year a chemistry set and a doll; one year a bike and a doll. And I always liked one as well as the other.

And when it was all over and when Mamma was an old woman she finally told me that she was very proud of me and that she was glad she listened to Daddy when he said, **"Ethel, leave her alone."**

About the Cover

A Knock on the Door

Spring 1955

Betty Jo Whitten stands at the door of Roberta Hollingsworth Gwathmey, Dean of Women at the University of Virginia.

On that day Betty Jo applied for entrance to the University of Virginia with plans to major in Speech Correction. There was no signage at the University indicating where the Dean's office was located!

Ethel!

Leave Her Alone!

Jo Whitten May

Ideas into Books® WESTVIEW
Kingston Springs, Tennessee

***Ideas into Books*®**
W E S T V I E W
P.O. Box 605
Kingston Springs, TN 37082
www.publishedbywestview.com

ISBN 978-1-62880-047-0

First edition, September 2014

Photo credits: All photos are from the author's personal collection.

Printed in the United States of America on acid free paper.

This Book is Dedicated to the Memory

of

Mamma and Daddy

Ethel Marie Duckworth & Elton Barber Whitten
1910-1998 1908-1989

ACKNOWLEDGMENTS

Writing this book could never have been completed without the encouragement and assistance of my husband, Peter Driscoll. He served as my editor and my technical advisor. Pete knows how to locate lost material on the computer; how to repair the copy machine; always has extra paper; and drives me to our computer technician when I am about to have a breakdown. He deserves all of the credit for my completing this manuscript. Thank you, Pete.

Francie Markum, my creative writing instructor at the Shepherd's Center of Columbia, SC, encouraged me to write and was gentle as she edited my assignments. One day she said, "Jo, you write a good story. Why don't you read some of them at one of the luncheon programs?" I did. Thank you, Francie.

Dottie Boatwright taught writing at Prime Time Palmetto Health Baptist and encouraged me to join her class. Her class focused on reading to classmates that, in turn, improved my own writing. In that class I met Jackie Von Besien who had just published her memoir. That gave me the idea for this book. Thank you, Dottie and Jackie.

Members of the South Carolina Writers' Workshop (SCWW) were honest, tough, encouraging, and intimidating. They are already accomplished published writers yet took the time to take me seriously. Thanks to them I was encouraged to keep at it and publish. Thanks Monette, Marion, Bebe, Dan, Sherrie, Bryce, Shawn and the others.

Finally, thanks to my mamma, daddy, grandparents, cousins, boyfriends, girlfriends, teachers, preachers, and professors who became the subjects for this book.

And, in answer to the question, "Is all of this true?"

The answer is "No. But it *could* have been!"

TABLE OF CONTENTS

Acknowledgments ... vii

Prologue ... xvii

DADDY .. 1

The Beginning ... 2
 The Visit .. 2

The Whittens .. 4
 Elizabeth's Death ... 4
 Malaria .. 6
 The Livery Stable ... 6
 Lamar .. 7
 Sheriff Albert ... 8
 The Faulkner House ... 8
 High School Valedictorian .. 9

Millsaps College 1923-1929 ... 11
 The Train to Millsaps ... 11

Public School Employment 1929-1948 ... 14
 The Early Years .. 14
 Mamma's Reading Lesson .. 14
 Daddy gets Fired! .. 15
 Let's Start Our Family .. 16

McLain, Mississippi 1935 - 1940 ... 17
 Betty Jo is Born ... 17
 Meeting my Kinfolks ... 17
 The Teachers' Home .. 18
 Mr. Baxtrum's Store ... 20
 SOCIAL SECURITY ... 23
 Mrs. Denton's Cow Pie ... 25

Bud and Henry ... 25
Miss Germany ... 26
Walking with Daddy ... 26
The School Is On Fire! ... 27
The Piano ... 29
That Ole' Time Religion .. 29

The University of Alabama **31**
Union, Mississippi 1940-1943 **34**
CHANGE.. 35
THE BROOM HANDLE.. 37
Picking Cotton ... 43
Memphis at Granny Whit's 44
A Brassiere at the Zoo? ... 46
Ice Cream Truck .. 47
Goldsmith's Department Store 47

World War II ... **49**
The Germans.. 49
Rationing ... 49
Daddy Goes to War ... 50
August l945 – Japan is Defeated 51

Jackson, Mississippi 1944-1948 **52**
Rub-A-Dub-Dub—Vote for Tubb 52
What's a Reprobate?.. 52
Mr. Tubb Wins!... 53
Croquet.. 54
MR. HAIRSTON... 55
Daddy Writes a Recommendation 57
Moving Again .. 58

ELTON WHITTEN GOES TO WASHINGTON............ **61**
Arlington, Virginia **63**
Daddy's Many Interests ... 63
We Were Wild About Harry 63
The Methodist Church .. 64
The Prodigal Son ... 65
Daddy's Sunday School Class 66
The Teetotalers ... 66
Gardening .. 69

Life in Virginia .. 71
The Cousins.. 72
Obesity ... 72
Child Rearing Practices .. 72
Bragging .. 73
My Driver's License ... 75
What's That Typewriter For?.................................. 75
Daddy Couldn't Do Everything............................. 76
Regrets ... 76

The National Rehabilitation Association 78
Six Presidents ... 79
Harold Russell & Dr. Rusk 80
Mayor Wagner and the Pope 80
1954 Vocational Rehabilitation Act........................ 81
1965 Vocational Rehabilitation Act........................ 84
1968 Vocational Rehabilitation Act........................ 85
1972 Vocational Rehabilitation Act Amendment 88
Rehabilitation Act Amendments of 1974 88
Rehabilitation Counseling Profession 89
The E. B. Whitten Silver Medallion........................ 90
The Congressional Record 1974 90
The Retirement Speech.. 92

Arbor Acres.. 93
Winston-Salem, North Carolina............................. 93
The Poor Man's Lobby .. 95
Daddy's Death... 95

MAMMA... 97
Ethel Marie Duckworth Whitten 98
Gilmer, Mississippi ..100
Kudzu ...100
A Boy Named Joe..102
The Middle Child..102
The Move to Taylorsville104
The Sewing Kit ...104
Another Boy Named Joe.......................................105
The Chicken Killer ..105
Goin' Fishin'...106

SINGING WATERS ... 107
Quilts ... 115
The Baptist Church .. 115
Do Methodists Go to Hell? .. 117
Mamma's School Days .. 118
Rebellion! ... 118
Mamma, Did You Ever Kiss A Boy? 120
We Almost Lost Ethel .. 120
The Storm Pit ... 121
IT HAPPENS EVERY SATURDAY 122
Mamma Goes to College .. 126
Mamma Plans Her Wedding... 127
There's a New Man in Town .. 127
A Diamond Ring.. 128
The Knock on the Door ... 130

McLain, Mississippi 1935-1940 .. 131
"It's a Girl!" .. 131
Maggie ... 134
The Piano Arrives .. 134
Buddy.. 135
The Robin's Nest .. 137
Dorsey Duck .. 137
I'll Just Run Away From Home 137
Staying Slim .. 138
What's the "Depression?" .. 138

Union, Mississippi 1940-1943 ..140
Moving Again.. 140
ETHEL! LEAVE HER ALONE!.................................... 141
Right? Left? Which? .. 143
The Pressure Cooker... 144
The Victory Bike .. 145
Piano Lessons... 146
Jenny Lind.. 146
Piano Recitals .. 147
An Anatomy Lesson... 148
ONLY CHILD .. 148

Jackson, Mississippi 1944-1947**157**

 Our Very Own House .. 157

 The Movies .. 158

 Mental Illness ... 158

 Uncle Joe .. 159

 WHAT'S IN A NAME? 160

 Mamma Returns to the Classroom 167

 Birthday Halloween Parties 167

 Saturday Afternoon Movies 168

 Seventh Grade Gym Class 168

 The Junior High Dance 169

 Lessons On How To Be "Lady-Like" 170

The Move To Washington 1947 – 1995**172**

 Are We Moving … Or Not? 172

 The Trip to Washington 173

 Life in Arlington, Virginia 173

 The Cherry Blossom Festival 174

 Porgy and Bess ... 174

 Mamma Helps Me Make Friends 175

 Nicky Comes Home .. 177

 Mamma's Life in DC ... 178

 ADMIRAL SAMMS .. 178

 Mamma is a Grandmother 181

 Children Are In The Family! 182

Winston-Salem, North Carolina 1985**183**

 Daddy Died .. 183

 You're Going to What? 185

 A NOT SO SUDDEN DEATH 186

 Remembering Daddy .. 194

 No Citizen Will Enter the Back Door 195

 Something's Wrong With Mamma 195

 Mamma's Memorial Service 197

 Mamma Returns ... 197

 THE LOCKET ... 197

BETTY JO ... **205**
 1935 – ...205
Betty Jo Whitten May **206**
 Me Do It Me Self! ..206
Union, Mississippi 1940-1945 **208**
 The Plight of the Working Woman208
 The Catholics ...209
Jackson, Mississippi 1944 **211**
 Playing Games ...211
 RECESS: GOD ANSWERS PRAYERS212
 The WWII Rubber Shortage216
 Dancing Class ..217
 President Roosevelt ...217
 Expression ...218
 Piano Lessons ..220
Bailey Junior High School **221**
 You're a Woman Now ...221
 Taylorsville ..222
 Finding her Talent ...223
 NOTHING'S WRONG WITH ME!223
 FIRST DANCE ...230
 Moving Again ...234
Arlington, Virginia 1946 **235**
 Washington Did Have Some Advantages!235
 Television ...236
 Southern Accent ...237
 The Fall Picnic – Ronald or Billy?238
 Billy ...239
 Hayrides and a Promise to God239
 The Swanson Log ..242
 Betty at the Baseball Game244
 Popularity ..244
 Mamma Designs My Clothes247
Washington-Lee High School **249**
 Boyfriends ...250
 Maryland Crab Feasts ..251

Extra-Curricular Activities251

The Blue and Gray Yearbook Staff251

The Student Council Election253

JACK JEGLUM ..255

Always in the Court – Never a Queen260

The Gold Key and Kiwanis Writing Awards261

Clarendon Methodist Church**263**

BILLY GRAHAM ..263

The Methodist Youth Fellowship (MYF)................265

Choir Practice ..266

The Ride Home ...267

Sitting in the Back of Church267

Hooks Haven ...268

A Fire Alarm..270

The Haven Hookers ...271

Al's Girlfriend ...272

Summertime at Virginia Beach........................**273**

The Potomac River ..274

My Dog Nicky..274

College Applications ...276

High School Graduation Parties276

High School Graduation ..277

The William and Mary Years 1953-1955**279**

BETTER TO HAVE LOVED281

PHYSICS LAB AT W-M......................................283

Low Grades ...286

Social Manners Required for Women288

What is a homosexual?...289

Sororities ...290

Rush Week...291

Jewish Prejudice ..292

Sorority Initiation Night..293

Swimming at William and Mary295

The Dance Recital ...296

The Theatre ...296

Restoration Comedy...296

Musical Comedy...297

Pan-Hellenic Council Resignation300

Transfer to the University of Virginia303

The Announcement ...303

The University of Virginia. 1955-1957 305

History of Women..305

Dean Roberta Hollingsworth Gwathmey.......................306

Mary Munford ..308

Mary Munford Hall ..309

Jim ..310

Mr. Jefferson's University...310

Discrimination..312

The Dress Code ..312

Mister Jefferson..313

The Honor Code ..313

Social Life..315

Don't Act Surprised ...315

Teaching Methods ..316

Sex Discrimination ..317

The Lonesome Gal..317

THE PERSIAN PRINCE ..318

A Proposal ..319

The Student Council Election ...320

Plans for the Future ...321

The Lychnos Honor Society...322

A Career in Speech Therapy ..322

Graduation..325

Marriage - Expected after College Graduation325

The Wedding...329

The Wedding Day June 22, 1957 333

Epilogue ...337

PROLOGUE

Why on earth are you doing this?

We thought you were going to retire.

Wha' da ya nutz?

The retirement parties are over. In a few months we are moving to Columbia, South Carolina. When we move I will enjoy going to book clubs, swimming at the Y, attending symphonies, going to the theatre and the ballet, and, of course, "spending time with my grandchildren."

To celebrate my retirement I and some friends registered for a meditation course. Ann McCarthy, MS, Wake Forest University Medical School was the instructor in a course on mindfulness meditation. We know that meditation is relaxing, helps to clarify our thoughts, and, in general, makes us more creative. At the conclusion of the eight week course students are required and encouraged to experience a day of silence. I and my ten classmates meet on the Graylyn Estate in Winston-Salem on a beautiful sunny cool day.

We are encouraged to participate in a few activities led by our leader, Ann. Most of the day is ours...for relaxing...creating... contemplating.

About six hours into the full day of mediation, an idea came literally crashing into my brain. I tried to ignore it. Something was "telling me" that I should write a book that would honor people in my parent's generation. And in addition, I should include my own youthful experiences during the days when we were labeled the *apathetic generation*. I expected to forget the idea. I tried to forget the idea. Why would I do such a thing during my retirement

years? No! No! That would be silly. Who would care? Who would want to read it?

Three years afterward, the obsession remained. I retrieved old letters, pictures, scrapbooks, and mementos. I began to outline the book.

Although my parents were deceased, I could hear Mamma saying, "No! Don't do it. In our family we don't 'air our dirty linen.' Just leave well enough alone. Don't do it! For Lord's sake, Betty Jo, don't do it! What will people think?"

I could also hear my Daddy's voice saying, **"Ethel, leave her alone.** She will write a good book. We lived in a time almost forgotten. Our family history is important. All families are important. It's a good thing that she's doing. So, I repeat. **Ethel, leave her alone."**

So, I invite the reader to the pages of my book. You will meet my mamma, daddy, teachers, preachers, boyfriends, girlfriends, enemies, and pets. You will meet the people who loved me and those who were cruel. You will know more about my life than Mamma *ever* wanted anybody to know.

And *some* of it is true.

Welcome.

ETHEL!
LEAVE HER ALONE!

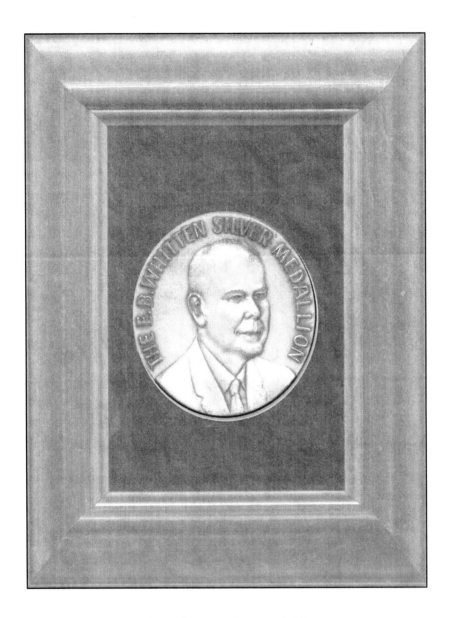

E. B. Whitten Silver Medallion

DADDY

ELTON BARBER WHITTEN

1908-1989

THE BEGINNING

The Visit

When my father was an old man, he and my mother traveled once again for what was to be their final visit to see their relatives in Mississippi. Mother told me this:

In 1987 my parents left Jackson to return to their home in Washington, DC when Daddy said he was driving home another way. He was going to Ripley, Mississippi in Tippah County where he was born and lived until he went to college at the age of fifteen years.

Mother said when they got to that little town Daddy drove down some back roads, and then traveled on an unpaved road. Dust swirled around the car as the tires turned in the soft ground. The car slowed down and then stopped in front of an old run-down dwelling. The absence of any breeze rendered the tall pine trees motionless. Without speaking to Mother, Daddy got out of the car and approached the old house almost covered with kudzu. Mother could see an elderly black man sitting on the porch.

Daddy called out: "This is Elton Whitten. Does Lamar still live here?"

The old man got up from the porch and walked slowly and carefully down the steps. He and my daddy walked toward one another, looked in the other's eyes, and embraced. Their shoulders shook, as they cried for a long time. Neither man uttered a word. Then Daddy got back in the car and drove away. He and Lamar played together when they were children...probably from about

1915 – 1925. He had never told me about Lamar, nor did he and Mother ever speak of it again.

How could it be that these two old men, one black and the other white, would embrace on that stifling hot day in Tippah County, Mississippi? Their sobs were the only sounds Mother could hear, with the exception of the occasional buzz of an insect or the squawk of a mockingbird hidden deep in the kudzu. Who could ever imagine that 75 years had passed since Lamar and Elton were playmates in that exact space where they stood in their backyards in Tippah County?

Daddy's life had changed. Daddy had changed the world.

Had Lamar's life changed? I wonder.

The Whittens

1907 – 1923

Elizabeth's Death

Daddy's full name was Elton Barber Whitten. He was born in Tippah County and lived in Ripley, Mississippi until he enrolled in college. From his earliest days he remembered Lamar, his Negro playmate. Lamar's mother, Estelle, took the short daily walk to my grandparents' house, where she assisted Daddy's mother, Nora, with the daily chores of caring for Elton and his six brothers and sisters. Lamar's daddy, Melvin, worked in the livery stable owned by my grandpa, Albert Whitten. Lamar was given a little work to do, such as picking the blueberries, feeding the dogs and cats, cleaning the horse stalls or sweeping the chicken yard.

My Grandmother Nora was the second wife of Albert, Elton's father. Albert's first wife, Elizabeth, died of malaria after having two daughters, Bama and Effie. During Elizabeth's final days her sister Nora was still living with her own parents. Nora was sent to nurse her sister as well as care for Bama and Effie who were four and six-years-old. This was a sad and confusing time for these two little sisters.

The malaria epidemic in the Mississippi Delta was considered an inevitable part of life until it was recognized that the disease was caused by the mosquito. Elizabeth Barber Whitten didn't live long enough to benefit from the quinine treatment that stopped the epidemic. Nora grieved for her sister and agreed to stay with my grandpa to care for Bama and Effie after their mother died.

Albert and Nora must have fallen in love after Elizabeth died. In Ripley on New Year's Eve, 1905, Grandpa Albert married Nora Barber (his first wife's sister). He and my grandmother Nora had five more children, including my father, Elton. *(I, her oldest granddaughter, inherited Grandmother Nora's gold wedding band; engraved 12-31-1905. I still wear it today)*. Nora was a devout Methodist. Every Sunday she and her seven children dressed in their best clothes to attend the Methodist Church.

Hermie and Elton Whitten - 1912

Malaria

When my dad, Elton, was four years old (in 1912) he contracted malaria. His father, my grandpa Albert, was terrified. He had lost a wife to this dreaded disease; now his first-born son seemed deathly ill. Grandpa sat by Daddy's bed night and day caring for him. Even though he "didn't have much for church" it was reported that he prayed for Daddy. In that day children who contracted malaria and who didn't die, often suffered stunted growth, decreased cognitive development, and were reported to be weak and listless.

Grandpa had heard about Dr. Gorgas, a U.S. Army physician, who had earlier discovered that quinine was an effective treatment for soldiers during the building of the Panama Canal. Physicians began using quinine as an untried treatment for malaria in the United States. Grandpa found a doctor in the Mississippi Delta who provided quinine for Daddy, which resulted in his recovery with none of the accompanying side effects of malaria. Although Daddy had no memory of having malaria, he came close to being cursed with a physical disability. Instead his life was spent changing laws for the benefit of disabled citizens in this country and throughout the world.

Mosquitos never bit Daddy as long as he lived. When we sat outside on hot summer evenings, the mosquitoes (who were biting me) would fly toward Daddy; when they got within one or two inches of him, they turned and headed my way! I believe there was some quinine in him his entire life!

The Livery Stable

My Grandpa Albert was the town's sheriff, as well as the owner of the livery stable where he rented horses to local citizens. In addition, for longer or more comfortable trips, (usually from Ripley to Memphis), his customers could rent handsome carriages with soft, shiny leather upholstery.

The year Elton was born (1908) was about the same time that Henry Ford invented the Model T, which eventually afforded travel for every middle class American. Grandpa Albert Whitten was later considered a fool when he said, "The automobile is just a passing fancy." He refused to sell his horses and carriages and almost overnight, Nora and Albert's family was poverty stricken. Now Grandpa's only job was that of Sheriff of Tippah County. Fortunately my grandmother Nora could sew. Daddy's sisters (my aunts, Hermie and Lib) recalled going to school in dresses sewn from printed fabric made from flour sacks.

Lamar

During those days, Elton retreated into the worlds of books. Daddy's sisters remember that he read most of the time. Although he did not like to attend parties, Granny Whit forced him to go. Daddy would hide his latest book under his shirt when he left for the party. When he arrived he gave his friend a birthday present, found a quiet room and continued to read his own book.

When Elton was not reading he was playing with Lamar. Daddy taught Lamar to read and Lamar taught Daddy how to plant flowers, vegetables and bushes. The two young boys watered their plants and enjoyed watching them grow. Lamar could use a knife to whittle sticks with points sharp enough to gut a fish. When Daddy and Lamar played in the woods they built tree houses and picked raspberries, blueberries and persimmons. The two boys ate their fruit as they sat in the tops of trees looking out on the world... Daddy and Lamar.

I wonder now what these two boys would have talked about. But I never thought to ask.

(My daddy became an expert gardener and always enjoyed watching his flowers, trees and vegetables grow. I know that must have begun with experiences shared with Lamar, his childhood friend).

Sheriff Albert

Daddy had absolutely no interest in working with his own father at the livery stable. He was, however, always interested in Grandpa's activities when he had to act as the town's sheriff. When the bell system rang that linked the local saloon to the Whitten house, Sherriff Albert Whitten would select a small key on his key ring to unlock the box that held his revolver. When he rushed downtown to keep the peace in Tippah County, Daddy and Lamar would sneak off to spy on Grandpa. They watched him as he settled arguments, bar fights, and the one time he had to call the coroner.

When his mother Nora, realized Elton had slipped off again, he was mildly scolded, but never severely punished. Elton was also aware that his father drank alcohol and when he was not putting "drunks" in jail, his own father might be drinking at home. As far as Elton knew, the bell never rang when his own dad had been drinking.

The Faulkner House

Another of Elton's childhood pleasures was to sneak down to the home of William Faulkner where there always seemed to be some sort of party going on. Elton and Lamar would hide and spy on the Faulkners who would tell stories, talk loudly, curse, and even drink liquor in public. Wow!

When Granny Whit (a Methodist teetotaler) discovered Daddy had been down to spy on the Faulkner's, she would scold him. Years later when I was a student at the University of Virginia, William Faulkner was the Writer in Residence. I asked Daddy to tell me all he could remember about the Faulkner's. He just smiled and said, "Well, Mamma never had much use for the Faulkners."

After Daddy's death in 1989 I found a photo among his belongings of him playing a guitar in a band. I never knew he played a musical instrument. I do know that he could not "carry a

tune" but enjoyed singing; and he enjoyed dancing, yet he had "no rhythm!"

High School Valedictorian

When Daddy was fifteen in 1923, he graduated from Ripley High School having completed all of the classes that were taught there. He was valedictorian of his class and his teachers told him they had taught him all that they could. He needed to go to college.

Daddy wanted to go to college, but there was no money in his family for such a luxury. I don't know the details of this, but Daddy's sisters told me that "someone who lived in that little town of Ripley, Mississippi" recognized Daddy's academic ability and arranged for him to go to college. He was admitted to Millsaps College, a Methodist college for young men in Jackson, Mississippi.

(On three occasions that I know of, after Daddy moved to Jackson and had a well-paying job, he arranged for three young people to attend college who could have not otherwise afforded it. I believe this was his way of paying the debt he felt he owed the man in Ripley who helped him. Today that would be called "Paying it Forward.")

As the story goes, the day Daddy left for college, Granny Whit, (his mother) filled his new trunk with clothes and other items she thought he might need in Jackson. On the day Daddy left home Lamar came to tell him good-bye. Lamar was dressed in socks, his daddy's shoes, with a jacket over his overalls. When he hoisted the trunk on the back of the wagon Lamar and Daddy sat side-by-side on the trunk as Grandpa turned the horses toward the depot. Granny Whit, sitting next to Grandpa in the front of the wagon, was silent as the two horses headed toward the train station. Grandpa got out of the wagon to buy the ticket for the long ride from Ripley to Jackson. When he shook Daddy's hand Granny Whit was crying so hard her shoulders were shaking and

she was unable to speak. Lamar helped the conductor put the trunk on the train. Then he and Daddy shook hands for the last time…two childhood friends, now young men, were saying goodbye.

Daddy never returned to Tippah County except for brief visits to see his family and years later, his last visit to see Lamar. I believe that Granny Whit knew he would never return home and that is why she was crying at the depot.

Millsaps College 1923-1929

The Train to Millsaps

On the train Daddy met a young man, Eron Sharp, who boarded in Forest, Mississippi. Eron was also enrolling in Millsaps and neither of them had ever been on a train, nor had they been to a city as large as Jackson. Night had fallen when the train arrived in Jackson. A stranger in the train station told them how to catch a streetcar to get to the college campus.

"Go stand in front of the Edwards House, catch a North State Streetcar, and ask the motorman to tell you when you are at Millsaps College."

In a letter Daddy wrote, "We rode and rode and the motorman finally put us off at a dim streetlight where a little shed sat on the street corner. The motorman pointed the way to Sanders Hall and drove away leaving us alone in the dark."

Eron Sharp (who became a Methodist minister) and Daddy became close friends and the friendship endured throughout their lives.

Daddy flourished at Millsaps. He always appreciated reading and studying about the arts, sports, American literature (especially O. Henry), poetry (especially Robert Frost), while he listened to classical music. His hundreds of books indicated his varied interests.

After the completion of three years at Millsaps, financial difficulty resulted in Daddy leaving college. For nearly two years he sold books door-to-door throughout towns in Mississippi until he earned enough money to return to Millsaps. He completed his coursework with an academic major in social studies. Debating

and public speaking were his primary extracurricular activities. His numerous awards as a college student included the Millsap's medal for debating during his senior year. He graduated with honors.

(E. B. Whitten was a gifted speaker as he traveled throughout the United States and abroad. He convinced people that the world should respect, educate, and hire handicapped citizens. And he always gave some credit to his professors at Millsaps when he received compliments on speech making ability … Congressional Record, 1974.)

In 1929 Daddy received his Millsaps diploma enclosed in a leather binding. The school motto was engraved. *Don't try dying, but die trying.* Interesting!

Today the motto is "Ad Excellentian." I have some difficulty deciding which is the better motto!

When they were old men Daddy received a letter from his college friend, Eron, who wrote, "You were always brilliant and didn't have to study as long or as hard as the rest of us."

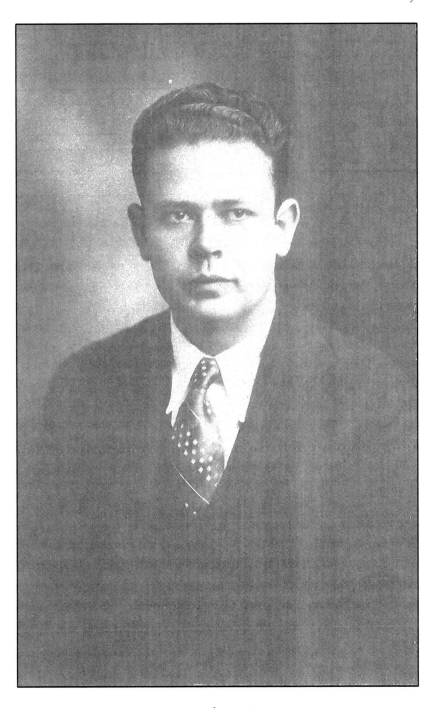

Elton Barber Whitten
Pickens, Mississippi, 1930

Public School Employment 1929-1948

The Early Years

Daddy's first year out of Millsaps he was employed as a Superintendent of Schools in Falkner (1929) followed by another year in Pickens, Mississippi (1930). In 1931 he was appointed the Superintendent in the Taylorsville Consolidated High School in Taylorsville, Mississippi, where he met my mother, Ethel Marie Duckworth. She was a first year teacher in the school. Daddy remembered her as a young, beautiful, smart, energetic musician with a "twinkle" in her eye.

Mamma's Reading Lesson

Daddy frequently entered Mamma's fourth grade classroom in order to "observe her teaching" which, in turn, caused Mamma to become quite flustered. Once, when he was observing Mamma, she called on the best reader in her fourth grade classroom to read because she wanted Daddy to see what a good teacher she was.

Young Anna Belle was reading beautifully when she came to the word "mildewed" which she pronounced correctly. Mamma said, "No, honey, that word is **mil-doo-wed**." Anna Belle said, "No, Miss Duckworth, the word is mil-dewed." Daddy never let Mamma live that down! And Mamma loved to tell that story.

Daddy's best friend in Taylorsville was Coach Tom Carmichael. The coach and Daddy and my mother often went out together, usually to the picture show located on Taylorsville's

main street. One night Daddy stopped by Mamma's classroom to arrange another outing.

Mamma said, "Is Coach Carmichael coming, too?"

Daddy grinned and said, "What do we need him for?"

And that was the beginning of their courtship.

Within a month Daddy went to my Granddaddy Ben's store in Taylorsville to buy mother a diamond. He proposed. She said "yes."

They married in 1932.

(Their 57 year marriage lasted until my daddy's death in 1989.)

Daddy gets Fired!

By 1933 the depression had affected the public school system. An influential man on the Taylorsville School Board had an adult son with no job. The son, with no college education or experience in teaching, was given Daddy's job as Superintendent. Daddy was stunned. My granddaddy was a respected merchant who had lived in the town his entire life. He was furious. But there was nothing to be done.

Just before school was scheduled to open in Taylorsville, Daddy was relieved to get a job in Waynesboro, Mississippi. My parents prepared to move from Taylorsville where Mamma had lived her entire life. She cried when she left her mother.

But my grandmother said, "Ethel, he's your husband. You must follow and support him." They say the day Mamma left Taylorsville, Grandmother Duckworth "took to her bed for a week" mourning the "loss of proximity" of her daughter.

In Waynesboro Daddy's Superintendent's salary was still not enough to support the two of them. Once again, Daddy sold books in the summertime to supplement his income. Although my mother had a degree in primary education, the school system would not hire her because during the depression there was a policy that two school salaries shouldn't go to one family. The school money should be spread around. And rightly so, I guess.

Let's Start Our Family

Mamma and Daddy knew they wanted to start their family and so they did. They did not know how they would support one another, much less a baby. When Mother became pregnant with me she recalled the nights they lay in bed, holding hands, praying and even crying because they felt so helpless.

(As an adult I learned that there were very few people born during the depression. As a result we "depression kids" had more advantages than the generation before or after we were born. I do believe that to be true.)

Fortunately, in 1935 a call came from the Chairman of the School Board in McLain, Mississippi. A new Superintendent of Schools was needed in Greene County. Mr. Baxtrum, a merchant in town, had some influence in making the school appointment. He arranged for Daddy to be interviewed.

Mamma said when Daddy returned from the interview he danced into the house singing a song and bringing her a gift of a small glass paperweight. The reader should be reminded that Daddy had no rhythm nor could he carry a tune. But they always remembered that event as a magical and life changing moment.

I still have that inexpensive but precious little paper weight in my home. When I look at it, I imagine how my young parents must have felt at that moment. Filled with joy and hope and knowing that Daddy would be making "enough money" was a moment they never forgot. They often referred to that day, even during their old age.

McLain, Mississippi 1935 - 1940

Betty Jo is Born

In McLain, Mississippi, school began in September and I was born on October 20, 1935, in the Hattiesburg Methodist Hospital. Mamma had a difficult delivery. Daddy sat in the hospital listening to her screams for over twenty-four hours. My Duckworth grandparents met him at the hospital. They said Daddy went off alone and cried and prayed for Mamma to live and for me to be okay. After what must have been a horrible birth event, with Mamma in labor for such a long time, I was born. Dr. Ross informed Daddy that I was twenty-one inches long and weighed a little more than six pounds. Mamma and I "were both okay."

They named me Betty Jo, after my Uncle Joe, who was Mamma's fourteen year- old brother. For over 200 years there are records of men in our family with the name of Joe. But I am the first woman in the family to have that name; and my granddaughter is the second.

Mamma and I remained in the hospital for over two weeks. When we finally checked out, Daddy needed to pay the bill. When Granddaddy offered to loan Daddy the money, Daddy refused. He said that he had been saving up and wanted to pay for me "in full." Mamma told me Daddy was very proud of that.

Meeting my Kinfolks

My first ride was the forty mile trip from the Hattiesburg hospital to my home. Granddaddy and Daddy were in the front

seat of the car and I, Mamma, and Granny Duckworth were in the back. I slept all the way home in Granny Duck's lap wearing my "little blue dress and daisy set."

My second car trip was to go with Mamma and Daddy to pick up the laundry at the home of our washwoman who lived out in the country. The third was a real trip at six weeks when I rode to Taylorsville to visit my grandparents Duckworth at Thanksgiving. Christmas I took another trip to Memphis where I was introduced to my grandparents Whitten along with my numerous aunts, uncles, and cousins. When Granny Whit first held me, she was speechless, just looked at me and cried. And throughout the years, even when I became an adult, she always cried when I arrived and again when I left.

Another often told family event was my Easter trip to visit my Grandparents Whitten in Memphis where I cut my first tooth. The story goes that when people tried to look at my tooth, I would clamp my upper gums on my little lower tooth and hold their finger tight. When they pretended I was hurting them and tried to pull away I would squeal with laughter.

First Tooth

The Teachers' Home

In McLain we lived with four other teachers in the Teacher's Home which was located next door to the school where Daddy was

the Superintendent and also the basketball coach. The school provided a Negro cook, Maggie, who came to the house each day to help Mamma manage the home during the five years we lived there.

When I was an infant Mamma told me that Daddy would come home from school three or four times a day to see me.

"What has she done today?"

"She hasn't done anything since you left two hours ago! I believe she burped twice and ate a little cereal."

Mamma said sometimes he would just come in my room to watch me sleep.

Of course, then as now, when babies were born, they were given gifts by relatives and friends of the parents and baby. According to the reports in my "Baby Book" I received approximately 75 gifts. Most would be similar to those of today: dresses, robes, shoes and silk socks, a piggy bank, jewelry, blankets, toys, comb and brush sets (3!), soap and bath cloths. Some of the gifts would be puzzling to the mothers of today. For instance, I received three "little slop jars, six sacques, and one shoulderette." My baby bed (crib) was a gift from my grandparents Duckworth and my Uncle Joe. As the years passed he seemed to really love me, and I know I loved him.

Mr. Baxtrum's Store

In small southern towns (maybe in the North, too … I don't know)… there was usually a main street with small businesses on one side of the street. There might be a dry goods store, a grocery store, the post office, the hardware store, bus stop, and a café connecting to the picture show. Across the street from the stores were the railroad track, the cotton gin, and some insurance and law offices. And so it was in McLain, Mississippi.

Every day after Daddy left school, he would come home, put me in my stroller, and take me downtown which was about four blocks from home. Daddy carried me into every store where he would sit me up on the counter while he talked to the men. What about? The depression, the impending war, Roosevelt, cars, politics, the weather, or the plight of the farmers? And, of course, the outrageous behavior of the young people in town.

Daddy told me that when I sat on the counter I would occasionally babble a few sounds in a conversational tone of speech and made the men laugh! I seemed to enjoy hearing their laughter and I laughed along with them as if I understood the jokes that were being told. When the conversations were quiet, I became still and attentive to the speaker, and seemed to understand the seriousness of what was being said.

One afternoon Mamma was sitting on the front porch waiting for us to return from town. She looked down the street to see daddy in front of the stroller. He was *pulling* me home. I had slipped over to one side of the stroller and my diapered rear was dragging on the ground. I was licking a sucker and seemed to be totally content.

The day before I was one year old (October 19, 1936) I walked. After that my trips to town with Daddy came to an end. I never did crawl because there were splinters in the floor of our house; I scooted around in a walker until I was "ready" to walk.

As a one-year-old I was walking everywhere, often directly behind my daddy and clearly imitating him. His head was always looking up (some said so he could look down on others!) with an

erect, straight back, and always moving with purpose. He never was seen sauntering. Others would laugh at me as I followed him around the house. They would exclaim, "Look! She is walking just like Elton!" And that made me very proud.

Even though we lived in McLain during the midst of the depression, Daddy and Mamma remember McLain in a positive way. Daddy didn't make enough money to last all year so Mr. Baxtrum, who owned the grocery store, would give him credit for groceries during the summer. Daddy repaid him in the fall when school started. Also, during those summers Daddy continued to sell books door-to-door to make some extra money.

First Step

In the fall when school started Daddy would have a paycheck again. By Thanksgiving the debt to Mr. Baxtrum would be paid in full.

During the school year Daddy was Superintendent of Schools and served as the basketball coach. After school was dismissed Daddy enjoyed playing tennis with our male teacher boarder, Mr. Phillips.

Teachers' Home, McLain, Mississippi

SOCIAL SECURITY

I was a three, four, and five-year old living in McLain, Mississippi where my daddy was Superintendent of Schools. My parents and I lived in the Teachers' Home located next door to the school.

Roosevelt was President and Social Security was offering hope to a struggling country. There was so much talk about the Depression during those years and history will confirm that times were tough; money was scarce; jobs were hard to get; and financial security was non-existent for the majority of the population in the United States and particularly for the citizens of Mississippi.

But I was unaware of the Depression, probably because Daddy loved to read and we always afforded magazines, books, and the New Orleans *Times Picayune*. Daddy read to me every evening and almost never read from children's books.

When it was time to read, Mamma was usually in the kitchen, finishing up the supper dishes. I could hear her putting the silverware back in the drawer; the plates were placed to dry in the dish drain; she might be humming a favorite tune.

I was barefooted and dressed in my pajamas and waiting on the large front porch of the Teachers' Home that extended the width of the house. Dusk was approaching, as I watched the sun set which might cool things off a bit. I would stand next to the large wood plank rocking chair, listening for Daddy's footsteps move throughout the house, as he approached the front door.

Daddy came outside holding a few books or papers. He might pretend to pass our chair and go into the front yard. Then he would stop (as if he forgot where he was going) and look around to see me with my hands on my hips imitating Mamma when she got mad. He laughed, returned to the chair, sat down and held out his big, strong, gentle, loving arms. I hopped on his knee and snuggled with my head on his chest. And he read.

We looked at the *Saturday Evening Post* each week where he read every cartoon.

"What is funny about this one? Why did you laugh?" he would ask.

He read about Captain Horatio Hornblower and told me about Norman Rockwell. He read Booth Tarkington's *Penrod and Sam*, or O. Henry's *Ransom of the Red Chief*. He would laugh so hard as he was reading I could hardly understand his words. I would laugh, too, although at times I had no idea why we were laughing.

"What, what, Daddy? What did you say?" My laughter continued.

Mamma would come out on the porch and she would say, "Elton, stop reading that to her. She can't possibly understand what you are reading. Read her something she can understand."

"I do understand! I understand all of it. Don't stop reading, Daddy!"

And, oh, how he read. He and I quoted Poe's Raven, "Nevermore." We rested under the shade of Joyce Kilmer's trees; we stopped by Frost's snowy woods; made Mark Twain's raft with Huck and Tom; and, oh, how I loved those brief funny words of Dorothy Parker. When I became sleepy and got quiet, Daddy carried me to my bed and

tucked me in. He always kissed my cheek and I always pretended to be asleep.

No, the Depression never hit the front porch of the Teachers' Home in McLain, Mississippi.

I never realized we needed social security.

Mrs. Denton's Cow Pie

I have a few vivid memories of McLain. We lived in the Teachers' Home that was located next door to the school and where we lived with four other teachers, three women and one man. Next door to the Teachers' Home lived Mrs. Denton who had a few acres of land, a small garden and one cow that needed to be milked each day. I liked going to see her and she would let me try to milk Dottie, which was harder than it looked. Once when I went to Mrs. Denton's, I was playing in the pasture and picking wild flowers to take to Mamma. Some big neighborhood boys picked me up, took me deep into the pasture and would not let me go home until I stepped into four cow pies. I was smelly and embarrassed when I ran home crying to Mamma.

Bud and Henry

I had two friends in McLain. Cousins Bud and Henry Weldon lived near-by and often walked down the road to play with me. We three would lean up against the school house in a shady spot and talk about how different people might look if they were naked. And then we talked about what we would do if someone ran off with all our clothes and we would have to get home naked. I said that I was such a fast runner, my legs would be going as fast as an electric fan and I would be running so fast no one would see me. And we would laugh so hard we would fall on our sides. I believe that is the first twinge of a sexual feeling that I ever had. But when I told this story later, I was told a five year old could not feel sexy! Hmm....

Miss Germany

Our house in McLain had a long front porch with enough large plank rocking chairs for all of the adults in the house. In addition to our family of three, we lived with four teachers. Mr. Phillips had his own room; Miss Germany and Miss Toler roomed together; and Miss Robertson had her own room. I felt sorry for Miss Germany because the war had started and we were supposed to hate Germans. I decided I would like her anyway, but I did not tell anybody. Miss Germany had "buck" teeth that showed even when her mouth was closed. (*When I became a speech/language pathologist I thought of her. She would have been a beautiful woman had she been born 25 years later.*)

Walking with Daddy

Daddy always liked to be outdoors. During the fall of the year I loved to walk outside holding one of Daddy's fingers as we kicked through the fall leaves. We always passed three persimmon trees on our walk. We ate the persimmons that had fallen on the ground and tried to spit out all of the seeds. Occasionally, Daddy would slip me a green persimmon and we would both laugh, as my mouth and face would scrunch up. I pretended my mouth had become smaller and that I could not talk. I loved the laughter that always followed the "tricks" I played on Daddy.

Daddy and I enjoyed walking in the rain. We would step in the puddles and splash in the muddy water. Mamma would come out on the porch and shout, "Elton, get that child out of the rain!" But she was smiling and we kept walking.

Daddy and I always talked on our walks. I don't remember what the subjects were, but if I asked Daddy a question about something, he would usually say "Well, Betty, what you think about it?" And I would tell him. He always took my answers quite seriously and seldom told me I was wrong. However, he would often say that "another way to think about it is"…and that's when I found out what he was thinking.

The School Is On Fire!

I have one vivid and terrifying memory Of McLain. The Teacher's Home was next door to the school which contained the first through twelfth grades. One night I heard some shouting and commotion and awoke to realize that the school was on fire. When I peered out on our porch I could see an orange glow in the sky. I had never seen such fear demonstrated by my brave daddy. He was rushing back and forth from our house to the school. Townspeople rushed to the school on foot; others arrived in cars determined to assist in some way. One man was hosing down the school. Two others were hosing water on the sides of our house so that if some sparks flew from the school to our house, the house would not catch fire and burn us up. I was scared but I didn't cry.

Mr. Phillips, one of the teacher boarders, had the flu and was too sick to get out of bed. He decided, however, that he had better get out of the house. He would stand up, stagger a few steps, and there would be the sound of a big thud, and a groan when Mr. Phillips would fall to the floor. Then he would stand up and stagger a few more steps, the sound of a thud, and another moan. He made it out of his bedroom, into the dining room, the living room, and finally on to the front porch … just taking a few steps and falling down. I wondered whose job it was to pick him up if the house caught fire. Would he just have to stay in the house and burn up? At the time it was a horrible event. But when the flu/fire event was just a memory, there was much laughter as the Mr. Phillips' story was told, retold, embellished and told again.

The school had to be rebuilt. I have no memory of where the displaced students were educated. But I do remember that I was instructed never to go past the little wobbly fence into the building site because it could be dangerous. One day I slipped through the fence to observe up close the recent pouring of the cement foundation over some slender iron posts. When I peered over the edge for a better view, I slipped, fell into a three foot crevice, and my thigh was cut by an iron post. I managed to get

out and went home bleeding. I was hurt but determined not to cry. I got "the look" but wasn't punished by Mamma or Daddy, nor did I ever go to the building site again.

Mr. Phillips

The Piano

It was an exciting and happy day when Daddy bought Mamma a piano. Granddaddy Duckworth was the merchant in Taylorsville who ordered one for us. It came on a big truck in a big box. When the piano was moved into the house, I was given the box to use as an outside playhouse. It was a wonderful playhouse until the rains came. Then it got smelly and Mamma asked Daddy to haul it away.

From the day that piano arrived, we had music in the house. My mother practiced and played every day. And as she played, I danced. I began to scuff up the wooden floors so badly that Daddy got me a 4'x 4' piece of linoleum, so that I could dance "to my heart's content."

I was also pleased to know that when I was in the second grade I would be allowed to take piano lessons and there would be two musicians in the house…mamma and me! (Some expected events don't occur…but that is another story.)

That Ole' Time Religion

Daddy's family of origin was Methodist. My mother's family was Baptist. In McLain the two churches were located directly across the street from one another. During our first two years in McLain, on one Sunday I went to church with Mamma and the next Sunday I went across the street with Daddy to worship with the Methodists. Finally Mamma said that I was too similar to my daddy for me to be away from him every other Sunday. She left her Baptist church became a Methodist and remained a Methodist for the rest of her life.

Daddy was always a leader in the Methodist church. He taught the men's Sunday School Class in every place we ever lived. He was often the Chair of the Board of Trustees and spent a great deal of time at the church throughout his life. We have many gifts he was given by his church members (bibles, clocks, watches, trees) throughout his life to express appreciation for all his service

to the church. He was an excellent teacher and speaker and throughout his life was encouraged to go into the ministry. He felt, however, he could serve others in other ways without choosing "preaching" as a career. We moved to McLain, to Union, to Jackson, and then to the Washington DC area always attending the Methodist church. And at this writing I am still a Methodist.

The University of Alabama

Summer 1937, 1938, and 1939

Even as a young man, Daddy realized, that if he was going to advance in achieving his goals he would need more education. Thus, for three summers Daddy moved our family to Tuscaloosa, Alabama where he enrolled at the University of Alabama. He earned high honors at the completion of a Master's Degree in Public Administration with a Thesis Study on Vocational Guidance Programs. During those summers I attended one of the first nursery schools in our country on the University of Alabama campus. (Today when I name the schools I have attended I might include UAB!)

Mother confided to me that in the mornings when Daddy wasn't in class and I was in nursery school, he would come home. She said their "most romantic times" were during those summer mornings. She told me years later when people thought of Alabama as a hot place, they were right. It was *hot* when they were there - in many ways!

I have three memories of the summers spent at the University of Alabama. The grass was filled with sandspurs and I was always barefooted. One day, some bigger boys picked me up and carried me out in a field that was filled with sandspurs. They put me down in the field and ran away and left me. I stood there terrified, crying and screaming. Mamma finally heard me, came outside, picked me up, and took me home. A discussion followed on why I might want to wear shoes when I played outside.

The second memory was the time I brought home some modeling clay from nursery school. Mother was upset and told me I had stolen it. I was afraid for Daddy to come home. I knew that stealing was wrong and assumed that I would be punished. I had never before seen modeling clay and I wanted it so I took it. When Daddy came home, he talked to me about what I had done. I was crying a little bit and told him I was ashamed and sorry.

He said, "Well, you will never forget it; you won't do it again; now bring me the clay and let's make something pretty out of it."

He molded a fish; and the eye of the fish was the red and white phosphorus from the tip of a matchstick. It was a beautiful fish. The next morning I took the clay back to the teacher. I was scared when I told her I had taken it home. The teacher took the clay, said she was glad that I brought it back and that she was sure I wouldn't ever do that again. She actually smiled at me and told me to sit down in my little chair at the little table.

Finally, I remember that on Sunday afternoons we went to the Tuscaloosa ice cream parlor (we didn't have ice cream shops where we lived in Mississippi) and I had my first (but not last!) dip of black walnut ice cream. I loved it! After we finished our ice cream we might take the long ride across the Lake Ponchatrain Causeway. I would be asleep by the time we got back home. Yes, our summers in Alabama were hot yet pleasant for our family.

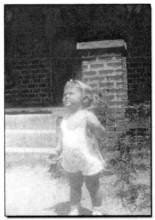

Mosquitoes – Tennessee! Alabama! Mississippi!

Union, Mississippi 1940-1943

In 1940 there was another move for Daddy, also "upwardly mobile," to the small town of Union, Mississippi where he was hired as the new Superintendent of Schools. Once again we stayed in a home designated for the family of the Superintendent. This time, however, we didn't have to live with other teachers. Mamma loved that little house and we were very proud of Daddy who was responsible for our having a much nicer place to live. I was starting first grade in the 1-12 school that was located across the street from where we lived and where Daddy's office was located.

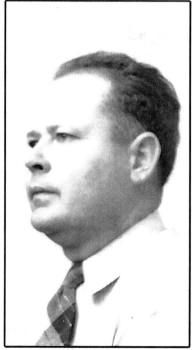

The short story that follows, CHANGE, serves to describe the times when all children couldn't attend the same schools. The story concludes with a glimpse of Daddy's dream for our future as he tries to explain why my playmates aren't going to my school.

CHANGE

1940

My name is Betty Jo and this is my first day of school in Union, Mississippi. I am finally a big girl going to the first grade. I am walking toward the school with my two neighborhood playmates, Conrad and Daisy. We are wearing our brand-new school clothes including our new shoes that have not been "broken in" yet. Even though our mammas told us that by the end of the day we will have blisters on our heels and toes, we three friends insist on wearing our school shoes. When Daisy left her house, her brother, Curtis, was crying because he wanted to go to school, too. Curtis could neither walk nor talk, but Mrs. Banks was not going to send him to an "institution." Curtis had to stay home.

I skipped across the street to the near-by school, but Conrad and Daisy stopped at the side of the road.

"Come on," I shouted.

Conrad and Daisy were silent and shook their heads.

"No, that's not our school. We'll wait here to ride our school bus."

Soon after a big yellow school bus picked them up and disappeared in the distance ... to some other place? Where? Why?

Walking alone into the school I was puzzled. I would find my daddy's office and was relieved that I could already read a few words. I located the door that said "Superintendent" and walked in without knocking.

"Daddy, why can't Conrad and Daisy just walk on over to my school instead of catching a school bus to go somewhere else? And why can't Curtis come, too? He can talk a little bit and he cries every morning when Daisy leaves him."

"Betty Jo, that's the law and that law is a bad thing. It won't always be that way. The people who are my age will change that law and that will be the easy part. The people in your generation will have to obey the law and that will be the hard part. One day white people, Negro people, and handicapped people will go to the same schools and ride the same buses. Things will change and you and I will do our part to see that these changes take place. Unfortunately, they will not change in time to help Conrad, Curtis, or Daisy."

The years passed as I walked across the street to my school while Conrad and Daisy rode the school bus. And each morning Curtis remained in his wheelchair on his front porch and continued to wave goodbye.

I waited each year for the change that Daddy had promised. But things stayed the same. I never got to attend school with Conrad and Daisy nor did Curtis ever get to go to school.

My adjustment to Union was not an easy one. I was entering the first grade where my daddy was the new Superintendent of Schools. Mamma was spending most of her days trying to unpack,

sew curtains, design and make my school clothes, and she missed her friends in McLain. When I whined about anything I was expected to "feel fortunate that I was not starving like the children in China." Although I didn't know any children in China I knew enough to know that I was not to complain about anything.

Mamma and Daddy told me there were neighborhood children with whom I could be friends. I was urged to "go outdoors and play."

The story that follows taught me a valuable life lesson… learned at the age of five and still being used today.

THE BROOM HANDLE

The cotton mill was the main employer for the citizens in Union. Numerous mill houses were located on the street behind us. Betty Jo's after-school playmates were children of the mill workers. In the beginning she had some difficulty adjusting to the young neighborhood tough guys. But with the help of her Daddy, things improved.

Betty Jo's family uses an expression that others may not understand. And the expression is: "*Is it time to get the broom handle?*"

For most families this would have little or no meaning. Betty Jo and her family know exactly what it means. Although it's seldom expressed, they know when they hear it, something extremely interesting is about to happen.

Betty Jo is five years old and has just moved to Union, Mississippi. Her handsome daddy has a new job and her pretty mamma has a new piano. Her parents are young and happy that they have survived the depression and the war.

Betty Jo's daddy is the new Superintendent of Schools and has just moved his family into the

pretty house designated for the Superintendent. Their freshly painted white house with green shutters is located directly across the street from the school. Blooms of the pink, white, and fuchsia crepe myrtles are flourishing on the grassy front lawn.

This year Betty Jo is entering the first grade. For the first time she has her own room. She helped choose the yellow paint for the walls of her room and selected a green flowered bedspread for her first full-sized bed with a green braided rug to match.

Her mamma and daddy kept their promise that as soon as they moved and got settled, she could have a pet. Daddy told her that Mr. and Mrs. Hinton, who lived in the country, had some kittens that were ready for a new home. Betty Jo put a soft towel in one of their empty moving boxes, hopped in their car, and the three of them rode out into the country to find the house that had the kittens. When Betty Jo saw the kittens she knew right away which ones she wanted. One was a boy cat she named Shadow because he was black; the other was a girl cat she named Sunshine because she was orange. She placed them in their box and took them home.

Her life was going perfectly. She was a big girl now. She expected to be happy forever.

Now it was time for her to go out to play.

On this perfect day she was wearing one of her new school dresses that mamma made on her new Singer treadle sewing machine. She picked up Shadow and Sunshine from their box to take them outside. She's going to teach them to follow her as she walks around the yard. The front porch of her house was almost level with the ground. She took

one step down, walked toward the school and stopped at the street. When she glanced behind, Shadow and Sunshine were following her.

Betty Jo looked again at the school and wondered what it would be like to be a first grader in only two more weeks. She continued to walk around the yard. Shadow and Sunshine were still with her. They actually followed her to the back yard! Her life's really going wonderfully well.

The grassy backyard of her house sloped downward about fifty yards ending at a dirt road. Across that road was a row of small identical houses provided for families who work in the cotton mills. Children were playing on the road and in their own yards. Betty Jo's going to make some new friends when she joins that kick-the-can game going on in the road or maybe that game of dodge ball in a near-by yard.

As she approached the children they began to scatter and disappear. She wondered why they were running into their houses. When she looked down the middle of the road she saw three boys looming toward her. She guessed their ages to be about four, six, and eight years old. They were *the Myzelle brothers!* They were dirty and barefooted, wearing identical faded overalls. They were sneering at her with their hands on their swaggering hips with their shoulders reared back.

The biggest boy walked right up to her and said, "I'm Roy. This here is Ennis Earle, and we call our little brother Buster."

Betty Jo stood silent and trembling. Why was she so afraid?

Roy raised one hand and pushed her shoulder.

"You're on my road and you better get off. Ya'can't never walk here."

He pushed her again. She lost her balance, took a few steps backward and fell onto the hot, dusty road. She was crushed. She could not keep tears from pouring from her eyes and flowing down her cheeks.

Betty Jo picked herself up from the road and ran home.

Days passed. The Myzelles continued to patrol the street. Betty Jo remained afraid of them and just played in her own yard with Sunshine and Shadow.

Now things were getting worse. The Myzelles came up from their road right into Betty Jo's yard. They told her that they were going to beat her up. Roy pushed her down again and then he grabbed Shadow and started running back to his house with Shadow squirming and yowling. When Shadow scratched Roy, the kitten was hurled into the air, landed on the road, and dashed back into Betty Jo's yard. She began to sob uncontrollably and once again ran inside to her daddy.

She and her parents discussed some things she could do. She tried again and again to smile and be friendly. She invited them to come in her yard to play a game. When her mamma offered them Kool-Aid out on the back porch, they actually sneered when they refused her hospitality.

Roy and Ennis Earl and Buster continued to bully her. She stayed in the house because she was afraid to go outside.

"Please, please! Daddy, make them stop."

"I won't make them stop. You'll make them stop. Come outside with me!"

And her daddy seemed more furious at her than he was with the Myzelles.

When her Daddy went out in the back yard, he reached under their house, retrieved an old kitchen broom, sawed off the handle and gave it to her. He told Betty Jo that the next time the three boys appeared and tried to bully her, she should hit them with the broom handle.

The next day, and the day after that, and the day after that, she walked outside and looked around…waiting…waiting. Her hands were sweaty as she clutched the broom handle. But the Myzelle brothers weren't in sight. She walked down on the road…waiting…up the road…down the road. As usual, children were outside playing in the road and in their yards…but no Myzelles.

And then, she heard a door slam in the distance. And *there they were!* Walking toward her…grinning…sneering…and with his usual swagger, she saw Roy and close behind him were Ennis Earle and Buster.

Betty Jo's heart was beating hard as she dashed full speed right up to Roy. She whacked him once on the top of his head and he looked surprised. She whacked him again and saw that his nose was bleeding. When Roy turned to run home she whacked him a third time on the back of his head. He was still running and she chased him. When she realized she could run as fast as he could, she whacked him for the final time. He and his brothers were yelling and still running! The neighborhood children stopped playing in their yards and lined up on the side of the road to watch. They were laughing and cheering for her. She kept running…right up on Roy Myzelle's porch. He ran inside, Ennis Earle and Buster right behind him!

Betty Jo's heart was pounding so hard she could hardly breathe. She was scared and exhausted. Yet at the same time, she felt elated! She was thrilled! The broom handle had worked its magic.

On her slow walk home the neighborhood children were motionless and silent as they stood at the edge of the road to watch her pass. When she got to her yard Shadow and Sunshine were waiting. They rubbed against her legs as if they knew some changes had taken place in their neighborhood. The three of them walked into the house.

When her Daddy came home from work that day, Betty Jo told him all that had happened. The two of them had a good talk. He told her never to use the broom handle until she tried to settle things with words. Try kindness! Try reason! Try Kool-Aid! Then think about it. And if there is no other way, use the broom handle. This was one of the most valuable lessons of Betty Jo's life.

As the days went by, Betty Jo began to play in her own yard and join in the games taking place in the road. Gradually, amazingly, the Myzelles began to play with her and the neighborhood children.

When school started Roy was in the third grade. He and Betty Jo saw each other at lunchtime. Someone told her that Roy told everybody in school that they better not "mess with" Betty Jo. As the year progressed it seemed that Roy even started to like her. But she was never sure about that.

To this day when things are not going well, Betty Jo wonders, "Is this the time to get the broom handle?"

And, yes, throughout her life she has needed to use it. Fortunately, rarely!

Perhaps she will need it tomorrow. Who knows?

Picking Cotton

The Depression continued to be relentless. The schools in Union, Mississippi, were in session for only seven or eight months because there was not enough money to pay the teachers. Schools also disbanded for about three weeks in October when it was time to pick cotton. One day Daddy dismissed the whole school for a day to go to one cotton field to help a family in great need. And Daddy went to pick cotton with all of the school students.

Although I was just five years old I wanted to pick cotton to help that family. Mamma sewed me a little sack to put over my shoulder similar (but smaller) to the ones the adults carried. I knew that if I filled it up I could get in the "weigh line" and I would be paid for my work.

It was hot; the sun was baking the back of my neck. I would trip and fall between the rows of cotton. The bowls pricked my fingers and I could even see little specks of my own blood on the white cotton. But I kept on picking.

At the end of the day I got in line to have my sack weighed. I was stunned to realize that I would receive only a few coins for that hard, hot, miserable day's work. That might have been the beginning of my thoughts regarding career choices. Working in a cotton field was not among my selections for a possible future. I wanted to help that destitute family but hoped I could find another path to improve the lives of others.

Memphis at Granny Whit's

Christmas 1942 we were unable to go to Vinton Street in Memphis to see Daddy's family. Because of the war we didn't have enough gas and good enough automobile tires to get there and back. When we mailed our gifts I felt sad because I loved to go to Memphis to see my grandparents Whitten.

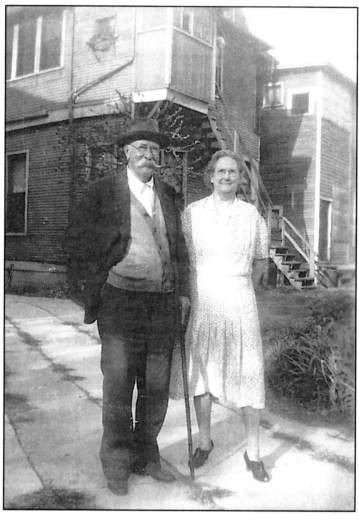

Grandpa and Granny Whit

I also adored my Aunt Hermie and Aunt Lib; Aunt Betty, Uncle Henry and Wanda; Uncle Albert, Aunt Lucile and Jim and Bill; Aunt Effie, Uncle Vibe and Anita Allen, Robert, Vernon and John Whitten; and Aunt Bama and Uncle Reuben.

I was also jealous of my cousins. On one visit when I was four years old our family of three arrived first and my grandparents and aunts Hermie and Lib were giving me their total attention and I just loved it. Then my Aunt Effie and Uncle Vibe and their children arrived. Of course, the attention to me was diverted to focus on my cousins. Within a few minutes someone noticed I was missing. "Where is Betty Jo?" They found me behind a chair, groaning and ripping Christmas ribbon through my teeth.

"Betty Jo is having a fit!"

(Who says *only* children are spoiled!?)

Granny Whit and Grandpa Whitten ran a Memphis boarding house with front and back stairs leading to the upstairs rooms. During the Christmas season when the boarders were away our twenty-two family members stayed in the vacated rooms. We cousins would hide and chase one another up and down the steps, squealing until our parents couldn't take another minute and they would stop our game. Then in an hour or two we would begin the game again, determined not to squeal so loudly. But we always forgot and our parents would scold us again. I wonder how my grandmother and aunts ever got all of those meals on the table with the only assistance provided by Belle, the Negro cook.

My grandmother, Nora, (I called her Granny Whit) always seemed old. She dipped snuff which my own mother didn't like. She wore cotton print dresses and black oxfords with two inch heels which I have always associated with being an old lady. But Granny Whit was an artist when it came to crocheting bedspreads, table cloths, aprons, doilies, coasters, containers for glasses, and dresses lined with satin. She even crocheted hats to match the dresses. When she was very old and after my grandpa died, she lived with Aunts Hermie and Elizabeth. When we asked what she

might like for a Christmas gift, they always requested that we send thread so Granny Whit would always have something to crochet.

Granny Whit was "tender hearted." She always cried when sad things happened even if she didn't know the people involved. After Christmas when we packed up to return home she would cry as she held her little dog, Fellow, in her arms. I cried too, until the car turned toward the highway and she and Fellow were out of sight.

My Grandpa Albert was considered a "dapper man" with a waxed handle-bar mustache. He loved flowers and planted them in every spare piece of ground in his Memphis yard. I walked through paths with him as he pointed out and named all of his flowers. My aunts told us that he never enjoyed living in Memphis as much as in his Ripley home and garden.

When I was ten years old Grandpa had a stroke. Today this is referred to as a CVA or cerebral vascular accident. When we visited him in Memphis he would sit at the table, trying to pick up his food with his hands. He became angry and frustrated when Granny Whit insisted he use a fork. When he attempted to talk he would get mixed up, use inappropriate words, and everyone would laugh. There was no one at that table who understood that his aphasia was caused by his stroke. I felt so sorry for him but didn't know what to do. I thought of him years later when I became a speech/language pathologist. I wish I had known how to help him then. Even today I feel sad when I think of him during his last years.

A Brassiere at the Zoo?

Our visits to Memphis usually included visits to the Pink Palace or the Memphis zoo. I loved seeing all of the jewels and beautiful dresses at the Pink Palace. It was always fun to see how many zoo animals I could name. We would also go downtown to the Peabody Hotel to see the ducks walk across the lobby to jump in the little pool.

There was a 'happening' at the zoo that I don't remember, but everyone else in the family does! At the zoo, there were bars erected to keep us a safe distance from the animals…and the bars were "head high" for someone five years old. Once I saw a zebra and shouted with exuberance, "Look. There is a brassiere!" and I ran toward the animal. My head hit the rail; I fell down and began to wail. Even today I don't think that's as funny as my relatives and on-lookers seemed to think.

But think about it! Brazziere is zebra pronounced in reverse!

Ice Cream Truck

Every afternoon on Winton Avenue in Memphis the ice cream truck came down the street with its bell ringing. Even when it might be too cold to eat ice cream, we would shiver with the cold when we ate our popsicles.

And in the summertime it was glorious! The ice man also came to the Whitten house to place a huge block of ice in the ice box located on the back porch. I knew I was in the big city and I loved it.

When I told my friends in Union, Mississippi that ice cream and ice came directly to my grandmother's house, no one believed me.

Goldsmith's Department Store

Daddy's sister, my Aunt Hermie, was a buyer for the Junior Department in Goldsmith's Department Store. We would meet her downtown to be treated to lunch in the Tea Parlor. I thought Aunt Hermie was as beautiful and as glamorous as a movie star. She often had red roses in the house from one of her suitors. Aunt Hermie would allow me to choose one item of clothing from "her" store for my Christmas gift. Years later Aunt Hermie sent me two beautiful net formals…a red one for my junior prom and a white one for the senior prom.

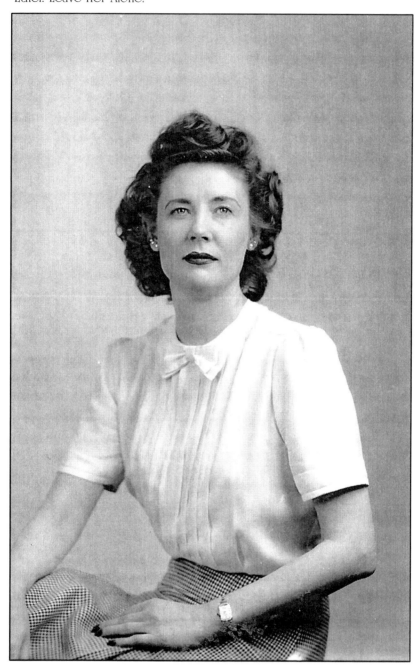

Aunt Hermie

World War II

The Germans

I remember the beginning of World War II. At night we would pull down our black window shades throughout our house to practice "blackouts" in case the Germans would fly over our house. I was worried.

"Daddy, are the Germans going to bomb us?"

"NO," he replied emphatically.

That settled it for me. I believed my daddy knew everything, and I continually wondered why so many people were worried during the war. If Daddy said the Germans weren't coming, I knew they weren't coming. I felt sorry for other people who didn't know what I knew about the war.

Rationing

World War II continued and it became necessary for the general public to sacrifice. The primary sacrifices that I can remember were that of certain foods, gas, and rubber (tires). People were required to register to get coupons in order to purchase these items. When Daddy was assisting with registration held at the school house or in churches, I was allowed to accompany him to watch that process.

One day I saw Daddy attempting to assist a woman who came in to register. He asked her to name all of her children along with their birthdates as he recorded this information on one sheet of paper. She had so many children that Daddy had to turn the

paper over to write on the back. She couldn't remember all of the birthdays and would have to start all over. I could see that Daddy was getting impatient; his face was getting red, but he just sat there until the woman had completed naming all of her thirteen (or fourteen, she could not remember for sure) children!

When she left Daddy placed her paper in the file, sighed, and said, "Next?"

There was a great deal of talk about what was going to be rationed which resulted in some of our neighbors hoarding supplies. Some people might even do a little lying or cheating to get extra tires or sugar.

Mrs. McCoy was one of our neighbors who would rush to town to buy out the stores when she heard news that an item might become hard to get. Once Daddy told her he had heard orange marmalade was going to be rationed. She dashed down to all three of the grocery stores in town and bought out all of the marmalade. One store owner, Mr. Reavis, told Daddy that some of his marmalade had been on his shelf for more than seven years! Thanks to Mrs. McCoy he had a good day in the store! I am sure that if she is still alive, Mrs. McCoy still has some of that orange marmalade.

Daddy Goes to War

Daddy enlisted in World War II to serve alongside his brothers, Albert and Henry. In 1944 he went to the draft board to fill out the papers. Daddy couldn't swim but for some reason he chose the Navy. I remember Mamma saying something sort of sarcastic about that. But he did go off to war…three times.

The first time he left, Mamma and I drove him to the bus station in Newton, Mississippi, and kissed him good bye. We came home and cried and cried "cause Daddy had gone off to war." The next day he came back home because the age for entrance had changed and he was too old.

About one month later he was drafted again. Mamma and I took him to Newton again to the bus station, kissed him goodbye, and we cried all the way home again "cause Daddy had gone off

to war." The next day he came back home because the Department of War determined that being the Superintendent of Schools was a necessary occupation.

The third time he was drafted, Mamma and I took him to Newton to the bus station, kissed him good-bye because "Daddy had gone off to war." Instead of going home, however, we went to Laurel to have lunch and do some shopping. When we got home, there he was …home again. The war was over! He seemed miffed that we had not cried this time, but instead we had gone shopping and weren't even at home to greet him on his third return from the war!

August 1945 – Japan is Defeated

My best friend Lisa McNeely and I had spread a quilt on the ground in our back yard to play with our dolls. We were sitting under the branches of the weeping willow tree that Daddy planted when we first moved to Union. Mamma had just brought out some lemonade and a cookie for us to use with our tea set.

Suddenly, in the distance we heard sirens from the cotton mills…then more and more sirens. Car horns were blaring. Our neighbors flew into the streets laughing, dancing, and crying at the same time. They were even hugging one another and I saw Mr. Higgins kiss Miss McMurray right on the mouth. I thought I should find out what was going on.

Lisa and I were just ten years old but we knew that we had already "beaten the Germans, and now we had beaten the Japs." We were happy, too. We put aside our dolls and joined the celebration on Northside Drive. We skipped, danced and sang, "The War is over! The War is over! The War is over."

Our Dads were safe and Uncles Craig, Henry, and Albert would soon be home from the war.

Several days were to pass before we learned the United States of America had dropped an Atomic Bomb on Japan.

Jackson, Mississippi 1944-1948

Rub-A-Dub-Dub—Vote for Tubb

In 1944 we moved again. This time our family had another "upwardly mobile" move to Jackson, Mississippi where Daddy had an opportunity that changed the entire nature of his life. He was well known among public school employees throughout the state, having served as President of the Teacher's Associations in Wayne, Green, and Newton Counties. A man named Mr. Tubb decided to run for Superintendent of the State Department of Education and asked Daddy to manage his campaign.

Wanting to help Daddy with the campaign, I recruited some of my neighborhood friends to put flyers in the doors of our neighbors in Jackson. We made up a song, "Rub-a-Dub-Dub, Vote for Tubb." It was not particularly clever but we must have looked somewhat cute because we were invited to sing and cheer at lots of political gatherings.

What's a Reprobate?

One traumatic family event I will always remember was when we were visiting my grandparents Duckworth in Taylorsville, Mississippi. Mamma's brothers and her sister, my three cousins (Marion, Charlotte and Ben), and friends were there. We were all so proud of Daddy because he was becoming well known in the state as he spoke on the radio and at large gatherings on behalf of Mr. Tubb. Daddy had all of his campaign materials to distribute to our relatives.

After our family dinner at Grandmother Duckworth's home I was distributing the campaign materials. My mother's cousin, George, announced that he was going to vote for Tubb's opponent. Mother was horrified and furious that anyone in the family would want to prohibit Daddy from having an opportunity to work in the Department of Education (assumed if Mr. Tubb won the election) and she began to cry. Cousin George laughed at her; Mamma called him a "reprobate," and ran out of the room. At nine years old I didn't know that word. When I looked it up I found it to be a bad dishonest scoundrel or worse! After that I never felt the same about Cousin George again….ever!

Mr. Tubb Wins!

Mr. Tubb won the election. That single event changed the life of Daddy, Mamma, and me in an amazing way. We moved to Jackson when Daddy was appointed the Supervisor of Technical Services in the Division of Vocational Education. And then something unexpected happened that we could have never imagined. The Director of Vocational Education, Mr. Vanderver (and Daddy's boss) died unexpectedly at age forty. Daddy received the appointment of Director. He accepted the leadership of the Division and began working in areas of public relations, legislation and staff development.

Although I was unhappy living in Jackson, Mamma and Daddy loved it. They bought the first house they had ever owned, a pretty little white house on Northside Drive. I had my own room with lots of windows and a new bicycle to ride on the flat, safe streets. We had a guest room for our visiting relatives. Mamma found some bridge playing friends, joined the woman's club and became active in the Methodist Church.

(Recently, I had occasion to ride by that little house in Jackson. It appeared much smaller than I remember it, now located in a less desirable, older neighborhood. I wish I hadn't done that. Some memories are best left as memories.)

Croquet

My happiest times in Jackson were in the evenings after supper. Mr. and Mrs. Bob and Lou Trim lived three doors from us and had an expansive back yard, perfect for setting up a regulation space for playing croquet. In the evenings after supper, the women would clear the supper dishes, apply some Old Spice perfume, touch up their hair, add a bit of lipstick and go outside to sit in chairs along the side of the croquet field. The three regular players were always Daddy, Mr. Trim, and Jimmy Ferguson, a young professor at Millsaps College.

(In 1979 when I was completing my doctorate at the University of North Carolina at Greensboro, a new Chancellor was inaugurated; his name, James Ferguson. I had not seen him since 1945 when we moved from Jackson to the Washington, DC area. I made an appointment and "Yes," he was the one I knew years ago and "Yes" he remembered me and Daddy and Mamma. We reflected on how far we had come since those days and we were not talking about miles.)

Daddy had the opportunity to make changes in the Mississippi Vocational Rehabilitation program—such that it became a model for other offices throughout the United States. I believe that was the happiest Mother and Daddy ever were.

(Daddy had a brother-in-law in Jackson, Mississippi, Leland Craig, who told his wife, Braddis (my mother's sister) who told my mother, that Daddy was the smartest man he had ever met! That was when he knew Daddy from 1945-1950 in Jackson, when Daddy was the Director of the State Vocational Rehabilitation Association.)

MR. HAIRSTON

The rehabilitation movement was in its infancy. Daddy was trying to get all of the "beggars" off the streets in Jackson and into newly established vocational educational centers where they could be evaluated and trained for jobs. I particularly remember one Negro man, Mr. Hairston. (Daddy called him Mr. Hairston; others called him Mack. Daddy insisted that we never call adults by their first names but to show respect by using Miss, Mrs., or Mister regardless of racial characteristics or social class.)

During the weekdays Mr. Hairston sat in front of the Emporium or Kenningtons, the two beautiful upscale department stores on Capitol Street in Jackson. Mr. Hairston had no legs and sat on a little 4'x4' platform on wheels about four inches off the sidewalk. His hands grasped metal handles so that he could push himself up and down the side walk (like Porgy used in Porgy and Bess!).

His attendant would bring him to town driving a big black shiny car. Then he would use his strong arms to lift Mr. Hairston to place him on his cart in front of one of the stores. When the stores closed in the afternoon his driver would retrieve him to drive him home. During those days, stores closed on Saturdays and Sundays. Thus, Mr. Hairston would go to the neighborhoods in Jackson on weekends where he knocked on doors of private residences to beg.

Mr. Hairston had been recruited and enrolled in the job training program provided by the

Vocational Education program in Jackson. He was intelligent, had "good hands" and could have learned to work in a variety of settings. He preferred, however, to beg. He could make significantly more money sitting on the sidewalk on his little cart. Since begging was against the law Mr. Hairston was repeatedly taken to Vocational Education Center to continue his job training program. But in a day or two, he was back on the street.

One Saturday morning when I was ten years old there was a knock on our front door. I opened the door and was alarmed to see Mr. Hairston sitting on his little cart on our front porch. I could see his car and driver parked on our street several houses away. I called Daddy, who came to the door.

Daddy sounded angry when he said loudly, "Well, if it isn't Mr. Hairston!" Mr. Hairston cursed and called his driver. The two men waited in total silence until the driver reached the porch. Daddy's face was red with rage…or perhaps disappointment.

I never asked Daddy if he was mad because Mr. Hairston was begging or if it was because Mr. Hairston cursed in front of his daughter. To my knowledge Daddy never used a curse word. When he got angry or hit his finger with a hammer, he said, *"THUNDER"* in a voice louder than usual. When I heard Daddy say "thunder" I knew he was as mad as he ever got.

Daddy Writes a Recommendation

My mother and I assumed we would continue to live in Jackson until Daddy retired. He had a good job; Mamma had great friends; and I was okay. Then, there was an announcement that the National Rehabilitation Association (NRA) Board of Directors was searching for its first full-time Director. The new office would be located in Washington, DC. There were a number of people applying for that job. An associate of Daddy's wanted the job and asked Daddy to write him a recommendation.

When Daddy recommended his associate for the job, he included a General Job Description that would be appropriate for the Executive Secretary (later named Director). Daddy's description included the duties of the new director, which were quite specific. He also included a section on how the funds would be solicited and spent. Methods of coordination with the congressional leaders were described. There was a specific description of how the states would have input into national policy. When he included the special personal characteristics of that person I am certain that he described himself. He even suggested the salary, explaining that the move to Washington would be expensive and housing near the NRA office would be necessary; also that annual increments in salary would be assured. He often used the phrase, "the right man will be able to...."and continued to describe how he would do it.

When the search committee read his recommendation, one member said, "Why don't we ask Whitten to come for an interview. He seems to know just how to run an office like this." Daddy got the interview, and....**MR. WHITTEN WENT TO WASHINGTON.**

(His "friend" told others, "Don't ever ask E.B. to write you a recommendation because he will get the job that you want.")

Moving Again

In 1947 Daddy was appointed the first full-time Director of the National Rehabilitation Association in Washington, DC. He left a secure, well-paid position and a comfortable home in Jackson. If we had told Grandmother Duckworth we were moving to China, she could not have been more distressed.

Granny Duck cried when we left Mississippi; Granny Whit cried when we told her goodbye in Memphis, Tennessee. My mamma did not want to leave Mississippi and cried during the entire three day trip it took us to get to Washington. I cried because I had to leave my beautiful white Spitz dog, Nicky, and my first boyfriend, Charlie Taylor.

But Daddy was determined. He drove us through the mountains of Tennessee, into the hills and tobacco fields of North Carolina, and through the horse country in Virginia. We drove for three days. Daddy didn't stop the car except to sleep until we rolled into Fairlington Village Apartments in Arlington, Virginia. Our new home was directly across the Potomac River from Washington, DC.

And Daddy was, indeed, one of many who were instrumental in changing laws that assured equality for all.

Yes, the laws were beginning to change in the United States of America. Our friends and some of our family members were angry and distressed when they had to obey these new laws. They were afraid for the health and safety of their own children when handicapped citizens left institutions to live in their own neighborhoods. White parents were afraid for black children to attend school with their children. There were riots in the streets, along with heated discussions in some schools and churches. Merchants were angry that they had to make their stores accessible for wheelchairs. In those days even our close friends and family members disagreed, often ruining our much loved holiday celebrations.

<p style="text-align:center">* * *</p>

As the years passed, however, most (but not all) citizens eventually became adjusted to the changes and realized they were appropriate for everyone. Daddy was instrumental in the passing of 7 Rehabilitation Acts in Congress, which provided federal support for the establishment of special rehabilitation centers. Before his retirement Daddy received two Presidential Citations, one from Mr. Nixon and the other from Mr. Johnson. One of his greatest honors was when, at his retirement, he received the first E. B. Whitten Silver Medallion (with his image in relief) from the National Rehabilitation Association. This medallion continues to be awarded annually to a person who has, in some way, advanced the rights of the disabled. My daddy, E. B. Whitten died in 1989.

And things changed for Conrad, Daisy, Curtis and millions of other citizens in the United States.

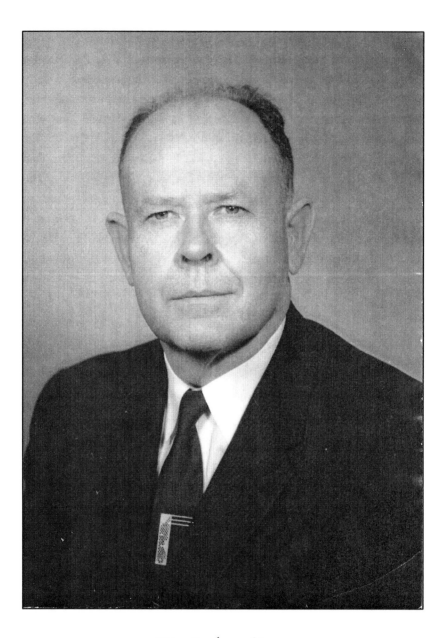

Elton Barber Whitten
Executive Director
National Rehabilitation Association 1948-1974

ELTON WHITTEN GOES TO WASHINGTON

1948

This section begins with Dr. Joseph Hunt's quote at Daddy's retirement from the National Rehabilitation Association in 1974. Dr. Hunt chose to remember Whitten's first day in Washington. As his daughter I feel that Dr. Hunt's words captured Daddy's style. I was pleased and surprised that others saw him as I did.

*　　　*　　　*

Joseph Hunt, former U.S. Commissioner of Vocational Rehabilitation. December 13, 1974, Congressional Record, in Honor of E. B. Whitten, p E7113

*I first met our honored guest early in 1948. He had been invited to attend, **as a guest, not as a participant**, a special in-house meeting in the Social Security Building (now HEW). Since the budget situation at that time was difficult and politically sensitive at one point I said to this small group: "I want to say to you **unofficially** that members of the House Appropriations Committee are very concerned about the trends in our program."*

*Suddenly a piercing voice from the sidelines spoke: **"Mr. Hunt, I need to know when you speak officially and when unofficially so I can plan my work here in Washington."***

*It was the voice of our honored guest. And do you know from then on he developed a style of speaking out anywhere, anytime, a style which he followed for 25 years with vigor, enthusiasm and effectiveness. While he graciously observed the basic tenants of civility, he seemed to believe that Protocol was a word you could find among the P's in the dictionary but that it wasn't of much use to the working man. So…let history record for all time in that great dramatic moment…**Mr. Elton Whitten comes to Washington.***

*　　　*　　　*

Arlington, Virginia

This section continues by relating some memories I have of my dad during my teen-age and adult years when he and Mamma lived in Arlington and Mc Lean, Virginia. In addition to my own memory I include the stories provided by my parents, the content of letters, documents and other written materials that report on Daddy's influence on the rehabilitation movement. My focus will continue to be on how much he influenced my life. I wish I could remember more than I do.

Daddy's Many Interests

Daddy had many roles as husband, father, grandfather, Sunday school teacher, friend and expert cultivator of over 400 azaleas. And although he never "told" me what to think, I realize that his philosophy of work and life have influenced my career and life from the day I was born until the day that he died ... and even after that.

When Daddy officially received the appointment to come to Washington, Mother and I knew our lives were going to change. During our early years in Arlington we really didn't fully realize the impact Daddy was having on the rehabilitation movement or the importance of his work.

We Were Wild About Harry

When Mamma, Daddy and I moved to Arlington in 1945 Harry Truman was President. Mamma and I were trying to get adjusted to the city, make friends, and take advantage of everything Washington had to offer...symphonies, plays, parks, monuments, and museums.

Soon after we moved Harry Truman was inaugurated for his second term. Mamma and I got on the city bus and went to the inaugural parade where we had bleacher seats along the route.

As soon as Truman waved to us with his black top-hat, the skies opened up. In the pouring down rain we decided to run for shelter under a huge oak tree along the mall. Lightening began to light up the sky and we decided standing under a tree might not be the best idea. So we stood out in the open. Mamma's hat was adorned with fake plastic colorful fruit on it. The red, green, and yellow colors of the fruit began to trickle down her face. My dress was soaked and my breasts were freezing cold and showing through the fabric. Mamma and I began to laugh, and laugh, and laugh. We stumbled to the city bus stop, found the Number 8 that would take us back to Glebe Road and 16th street and home. That was our first and only attempt to attend a Presidential Parade in Washington.

It didn't take long for me to realize that this was an amazing time to be living in the Washington area. I saw my daddy testify before congressional committees to assure that handicapped people gained an equal place in our society. He employed disabled adults to work in his office. I met Helen Keller when she was scheduled to speak at rehabilitation events. I was in Washington when Martin Luther King marched for Jobs and Freedom in the hot summer of 1963. I remember as a young adult holding my son's hand as I watched President John F. Kennedy's caisson roll along the streets of Washington.

Mamma and I knew that Daddy had an important job. But the two of us were also self-absorbed arranging our own lives. I loved living in DC during my junior high, and high school years, after which I left home to attend college, marry, and forge a career that in itself extended my father's goals and hopes for the future.

The Methodist Church

Daddy's family of origin was Methodist. Before the Whitten's left London in 1635 on the ship *Elizabeth*, my Granny Whit (Nora Barber Whitten) said the Whitten's actually trouped through the

London streets with John Wesley. (I have tried unsuccessfully to document this; I suppose it could have been true.)

Although Mother's family was Baptist she became a Methodist soon after I was born because it was evident that I had characteristics similar to those of my daddy. (I loved hearing that throughout the years.) Mamma also felt that the three of us should all go to the same church. Furthermore, Daddy would never have considered being anything but a Methodist.

We went to church every Sunday…there were never any exceptions. If I suggested that I was sick, Daddy's position was that if I were too sick to attend church, I was also too sick to run around with my friends in the afternoon or attend the Methodist Youth Fellowship (MYF) during the evening. Thus, I often went to church when I wasn't well. One Sunday I had severe menstrual cramps but I knew the rules and went on to church. My pain became so severe that I went into the women's restroom where I was moaning and throwing up. When Mrs. Smitherman walked in I fainted. She rushed out to inform my mother who found me, located Daddy, and the three of us went home.

On that day Mamma was as mad at Daddy as I had ever seen her. She told him he could just change "those crazy ideas" of his. She said when I said I was sick, I was sick!

In essence, she said, **"Elton, leave her alone."**

The Prodigal Son

Daddy and I also enjoyed discussing parts of the Bible and what they might have meant in the days they were written and why they might still be important today. Usually these discussions would take place in the car as we were riding home from church.

We had a preacher who would "work the scripture to death!" For several Sundays he had been preaching a series of sermons on the Prodigal Son. We had heard a sermon as the preacher interpreted the scripture from the point of view of the father; the next Sunday on the point of view of the brother; the next Sunday on the point of view of the Prodigal Son; the next Sunday on the

point of view of the servants; the next Sunday on the point of view of the mother.

As Daddy was driving home from church I said, "Well, I am glad that Prodigal Son stuff is over."

Daddy said, "Oh, no! It's not over yet. Next Sunday he will preach on the point of view of the pigs in the pigpen when the son was at his lowest and eating out of the pig trough."

Mamma said, "Elton, hush!"

But we were all laughing.

Daddy's Sunday School Class

When we arrived in Arlington we immediately joined Clarendon Methodist Church. For over thirty years Daddy taught over 100 men in a weekly Sunday School class. Some men crossed the street from the Baptist and Presbyterian churches to his class, and then returned to their own churches for "preaching." When Daddy left the Washington Area, one of his friends announced, "Whitten had taught 1,440 Sunday school classes in the thirty years he had been at Clarendon Church."

I know that Daddy had a deep faith in God; and he tithed. Mamma felt that others in the church took advantage of him, but I don't believe that he would have agreed.

Every Saturday afternoon after spending the day in his garden tending his 400 azaleas, he studied as long as three or four hours using many sources of reference as he prepared a Sunday School lesson that would interpret scripture for his adult students.

The Teetotalers

The Methodist church promoted abstinence and Daddy was a teetotaler. Mamma told me she never saw him take a drink of alcohol; nor was there ever any in our house. The National Rehabilitation Association served alcohol at the national annual conventions. Although Daddy was opposed to it, the Board of

Directors and members of the Convention Committee said drinks would be provided at the convention parties. And they were.

On one occasion Daddy and Mother were invited to represent the National Rehabilitation Association in London which included an invitation to dine with the Queen of England. He and mother received detailed instructions on their time of arrival and exactly when and how to toast the Queen. Daddy told Mamma he was *not* going to toast the Queen of England when they were invited to dinner at Buckingham Palace. Mamma told him he certainly *would* toast the queen.

"You can just get off that high horse of yours and toast the queen like the rest of us will."

I wondered how all of that would come out. Mamma told me that when it was time for the toast, he did raise his glass, (to the relief of my mother) but when he brought the glass to his lips, he did not take a sip of the wine. Imagine that.

I have always wondered about this.

Once I asked him why he was so opposed to drinking alcohol, and he replied that he "never saw any reason to drink." But I think it might have been because his father drank and he had memories that he was determined not to repeat.

I decided I would do what he did; that is, not drink alcohol. And I did not drink even one sip of liquor until my 30th birthday.

Because of Daddy and the Methodist church I continued through high school with the sophisticated Arlington crowd and never drank alcohol. During our senior year parties, champagne was served at several homes. I refused the champagne and instead chose ginger ale.

Word got around and my preacher wrote me a letter telling me he was pleased at the strength I had to refuse. (It really took no strength at all for me!)

A few months later I enrolled at William and Mary, a school that rioted against the administration because all that could be consumed on the campus was 3.2 beer. (I never knew just what that meant!) The first week I was there I went with a date to Chownings Tavern. Everyone in our group ordered a beer. I asked for ginger ale.

The waiter laughed at me and said, "We don't have ginger ale in Williamsburg."

I said, "Well, I have seen a bunch of cows in Williamsburg, so you can just bring me some milk." And he did.

I was embarrassed, mortified, and humiliated. When I returned to my dormitory, I cried.

My first really interesting date at William and Mary was with an intelligent, blond, athletic, drop-dead handsome sophomore (older man!). When we went to Chownings he ordered beer for both of us. I told him I didn't drink. He said that he was looking for a "drinking buddy" and he wouldn't be calling me again. I continued to see him on campus with a beautiful coed. He got his drinking buddy and I was sad for a while longer.

When I told my parents about this, I received the following letter from Daddy.

September 1953
Dear Betty Jo,

I take my pencil in hand to write you a few lines to let you know we are well and hope you are the same, if not more so. Everything considered, your mother is bearing up very well under the separation, in fact, seems a bit surprised that she has not been bursting into tears at regular intervals. Nicky has seemed a bit dejected, but whether because of your absence or not having Jim's [my boyfriend] midget Crosley automobile to bark at, I do not know.

By the time you read this, the upper classmen will be arriving and college will really have begun. Unless sophomores have changed a lot, they'll be trying to make you freshmen appear mighty dumb and insignificant, but this won't last long. Human nature, like water, eventually finds its own level.

I understand you have attended your first college drinking party and that you were the only one who passed it up. Human nature is a funny thing. It's well known from studies that a high percentage of college students do not drink at all. It would be most interesting to know how many of the 14 in your group didn't want to drink but didn't have the moral courage to refuse when the pressure was put on. Since you did have the courage, it is probable that some others of this group will turn alcohol down

the next time it is passed. Thus, your example will probably help some freshman who was weaker than you were.

It gives us lots of satisfaction to know that you have made up your mind about this and other moral questions and that you cannot be swayed from your convictions by the mob. Practically everyone admires one who has the courage of his convictions, but a feeling of inferiority keeps many from admitting that they do.

Guess you attended church yesterday and hope you found it stimulating. College town churches are frequently among the most active and progressive, particularly in regards to youth programs.

Finally, we really miss you but do not regret you going. Any addition that can be made to the sum total of knowledge possessed by the Whittens and Duckworths should be encouraged by any and all means.

With love,

Daddy

I continued my no drink policy at the University of Virginia where in 1956 *Newsweek* Magazine noted U.Va. as the University with the highest drinking rate among students in the United States. By that time I was confident and not embarrassed when teased about being the "only teetotaler at Mr. Jefferson's University."

My no drinking policy continued when I was living with my Lieutenant husband at the U.S. Army's Aberdeen Proving Ground at the Officers' Club where alcohol flowed at every party.

Finally, on my 30th birthday I drank my first mixed drink. I believe that by that time I realized I could remain a devout Methodist and still consume alcohol. I told Daddy I was drinking but I never drank in front of him. I know my decision to drink, even moderately, disappointed him.

Gardening

Daddy loved to garden at our first house in on 16th street in Arlington as well as on the larger two acre lot on Woodley Road in the Chesterbrook neighborhood in McLean, Virginia. In Mississippi he always had a small (about one-half acre) garden of

vegetables and a few flowering plants (zenias, daisies, marigolds, petunias, candy tuft, flox and golden glow).

When we moved to Virginia he was amazed, grateful and overcome that he and Mamma could afford to purchase a beautiful two acre corner lot in McLean. When they showed me their house plans they were as excited as young children. Mamma told me that Daddy had prayed when she was pregnant with me and he had no job that he could provide for us. But he was overwhelmed and amazed that God had not only provided for him a great career and a healthy family, but even a life of relative luxury.

When he got salary increments he would tell Mother that he felt he was making too much money. She would tell him, "Take it, try to get more, you have earned every penny of it!"

When Daddy was at home in McLean on the week-ends he spent most of his spare time in his yard planting rooting, and cultivating his azaleas. He also planted camellias, flox, lilies, iris, candy tuft , forsythia, Japanese magnolias, a crepe myrtle, plum and a weeping willow tree.

By the time Mamma and Daddy moved from McLean thirty years later there were more than four hundred azaleas in his garden. Every year, on the first week-end in May, traffic would encumber their neighborhood as cars would slowly pass their corner home. Passengers would jump out of their cars to take photos and then

drive on. And always, on the first Sunday in May, Mamma had a coffee and open house for over one hundred of their friends and neighbors. Guests came to visit and stroll on the slate garden paths, or amble by the fragrant blossoms to enjoy the little waterfall splashing over the rock garden that Daddy had built. They might stop for a few moments to rest on one of the concrete benches by the fish pool to enjoy the sculpture placed in the near-by woods.

Once when Daddy was working in the yard, a stranger stopped his car and asked Daddy how much he got paid to work in the yard.

Daddy replied, "The lady of the house lets me sleep with her!"

I can't really believe he said that, but it has become part of the lore in our family.

Life in Virginia

The most difficult part of our move from Mississippi was that we couldn't return as often to visit my grandparents, aunts, uncles, cousins and friends. During the first several years we drove "home" during the summer and at Christmas. After my grandparents died we didn't go as often. There was some family resentment that Daddy had "deserted" his family and didn't return as often as they felt was appropriate. After all, he was the oldest son, and it was his duty to watch over his parents.

For a while our Mississippi relatives and friends enjoyed visiting us in the summer; and we loved to have them. Most had not been to the Nation's Capital and they all wanted to see the sights. When they visited us it was my job to drive them to all of the museums, Mount Vernon, the capital, Great Falls, the zoo.... and when they came it was always hot...really hot.

Until I moved to Washington I had never heard the expression, "It's not the heat...it's the humidity." I still say it's the heat that rises from all of the marble and concrete that covers the city.

While I was the tourist guide for our guests, Mamma was home cooking dinner or going to the grocery store to purchase food to prepare the next meal. Each day she packed a lunch for the

sightseers. She loved to have our family and friends. But she was always exhausted when they returned to their southern homes.

As the years passed, however, the kinfolk's visits became less frequent.

The Cousins

Mamma and Daddy were excellent bridge players. Daddy belonged to one men's group, Mamma played in two women's groups, and they belonged to two couples groups (one was named the Cousin's Club, so named because none of the members were from the DC area and had no family members near-by.) And as the years passed we began to think of them as our real cousins. And the sad truth was that after we moved from Mississippi to Arlington we never saw some of our real kinfolks again.

Obesity

When Daddy met mother he was overweight. Well, perhaps I should say he was fat! He was five-feet-ten inches tall and weighed over two hundred pounds. When he moved to Washington he was required to go to a doctor to get a physical examination as one requirement of securing a life insurance policy. The doctor checked "obese" on Daddy's chart. When Daddy saw the word "obese" he immediately began dieting in order to lose weight. He achieved a proper weight (about 165 pounds) and maintained that until his death. No more obese for him!

Child Rearing Practices

Daddy never punished me a single time; he just left that to mother. On occasion he would say in a gruff, angry sounding voice, "Betty!" And I would immediate change my inappropriate behavior. He never hit (or spanked) me.

When he did not approve of the way I spoke or behaved, he would want to know what I had been thinking that caused me to

speak in such a manner. I would tell him and then he told me what his point of view was on that issue. He never told me what to think; but he always told me what he thought.

At times I would "test" him and express an opinion I knew he would probably disagree with. Once I told him I did not see why we had to visit one of our Mississippi relatives because that person was rude and insulting to us.

Daddy would say, "Well, some folks think the same as you do. But I look at that another way." And then he would tell me why he thought it was best for us to continue to visit that relative, even though no one liked him.

We seldom argued and he seldom told me I was wrong.

Bragging

Daddy never bragged, ever, about himself. As far as I knew, he never bragged on me either. (But Mamma told me that he would occasionally tell others about my accomplishments.) I knew, however, that he loved me, that he was very proud of me and that was enough for me!

Daddy didn't want for me to brag on myself. He expected me to be tolerant and friendly to others who might not be in my social group. When I was in the ninth grade, I ran for Miss Swanson Junior High School and I won! I was, for one moment in my life the most popular girl in the school. And I had a crown to prove it! Why, I had been elected the Queen of the School. I was exhilarated! (The students said the only reason I won was because I was nice to the eighth graders; that the ninth graders wanted someone else to win. And all of that was true!) Oh! And Richard Calvert was Mr. Swanson.

When Daddy came home from work, I ran out to meet him.

"I won! I won!"

"Well, that's fine. And what did you do that was worthwhile today?"

Well, the truth was, I had done absolutely nothing for others. I had basked in my own popularity with no thought for anyone but

myself. I believe that experience resulted in one long-term behavior that I try to carry with me today. When something great happens to me, or my children, or my friends, I rejoice! And then I think of my daddy and do something worthwhile for someone else.

Miss Swanson

My Driver's License

When Daddy took me to get my driver's license on my 16th birthday, I was nervous about that parallel parking. When my car slipped between those two poles perfectly, I saw him walking out of that little brick license building. He was laughing so hard with pride (or relief) that his shoulders were shaking. And I drove us home!

What's That Typewriter For?

My handwriting has always been illegible…atrocious…ugly. I have a tremor in my fingers that presents itself when I attempt to write or participate in any artistic endeavor requiring fine motor activity.

When I was in elementary school I couldn't keep my pencil on the lines provided for writing practice. During art class the only thing I could draw were pictures of fire or a rainbow. In short, I couldn't "stay in the lines." (As time passed I was also unable to knit, crochet, or sew, which was also a concern for my family members.)

When I entered high school my daddy came home with an Underwood typewriter.

"What's that for?"

"You are going to learn to type."

"No, I'm not. I have already told you I'm not going to be a secretary. I am not going to take any of those business classes."

"Oh, yes, you are! You're going to take typing from Miss Purcell. I have already talked to Principal Gerich. He is going to admit you into a business course even though you plan to go to college. If you continue in any professional field, you must write legibly. So, typing it is!"

I took typing. I passed. That class has been of more value than any I had taken before or have taken since.

Daddy Couldn't Do Everything

There were things Daddy could not do! He couldn't swim, fix a water faucet, hammer a nail, saw a board, repair a car, hang a door, unstop a commode, lay a carpet, cook a meal, or hang a picture. (He could, however, tell if the picture was the slightest bit crooked!)

Regrets

I have one long-lasting childhood regret. My daddy wanted to show me the great country in which we lived. He had occasion to travel throughout all of the United States to consult with rehabilitation professionals. He planned several trips so that mother and I could accompany him. I never wanted to go, but instead, preferred to stay at home to participate in fun activities with my friends…which actually meant going to the pool every day to get a tan. My parents and I went to New York, Philadelphia, Richmond, Atlanta, Charleston, Savannah, Annapolis, West Point, New Orleans, Montgomery, Yellowstone Park, Seattle, the Redwood Forests and more.

The summer between my junior and senior year in high school Daddy planned for Mamma and me to have the trip of a lifetime. For six weeks we were to get in our car and ride as he drove us across the United States. I whined the entire six thousand miles. The mountain roads of West Virginia were too scary. Kansas and Nebraska were boring, too flat, and too hot. Yellowstone Park was overrated. Old Faithful didn't live up to my expectation. Seattle was too damp and foggy. I had just fallen in love with my boyfriend, Jim, in Arlington, Virginia to whom I wrote a letter every day, after which we had to find a mailbox in order to mail it. I was selfish, uncaring, and, to quote Mamma, "Rotten to the core!"

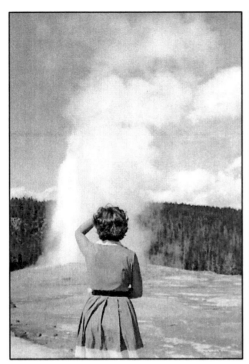

Old Faithful and Rockefeller Center

They never took me on any trips anywhere again. And I don't blame them a bit!

The National Rehabilitation Association

This section is intended to describe Daddy's professional accomplishments in Washington and at the same time to demonstrate his love for his family. I will rely on my own memory as well stories my parents related to me. In addition, I will summarize the content of letters, documents and other written materials that report on Daddy's influence on the rehabilitation movement. Along with his great accomplishments I also include some letters that he wrote to me during parts of my life when I needed parental guidance.

The section concludes with some of the accolades and tributes that were printed about him when he retired as Director of the National Rehabilitation Association (NRA). Some of this information is printed in the *Congressional Record*, December 1974, though he was also quoted in the Congressional Record in 1954, 1965, 1968, and 1972.

In addition, The *Journal of Rehabilitation* documented his accomplishments and philosophy throughout the twenty-five years he was in Washington. When I read the summary of his accomplishments in the April, May, and June, 1990, Journal, I was amazed. Yet he always seemed to have the time to maintain his role as a daddy, a husband, a father-in-law, and a granddad to Michael Gaylord May and Gordon Whitten May.

Daddy Makes a Speech

Six Presidents

Daddy served under six presidents: Truman (1945-1953); Eisenhower (1953-1961); Kennedy (1961-1963); Johnson (1963-1969); Nixon (1969-1974); and Ford (1974-1977).

Harold Russell & Dr. Rusk

During his first years in Washington, Daddy spent much of his time visiting all of the state rehabilitation agencies in the United States and became friends with Dr. Howard Rusk (who was already directing a medical rehabilitation center in New York City) and Harold Russell (a double amputee, having lost both hands in WWII and who was among the first to receive hooks). Mr. Russell later starred in a movie *The Best Years of our Lives* in 1946 for which he received two OSCARS and was an inspiration to all returning from the war.

Mayor Wagner and the Pope

Daddy and Mamma were invited to New York Mayor and Mrs. Wagner's home to continue to promote the rehabilitation movement. Whitten (as he was called) understood that the rehabilitation of disabled people was a movement that was (or should have been) worldwide and not just for those in the United States.

He and Mamma met with Pope Pius in 1957, and in addition attended the "Seventh World Congress of the International Society for the Welfare of Cripples" in 1957. Senator Robert Kennedy was also interested in assuring that the legislation was presented in a favorable light to Congress. Daddy was often called upon to testify before Senate Hearings on Capitol Hill. He developed the reputation as a man who could be depended upon to be prepared and accurate in his presentations and writings.

With all of this "important stuff" going on he found the time to attend my high school functions, to correspond with me as I struggled through my first few weeks as a freshmen at the College of William and Mary; and to advise me when I decided to leave William and Mary in order to attend the University of Virginia to begin my life long study of speech-pathology (a relatively new field in the 1950's).

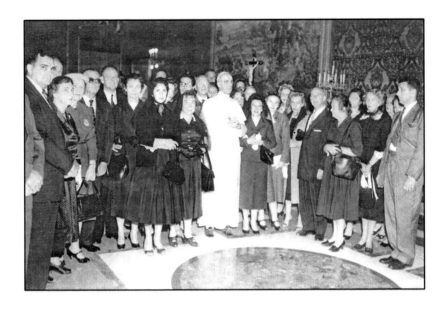

Pope Pius XII Elton and Ethel Whitten, 6th & 7th from left.

1954 Vocational Rehabilitation Act

One of daddy's **first** major achievements included directing the passage of the **1954 Vocational Rehabilitation Act,** a piece of landmark legislation, which authorized large appropriations to fund local state agencies and also provided for research and training programs.

At this time, I had entered William and Mary and was distressed because I was making D's in two of my courses. I knew that he was very busy going to Congress to testify before congressional committees. Yet he wrote me the following letter in 1953, as he was traveling to Detroit and to the University of Michigan at Ann Arbor, to gain support for his Vocational Rehabilitation Act.

Monday

Dear Betty Jo,

It seems that every time I write you lately I am "up in the air." This time I'm on my way to Detroit and the University of Michigan at Ann Arbor. Next letter I shall attempt to give you my impression of college life in the Big Ten, with emphasis on female styles. But for this letter we shall consider more mundane subjects.

Congratulations upon your success with your first English theme. We hope this is a forerunner of many more "A's." We must admit some surprise, but it is a very pleasant one.

Too bad that your second history grade was no better than the first. I assume, however, that this was not the test you mentioned just a few days ago, upon which you were sure you had done better. We shall hope you were right about that. Anyway, maybe your instructor can give you some advice with respect to how to study for the course. Evidently, the trouble is not in the time you are spending in studying, but in the effectiveness of your study.

Not knowing how the professor is teaching or the emphasis of the text, I am afraid to offer many detailed suggestions, myself. I have generally found it desirable to read a whole assignment rather quickly and then see if I can recall the story in my own words. When one can do this, he can usually fill in a few names and dates with a bit of memorizing. Be sure to take some notes of your own, instead of depending entirely upon someone else's. One thing I can say with confidence. Getting emotional about a low grade never helps, and worrying is no substitute for studying. I have no doubt in my own mind that things will be much better soon and that you'll pass the course with plenty to spare.

Ethel has told you that we will see you the evening of the 20th. We hope to see Jim Wednesday afternoon or Thursday in route to Woodrow Wilson Rehabilitation Center.

Well, until Tuesday week, I am, with love, your

Daddy

During those years he and Mother came to support me in most of my activities at William and Mary. He attended every play (I had the comic lead in both musicals), dance recital (I was pretty good in that), swim show (I almost drowned when I had to do my

group routine in the deep end of the pool), or my initiation into honor societies.

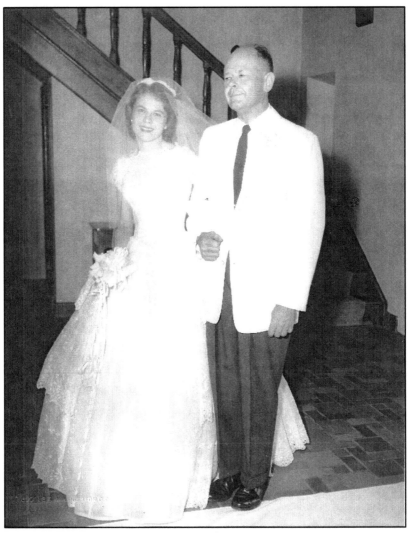

Father of the Bride

And not only that, he was "father of the bride" when he walked me down the aisle in 1957 to marry Jesse Gaylord May. Two years later he was at the University of Virginia Hospital to greet his first grandson, Michael Gaylord, and in another two years when another grandson, Gordon Whitten, was born in

Aberdeen, Maryland. It never occurred to me that he had anything much else to do than to just be my Daddy and love me and Mamma and my new little family.

1965 Vocational Rehabilitation Act

Daddy's **second** accomplishment of note was the passage of the **1965 Vocational Rehabilitation Act**. President Kennedy had a mentally handicapped sister who resided in a private institution in Wisconsin. JFK was always extremely interested in providing assistance to disabled people and their families.

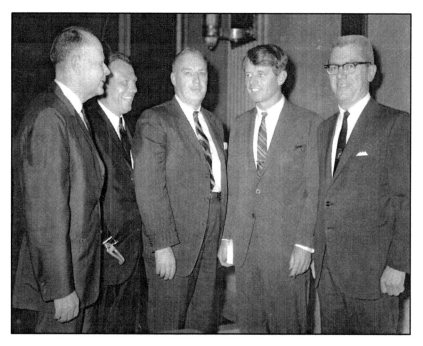

1967 Senate Hearing E. B. Whitten, Harold Russell, Sumner Whittier, Robert Kennedy, Dean Roberts.

After Kennedy's assassination President Johnson stepped up with plans for *The Great Society* and was also a staunch supporter of the rehabilitation movement.

The 1965 Act authorized special provisions for construction of rehabilitation facilities. After the passage of this Act rehabilitation centers were established in every county in the United States.

During this period Daddy made regular visits to Winston-Salem, North Carolina, (where I and my family had moved in 1963). He came to see me and my Wake Forest professor husband and, of course, to enjoy his two grandsons, who were five and seven years old. Daddy also welcomed our visits to McLean, Virginia where he took our children to the Museum of Natural History, the zoo, the botanical gardens, the museums, and most of the memorials and monuments. Mike and Gordon loved to go with him.

They said, "It is so nice to go somewhere with Gran'dad because he doesn't make us feel like we have to learn anything." Daddy really did love hearing that.

By this time I was immersed in what was to be my lifetime career. I had just begun a new job in a beautiful new Children's' Rehabilitation Center in Winston-Salem where I worked with youngsters who had a variety of disabilities: cerebral palsy, spina bifida, muscular dystrophy, autism, and disabling conditions. Even as a young woman, I was aware that I had chosen a great career and that as long as I lived I would be learning about disabilities. When I took Daddy to my workplace and introduced him to some of my young disabled students I believe I saw his eyes glisten with tears.

1968 Vocational Rehabilitation Act

Third, the 1968 Vocational Rehabilitation Act broke down the existing barriers in established facilities, and integrated large groups of disadvantaged citizens to the general public. Daddy was also instrumental in establishing a national commission on architectural barriers.

E.B. Whitten with President Lyndon Johnson - 1968

As an example, today we are accustomed to walking along sidewalks that provide gentle slopes from the curb to the street as well as wide aisles and doorways for wheel chair accessibility. As a

result of that legislation President Lyndon Johnson presented Daddy with the Distinguished Service Award for encouraging and promoting employment of handicapped.

Now that handicapped people had access to all parts of society, it became important to find a suitable icon to assure that all public areas were accessible. Daddy hired two artists and assigned to them the task of creating an appropriate symbol. Suzanne Koeford and Karl Montan presented three icons for consideration: a wheelchair, a crutch, and a brace.

Daddy brought the drawings home for Mamma and me to see. He placed the renderings on our dining room table and asked which one we liked. We looked carefully at all three and agreed that we liked the wheelchair.

Daddy said, "Now I just get one vote, but when I present this to the President's Committee for the Employment of the Handicapped, I will tell them that both my wife and daughter like the wheelchair; and that's the one I am going to vote for."

The wheel chair won! This simple icon has become the international symbol representing disabled people all over the world. It thrills me to think I might have had just a little something to do with all of that! I was so proud of Daddy.

With all of that going on, he and Mamma found time to visit us when his grandsons played Pop Warner Junior Pee Wee Football. Daddy also visited me at the Child Guidance Center where I was the lead therapist in a center that treated children and adults with speech, reading, and psychological disorders. (By this time I realized that I needed more education and made plans to enter graduate school to begin a Master's degree.)

1972 Vocational Rehabilitation Act Amendment

Fourth, the 1972 Vocational Rehabilitation Act Amendment was vetoed twice by President Nixon. I knew that Nixon was no supporter of the Rehabilitation Movement. Even though the Act passed later in Amendment, I hated him.

Daddy would respond, "Life will be filled with people that don't think as we do. But we must be sure we never get so discouraged that we stop doing what we believe is the right thing."

And then … the next week there he was, back in Winston-Salem, in the stands cheering for Mike and Gordon at a Junior Pee Wee football game in the fall, or when they raced for Westwood Swim Club in the summertime.

When we visited my parents at their home in McLean, Daddy showed his grandsons how to plant flowers. "Always dig the hole two times deeper and two times wider than the directions say." To this day my sons quote their granddaddy when they dig holes for new plantings in their own beautiful yards.

Daddy also encouraged me when I entered the University of North Carolina to begin studying for my Ph.D. This degree was a necessity if I planned to continue my teaching at Wake Forest and Winston-Salem State Universities as well as continue my work with disabled children and adults.

Rehabilitation Act Amendments of 1974

Fifth, the Rehabilitation Act Amendments of 1974, vetoed by President Ford, was passed over his veto by a vote of 398-7 in the House of Representatives and 90-1 in the Senate!!! This Act authorized an expenditure of Federal Funds of over three-fourths of one billion dollars to improve the lives of handicapped citizens. It was a great victory for Daddy and for disabled people throughout the United States. I still find it hard to even consider forgiving Presidents Ford and Nixon for vetoing this act. But I am thrilled that it was passed so enthusiastically by Congress.

Years later one of President Ford's sons was hired at Wake Forest University to serve in an administration position. I could never "warm up to him" because I knew that his daddy had voted against my daddy when voting on the 1974 Rehabilitation Amendment.

I just couldn't think like Daddy. "Betty," he would have said, "we are fortunate to live in a great country that allows different opinions on all topics." As far as I knew he really felt like this. He never felt resentment toward people who didn't agree with his opinions.

He was an amazing man and I was proud he was my father.

Rehabilitation Counseling Profession

During his last years as Director of the National Rehabilitation Association, Daddy supported and assisted in the design of a new profession, Rehabilitation Counseling. He, along with professors at George Washington University, taught the first course in Rehabilitation Counseling ... "Introduction to Rehabilitation." The G-W professors wanted him to remain on the faculty but he was not interested in obtaining a doctorate. He said there were so many Ph.D.'s in the country that someone had to be around to hire them! And at his retirement, he did have three Ph.D.'s working in his office.

In 1976 James Holshouser, Governor of North Carolina, presented daddy with the Order of the Long Leaf Pine, the highest award from the NC Governor's office. I was particularly pleased because by that time I was teaching courses in speech/language pathology at Wake Forest University in Winston-Salem, North Carolina.

The E. B. Whitten Silver Medallion

I think Daddy felt his greatest honor was the establishment of The E. B. Whitten Silver Medallion to be awarded each year to a person who has furthered the cause of the disabled. Mr. Elton Barber Whitten (my daddy) received the first commemorative medal at his retirement in 1974. Since that time the E. B. Whitten Medallion has been presented each year to a person who has devoted his/her life to improving the lives of disabled people. The following passage is a quote which honored Daddy at his retirement.

The Congressional Record 1974

From the Congressional Record...1974

When Mr. Whitten took office in 1948, the National Rehabilitation Association was relatively small. He was the first and only Executive Director until his retirement. Many believed the Association had a provincial, parochial outlook. At his retirement, however, under his leadership it is an organization of 38,000 members with seven divisions and active associations in every part of the country. It has become a unique community of many professions, planning and working together to serve the growing needs of a national society. Mr. Whitten's leadership has not only penetrated the membership of his own Association but as well a variety of voluntary agencies whose missions are related to NRA's. His knowledge, his strength of personality, his credibility, his courage and openness, high ethical standards, trust in and sensitivity into our ultimate goal have put the stamp of leadership on the National Rehabilitation Association. We have witnessed changes so profound and far reaching that the mind can hardly grasp all the implications.

E.B. worked in quiet and unspectacular ways. He was deeply sensitive to the feelings and vulnerabilities of others. This was of great value to him and his agenda when operating in areas of considerable emotional context. His opponents were many and able but they nonetheless considered him a friend. Conscientious politicians and their staffs recognized that they could depend on his reports and data. The many favorable votes of the issues that the NRA supported indicated that trust. The all-important Public Law 565 was passed 81-0 in the Senate and 347-0 in the House.

He was a true southern gentleman and was exceptionally committed and able. The serendipitous event in 1948 that brought together Whitten, the National Rehabilitation Association and an idea that whose time had come.

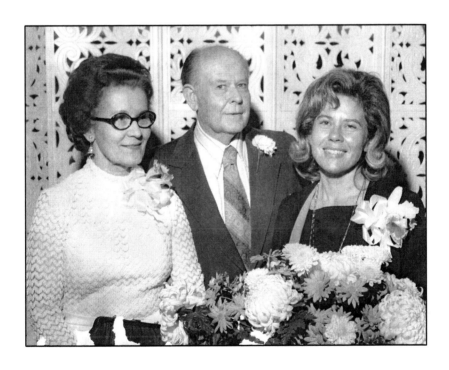

Retirement Party, December 4, 1974

"Just Ethel and Me, and Betty makes Three."

The Retirement Speech

At his retirement celebration one of the Congressmen said, "E.B. was a true southern gentleman and was exceptionally committed and able. The serendipitous event in 1948 that brought together Whitten, the National Rehabilitation Association and the idea whose time had come...that is rehabilitation...resulted in succeeding decades of fantastic growth in all facets of opportunities for persons with disabilities...that is rehabilitation... resulted in succeeding decades of fantastic growth in all facets of opportunities for persons with disabilities."

And at the writing of this book, the rehabilitation movement continues today. Thousands of beneficiaries, friends and colleagues will remember the legacy of E. B. Whitten, and will be grateful to him, always.

And I will always be grateful that he was my father.

I loved him. I miss him. I was honored to be his daughter.

Arbor Acres

Winston-Salem, North Carolina

In 1982 Daddy and Mamma moved to Arbor Acres Methodist Retirement Community in Winston-Salem, North Carolina, to be near me and my family. My parents knew it would be their last move and it was sad for them to leave their home in the Washington area. Daddy was becoming frail as he dealt with the early stages of prostate cancer when he and Mamma moved into a lovely new patio home. They were able to furnish it beautifully with most of their "best" furniture and accessories. On his 80th birthday I hosted a party for him in my home in Winston-Salem. We gave him two pear trees and twelve azaleas to add to the garden at his new home. Mike and Gordon planted the trees and remembered to dig the hole twice as wide and twice as deep as the directions said...a lesson they learned from their granddaddy when they were little boys.

Daddy's view from his back yard in Arbor Acres provided a rural vista where he could see the barns, cows, horses, and vegetable gardens that were part of the Methodist Children's Home. In his last days he spent hours sitting under a huge oak on the expanse of lawn that sloped toward the fence separating his property from that of the farm. As I observed him I wondered if he was reflecting on his boyhood home in the Mississippi Delta. Or was he thinking of the cow Granny Whit milked twice each day... or about the horses in his daddy's livery stable? Was he reflecting on the time he and Lamar, his boyhood playmate, said good-bye when Daddy boarded the train to go to Millsaps

College, never to return home again? Perhaps he was thinking about me, pleased that I was carrying on the rehabilitation movement in my own way. I wondered if he marveled at how far he had traveled and how much he had done to change the world for disabled citizens.

Or was he thinking about Washington in April when he wrote in his book:

Much has been said about Paris in the springtime. As much can be said for this Nation's capital. Today I took a noontime walk downtown and returned by the White House and through Lafayette Park. The grass is emerald green and the trees add their pastel shades of color. The tulips, brilliantly red, contrast vividly with the rich lavender of the grape hyacinth. The azaleas, every shade from white to dark red, were never more beautiful. The dogwoods are a soft white umbrella for the colorful masses of blossoms. Always like a picture postcard in the spring, the Nation should be grateful for the added beauty that resulted from the efforts of a dedicated group of women a few years ago. Washington is proud of its beauty and its parks are well maintained.

We must not forget that Washington is a city of demonstrations, and the city today is full of people who carry banners espousing their various causes. Of course, most of the people who come to Washington to demonstrate are seriously concerned for the state of the Nation and the world. And one can understand and share their concerns in many instances. Unpopular wars drag on; there are poor people in the land, many of them poor for reasons beyond their ability to control. Only the senseless can be unconcerned for the proliferation of nuclear weapons and the rigid stances taken by the nations that control them. Yes, there are problems enough, and people must continue to be concerned about them.

But there is reason for hope, too, and one can feel hope in Washington in April. Hope is precipitated by the beauty of the earth, the concern in the faces of its citizens, and the knowledge that those who went before us have left us a great democracy that continues to lead us into the future.

E. B. Whitten: The Poor Man's Lobby. 1980

The Poor Man's Lobby

E. B. Whitten documented all of his work in the book that he wrote: *The History of the National Rehabilitation Association: The Poor Man's Lobby* located in the Library of Congress ,TXu 1-668-029.

Daddy's Death

My daddy died with prostate cancer in 1989. He always loved me unconditionally. At his funeral my body shook and trembled. I just couldn't get control. My dear sister-in-law, Harriett Phillips May, said, "You feel as if you are in airplane turbulence, don't you?"

She was correct. Eventually, with the passage of time, my loneliness dissipated. Today I feel his presence every minute of every day…not in any sad way. I know he is with me and still guiding me. I still ask him for advice and wait for the answer to come. Or I might see something funny and know that the two of us are laughing together. The reader might think this sounds weird.

So be it!

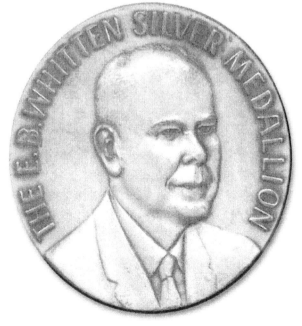

Ethel Marie Duckworth Whitten – 1910-1998

MAMMA

ETHEL MARIE DUCKWORTH WHITTEN

1910 – 1998

Ethel Marie Duckworth Whitten

January 21, 1910 – July 16, 1998

My mamma, Ethel, was slim and physically beautiful with dark wavy hair. She played the piano and wrote poetry. Ethel was an expert seamstress, a designer of clothes, a gourmet cook, and a visual artist (flowers in pastels were a favorite). Arrangements of fresh flowers were always in our home. Her creation of an elegant and comfortable home resulted in her enjoyment of hosting parties, cooking and decorating for holidays. Mamma maintained a healthy diet and exercised every day. Her great sense of humor and infectious laughter resulted in her being a wonderful story teller to both children and adults. When she met my daddy she was a fourth grade teacher in the Taylorsville, Mississippi public school system.

Her parents, Benjamin Silas Duckworth and Lula Susanna Walker Duckworth were Baptists. When Mamma married Daddy and after I was born she changed her membership to the Methodist church where she was usually a children's Sunday school teacher and also sang in the church choir. Mamma was a talented, energetic dancer (she taught me the Charleston), and enjoyed wearing the current fashion styles along with the latest make-up trends. She always loved dogs. She couldn't resist *Milky Ways*. My mamma was the prettiest one in the PTA.

And she was considered a rebel for her day.

Mamma was extremely proud of my daddy and loved me fiercely. She was also determined that I would always be "lady like" in my behavior. This was a difficult task for the two of us, as it seemed that I was always trying to go beyond the boundaries

that she had set for me. My interests centered around the climbing of trees or racing boys on my bike. She felt that I talked and laughed too loudly. As I became older, I wanted to have a career other than the accepted ones in my family, which were teaching in elementary schools, teaching piano, or being a nurse…and then only until you married.

As I grew into adulthood, I can remember hearing Mamma talking to Grandmother and my aunts about me. She would say, "I do not know what's wrong with her. I just don't know just why she is like that!"

I was always proud of her and I believe she felt the same about me. I hope to do her justice as I write about her.

Mamma's life is worth remembering.

I loved her and she loved me.

Gilmer, Mississippi

In 1910 Mamma was born in Gilmer to Lou Walker Duckworth and Benjamin Silas Duckworth. Gilmer, (a small town that no longer exists) was located about ten miles from Taylorsville. She lived there with her parents, her sister Braddis, and brother Hubert until she was six years old.

Kudzu

When I was an adult, I, along with Mamma, Aunt Braddis and Uncle Hubert, went back to Gilmer. The town (today not even on the map) was difficult to find. There was not even a state road to lead us to our destination. It was an eerie experience for all of us because Gilmer was completely covered with kudzu, a plant that literally runs wild in Mississippi and elsewhere in the south. Kudzu will climb to the highest pine tree to kill it. I still wonder if kudzu killed not only the trees in Gilmer but the entire town. Perhaps it just smothered the citizens and they had to move or be strangled to death.

As our family stood next to our car, we tried to visualize the town as it would have been before kudzu covered the outline of the main street. We could "see" a few of the stores and even imagine some houses. When Mamma finally located her grandmother's house, her eyes became moist and she was silent. Standing motionless she gazed at the kudzu covered house. I wondered if she was thinking of her happy days when she was a little girl and would stay with her grandmother Virginia Anderson Walker. Mamma often told me that her Grandmother Walker loved and appreciated her more than did her own parents. I wonder.

Mamma's young father and grandparents were farmers and owned a parcel of land that afforded them a good, if not luxurious living. (History reveals that in the 1800's the Duckworth's owned thousands of acres of land that was planted, tended and harvested by hundreds of Negro slaves. The Civil war wrecked parts of Mississippi and most of the Duckworth land was lost during that time.)

Grandmother Lou Walker Duckworth
1885-1961
"A woman of extraordinary intelligence."

A Boy Named Joe

Soon after their marriage my Grandmother Lula (Lou) and Granddaddy Ben wanted to start their family. Granddaddy wanted a son to name Joseph because his own brother named Joe had died at the age of fifteen years. Granny Lou's first two babies were boys, one of whom was still-born and the second one died after living only one month. Each of these infant sons was named Joseph, a name that is recorded throughout the Duckworth family history, appearing as early as 1684 when the Duckworths were still in England.

Granny Lou and Granddaddy wanted a big family and soon after the two baby boys died, Grandmother had a daughter, Braddis; then one year later another daughter, Ethel (my mamma) and only two years afterward a son. Granddaddy wanted to name that son Joseph.

"Absolutely not!"

Granny Lou said, "The name of Joe is cursed in the Duckworth family. We will not place a curse on the head of a single one of our children. His name will be Hubert."

The Middle Child

Mamma was the "middle child" with the reputation of being an active child and often "hard to manage." Her older sister (Braddis) was intelligent, obedient, and talented. Mamma felt that she and her younger brother Hubert were always at odds, even when they were adults. I remember occasions when they got in heated arguments about politics, religion or finances. Once when I was present, Uncle Hubert said something to Mamma that made her so angry she cried. I never really felt the same about Uncle Hubert after that….ever. But I never had any brothers or sisters and didn't ever understand the point of family arguments.

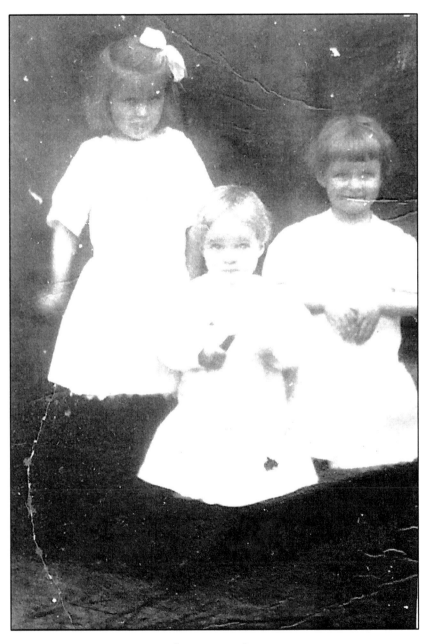

The Middle Child

Braddis-Hubert-Ethel 1913

The Move to Taylorsville

When Mamma was three years old, Granddaddy moved his family to the small town of Taylorsville where he opened a dry goods store on the main street that sold farm equipment, groceries, and clothing. He continued to "do a little farming" and "kept a few cows." He also built a large rambling home with a huge front porch holding four large rocking chairs and a side porch with a porch swing.

The store must have been profitable because in the 1930's during the height of the depression he was able to send all four of his children to college: two sons to Mississippi State College and two daughters to Mississippi State College for Women (MSCW).

Granddaddy had planned to send only his sons to college because "education was wasted on women." My Granny Lou wouldn't stand for that.

"The girls will go to college." And they did.

I believe Granny Lou was probably the first feminist in our family!

The Sewing Kit

Mamma had several memories of her childhood. One Christmas she and her sister Braddis received tiny leather sewing kits containing little spools of thread in a variety of colors. Throughout Christmas day her sister Braddis convinced my mamma to swap one spool for another until at the end of the day her sister owned all of the bright colors (red, pink, blue, orange, yellow), while Mamma wound up with black, grey, brown, tan and white. When Mamma finally realized what had happened, she began to bellow! Grandmother made Aunt Braddis "make it right." Incidentally, through the years, Aunt Braddis never did remember any part of this story. Or did she?

Another Boy Named Joe

Eight years after my grandparents moved to Taylorsville Granny Lou was pregnant again, this time with a son. Granddaddy said, "This boy will be named Joe." So Joe it was!

Granny Lou still felt that the name was cursed because of the death of the three previous sons who had died untimely deaths. But she agreed this time.

(When Uncle Joe was thirteen years old I was born and named Betty Jo. I loved being Uncle Joe's name sake. I thought with assurance that I was loved more by my grandparents than they loved their other grandchildren!)

The Chicken Killer

Granny Lou was slender, feminine, and stylish, wearing pastel floral print dresses with black oxford shoes and thick flesh colored nylons. There was, however, one of her behaviors that made me wonder about her true character. When I realized that ritual was about to occur, I found a fence post on which to perch to get a good view of the event.

When we were having family dinners, it was Granny Lou's job to provide our meal. In her pretty pastel flowered dress she would run down a chicken, corner it, and grab hold of its neck as the chicken squawked. Then she would wring that chicken's neck by swinging it in a huge circle over her head. When the chicken's neck was broken, she would place that chicken on a tree stump and chop off its head.

And that wasn't all. When the head hit the ground its eyes always seemed to look at me with surprise, while the rest of the chicken would flop around the yard with blood spurting in all directions. When the bird finally came to rest with no more movement, Granny Lou would drop that bird into a huge black pot of boiling water that had been sitting outside over the red smoldering coals. Once again, the chicken would begin to flop in the water. I was always sure that the chicken could feel the pain of

the hot water. Finally, after all of that, Granny Lou put the bird on a newspaper on the picnic table to pick off the smelly feathers.

Then she demurely removed the chicken from the "picking table" and with her graceful feminine walk, returned to the kitchen. Interesting.

Goin' Fishin'

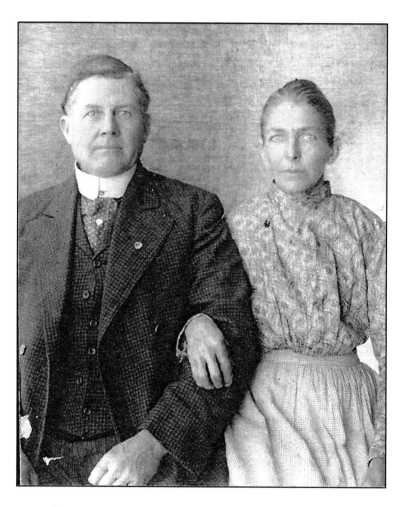

Benjamin Preston and Virginia Anderson Walker

Mamma said that when she was growing up she felt she was the least favorite of the three children. But she also believed that her grandmother Virginia loved her more than any of the other grandchildren. Mamma often went to Gilmer to stay with her grandmother for days at a time. She realized later that she was probably sent there to give her own mother a rest. She recalls these visits with her grandmother as among her happiest early childhood memories.

Mamma and her grandmother would frequently go fishing. Mamma didn't like the dirty, hot, boring fishing because she had to sit still and be silent. But she loved her grandmother so much that she was able to endure these hardships. As they sat on the riverbank her grandmother told her stories that would help pass the time as they waited for a fish to bite.

Mamma especially liked the story about the Pascagoula Indians. She and her grandmother would put their cane poles in the water, prop their backs against a tree, and she would wait for Granny Walker to begin.

SINGING WATERS

There is a famous river known throughout the world for its mysterious music. It's reported that the singing sounds like a swarm of bees in flight and is best heard in late summer and autumn. The music is barely heard at first … but the music seems to grow nearer and louder until it sounds as though it comes directly under foot.

* * *

An old legend connects the sound with the mysterious extinction of the Pascagoula Tribe of Indians. The Pascagoula's were contented, innocent, peaceful people. The Indians in the nearby Biloxi tribe were warriors. A love affair between members of the two tribes resulted in war.

The Pascagoula tribe was out-numbered and faced enslavement. They joined hands ... began to chant a song of death as they walked into the river and disappeared.

It is believed that the modern day's sound is the death song of the Pascagoula tribe as they entered the river. No other scientific explanation has been proven.

*　　　*　　　*

And now the story Ethel's grandmother told her again and again and again...

Fulton Manor, a stately Mississippi mansion, stood alone on a hillside with cotton fields rolling around her feet. On this hot, sticky afternoon the workers in the field were trudging slowly down to their shacks on the Pascagoula River. The farm hands (men, women and children) were just temporary tenants in the shacks ... called migrant workers. Today the workers were exhausted and spoke to one another in the soft voices of fatigue. Twilight was nearing and lights were beginning to bring to life the halls of the old mansion.

The Fultons were the owners of the home and landowners of thousands of acres of property. The family had lived there for generations and they continued to raise cotton crops as their forbearers did before and after the Civil War. You could hear the sounds of supper being prepared by Cecilia Fulton, the mistress of the house. Mr. Fulton was usually in the parlor reading the paper while three-year-old Tommy (the youngest of the family) was ready for bed and beginning to whine.

Out on the veranda in the shadows of the great white columns sat Emmy, the five-year-old daughter of the wealthy owners of Fulton Manor. She was dressed in a crisp, white sundress, her yellow curls bobbed in the soft breeze as she

happily waved and shouted good-bye to the children of the tired workers.

And now she waited for her special friend to come in from the field. His name was Bill-George and she thought of him as an old man. He had a ruddy face with arms that had labored in the hot sun for so many years they were deep brown. She would often laugh and ask Bill-George to roll up his sleeve so she could see the contrast of his white shoulders against his brown arms and calloused hands.

The cotton was in, weighed and prepared for the journey to the town gin the following day. After those chores were completed Bill-George always stopped by for his daily chat with "Miss Emmy."

Bill-George was more than just a farm worker. He had lived on the place since her daddy was born. He was a rodeo cowboy until he injured his leg, and later turned up on the porch looking for work. After her grandfather hired him, Bill-George taught her daddy to ride his pony and to round up cows at milking time. He was standing on the steps when her daddy brought home his bride, her mother Celia! Bill-George was also the faithful friend that walked the floor with her daddy the night Emma was born and just kept saying, "Ever' things gonna be alright."

"Did you really hear my first yell?" Emmy often asked.

She delighted in hearing the old man say, "Yep, honey and your daddy was mighty proud of his lil' gal."

Knowing when and where the trout bit best, Bill-George spent many happy hours fishing with her daddy telling him stories about the Pascagoula

River. And now he told those exact same stories to little Emmy She loved knowing that her own daddy listened to the same stories that now held her spell-bound.

This evening as Bill-George stopped by to chat with Emmy, squeals of glee filled the air when she heard him say, "Tomorrow's gonna be a right pretty day for fishing and it would be right nice to have somebody come along so as I wouldn't have to bait my own hook."

"Mr. Bill, I'm pretty good at baiting hooks," she teased. And the plans were made!

"Well," he said with a grin, "if you go to bed early tonight I'll be 'round 'bout seven tomorrow morning and we'll make a day of it."

Early the next morning, Emmy hopped out of bed, dressed in her red coveralls, and rushed down the long staircase to the kitchen.

"Mamma, pack me a big lunch with lots of cookies; and Mr. Bill likes cheese. He's coming in a minute to take me fishin'."

Her mamma laughed. She lovingly tousled Emmy's curls and began to prepare a nutritious lunch. She even added some chips for a special treat.

Emmy heard Bill-George's whistle and darted down the path to greet him.

"Are you ready, Mr. Bill? I hope so, because I am, and I've just been waiting for hours and…"

She had remembered to bring the lunch and also her pretty red straw hat that matched her overalls.

"Oh, we'll get there soon enough now, honey. Don't you be so impatient."

Bill-George walked slowly, his light limp from the rodeo injury more apparent today than on other days.

The day, just as Mr. Bill has predicted, was a perfect one for fishing. The clouds were white and fleecy, the birds were singing and Emmy was bubbling with excitement.

A gray squired darted across the path with an acorn in his mouth. A redbird whistled his tune high up in a sycamore tree. A lizard, frightened by their arrival, turned from green to reddish brown on an old tree stump. The little frog, giving his monotonous croak, seemed to be watching the snail laboring slowly along with his house on his back.

When Bill-George and Emmy reached the Pascagoula River, they found just the right spot, sat down, and dropped their baited hooks into the still, clear water.

Emmy loved listening to the water as it rushed over the rocks in the center of the river. As she lay on the cool ground gazing through the Spanish moss, it seemed that the river was singing a song.

The day wore on. They ate their lunch.

"Mr. Bill," she asked sleepily, what makes the water sing like that? It's getting louder and louder."

"Well, Emmy, it's like this," Bill-George replied. Emmy waited for him to settle down comfortably against the old tree for she knew that another story was going to begin.

"Many years ago, before the white man conquered the new world, this country was a huge forest. Here on the banks of this winding river lived the Pascagoula Indians, a brave noble tribe who didn't believe in war. They lived in one harmonious group, loving each other, sharing feasts, singing and dancing.

"One day, Ninkoo, the chieftain's little boy, came in running with an alarming story. He had

seen hundreds of red men with paint all over their faces.

"I heard 'em talking," little Ninkoo shouted excitedly.

"I think they are the Biloxi's and they said they're gonna come here tomorrow. They said we're peaceful, dumb Indians and that they'll take our fishing grounds and kill our people."

The chief was alarmed when he called all members of his tribe together.

"Until now," he said sadly, "we have been a peaceful race. We have gotten along together and have never quarreled with our neighboring tribes, but today we have sad, disheartening news. Tomorrow we must fight with the few weapons we have. Remember that you're fighting for your land and your loved ones. May the Great Spirit be with us all."

The Pascagoula Indians retired for the night.

The next morning was beautiful. The sun was shining through the trees and the Pascagoula waters seemed bluer than they had ever been before.

It wasn't going to be a good day for the Pascagoula's. The little village was so still and quiet you could hear the buzz of the insects as they did their daily chores. The Indians were waiting!

The dreaded Biloxi's came into view, carrying weapons of war. Some of the Pascagoula Indians had never seen such weapons. They weren't a tribe of war. One of the women screamed and began to run ... she was stopped abruptly by a loud thud. This seemed to be what the Pascagoula's were waiting for. Even though they were inexperienced, clumsy, and afraid, they charged at the Biloxis. In a

short time the Pascagoulas realized that their resistance was in vain.

When the bloody, red sun sank below the horizon, the chief called the remnants of his tribe together. All of their faces were downcast as they realized the only fate left for them. They turned almost triumphantly toward the great Pascagoula River. With their hand clasped and voiced lifted in song, they, one by one, disappeared into the depth of the "Singing Waters" never to be seen again.

"And that is why, Emmy, the Pascagoula River sings its song."

"My," signed Emmy, "did any little Indian girls drown?"

"Oh, yes, honey, but don't you worry because you can tell by their singing that they're mighty happy down in those beautiful, blue, singing waters."

Darkness was coming and Emmy was feeling drowsy. Pretty soon it would be her bedtime. They knew that her supper would be waiting. They trudged back to Fulton Manor.

After dinner, as her mother was tucking Emmy in bed, she laughed when Emmy asked if the little Indian girls were really happy in the river.

The next day there was no picnic, no fishing, but lots of work to do on the farm. The workers were picking cotton. Emmy wore her blue straw hat today to match her new blue overalls. It was so hot that the hat didn't seem to be protecting her from the sun.

"Mr. Bill, are the Pascogoula Indians in the river right now?"

"Yes, mam, honey. And if we were in the woods and listened closely we could hear them still

singing of their happy days spent here in the great forest."

Emmy went to the fields to pick her cotton. She put it in the little sack her mother had made for her. She couldn't pick as fast as the field hands or Mr. Bill. Soon they were far out ahead of her.

Standing alone, she thought again of the sad story of the Pascagoula Indians. She wondered if she could slip quietly down to the river's edge to see these Indians. Mr. Bill would never let her get close enough to really see them. No one would ever know if she took one quick look alone.

Soon she found herself on the bank of the sparkling, singing Pascagoula River. She listened to the singing that seemed more beautiful than it had ever been before. She could hear the children playing games on the river bed. Their cries of joy became louder and louder. She peered over the bank into the rushing water. A little Indian girl with blonde hair peered up at her. Emmy smiled and the little Indian returned her smile. With outstretched hands, she stepped closer to the shiny beautiful, treacherous singing waters.

* * *

The cries could be heard up and down the cotton rows … the field hands stopped picking and began to scream for Emmy. Bill-George's voice could be heard calling, calling. Suddenly he thought of her question pertaining to the Pascogoula Indians.

He rushed frantically to the river's edge, calling her with every breath. The trees mournfully echoed her name; the birds ceased their song; the woods became silent.

From the bank Bill-George saw the little blue, soiled straw hat floating down the river. Rushing to the river's edge, he saw a beautiful shadow ripple in the depths of the river. The gray Spanish moss waved back and forth in the summer breeze while the Pascagoula River continued its voyage, singing it is mournful song of death.

Quilts

Mamma remembered that my great-grandmother Virginia could whistle any tune and she taught Mamma to whistle (not considered an appropriate skill for women at that time)! The only tangible objects that I have of Virginia are some of the amazing, colorful, beautifully stitched quilts she made … in abundance.

When I married, Mamma gave me one of great-grandmother Virginia's quilts. When my mother died I inherited several more quilts. I have given one quilt to each of my granddaughters; I continue to hang one on the wall of my home. There are two more tucked away in a trunk waiting to be presented to another heir that might join our family.

When I was born it was assumed I would "carry on" the art of quilting and other handwork that was prevalent in our family. But that didn't happen.

The Baptist Church

The Duckworths had been Baptists since they trouped through England in the 1600's. Granny Lou's brother, Barney Walker, was a well-known Baptist preacher who served five different churches (not at the same time) in Mississippi prior to becoming a popular Evangelist preacher.

He died prior to my birth, but I enjoyed hearing about his wild youth and service in World War I ... clearly before he "came to Jesus." (Or, perhaps, before Jesus came to him.) Family stories were often told of that night at Granny Lou's house when Uncle Barney caused quite a ruckus. He came home late, drunk, and stumbled up the ten steps to the front door of the house. Granddaddy slipped out to pick him up, drag him into the house and put him to bed. Mamma told me about it but when I asked Granny Lou to tell me about it she said that never happened and I was never to mention it again ... suggesting to me that it probably did happen!

When I was an adult I read Uncle Barney Walker's book, *Seven Spiritual Ships*, published in 1915. The book was intended to "steer Christians back to Christ." I suppose he felt he had been "steered" there before the rest of us.

Granddaddy was a deacon in the Fellowship Baptist Church where the men sat on one side of the church; the women and children on the other. When we visited Taylorsville we always went to church no matter how hot it was or how sick I felt. Organdy was a popular fabric for little girl dresses although it was scratchy and itchy. I had to wear it anyway, even though it left "marks on my stomach."

One Sunday when I was two years old, Mamma and Daddy and I were visiting my Duckworth grandparents and, of course, on Sunday we went to the Baptist church. I wanted to sit on a pew with my Deacon Granddaddy who sat on the left side with all of the men. Instead I had to sit with Mamma, Daddy, Aunt Braddis, Uncle Craig, Uncle Joe and Grandmother. On this Sunday it was "Mississippi hot" (very hot!) and in those days there was no air-conditioning in churches. Our family members were the only ones sitting on one of the pews on the right side next to an open window ... hoping to catch a little breeze. My yellow dotted Swiss organdy dress was scratching my stomach and my neck. My bran' new black patent leather Mary Jane shoes with white socks were hurting my feet because I was accustomed to going barefooted.

The heat was stifling. I decided to remove my shoes and socks, placing them between Mamma and me on the pew. I was still hot and decided to remove my clothes ... my organdy dress and then my little panties. They were my good "Sunday clothes" so I knew to carefully fold them and place them by my side.

The teenagers in the pew behind realized what I was doing ... but not my parents. Mamma heard them snickering, glanced toward me and there I was, "necked as a jaybird." I was sitting quietly and appeared to be listening to the preacher. I was definitely more comfortable than other members of the congregation.

By this time, the teenagers behind us were laughing hysterically, trying not to make any noise that would have caused them to disturb the preacher. Mamma quickly gathered my clothes and dressed me before my Baptist Deacon Granddaddy spotted me!

Do Methodists Go to Hell?

Early in their marriage Mamma and Daddy went to different churches ... Daddy to the Methodist and Mamma to the Baptist. Soon after I was born Mamma moved her membership to Methodist because "Betty Jo is so much like her daddy, Elton, we should all go to the same church." And from then on, we three were Methodists. (I worried when I heard I was just like my daddy because I thought it meant I looked like a boy. I asked Mamma about that. She explained that was just a "figure of speech" which I did not understand either.)

Granny Lou was distressed when Mamma changed her church affiliation to Methodist. She felt that Daddy and I would go to hell because we had not been immersed at baptism.

One Sunday when we were visiting Granny Lou, the dinner had been served and eaten, the dishes washed. I quietly took my usual place under the kitchen table so that I could hear the talk that children were not supposed to hear. My Mamma and Granny Lou were arguing about whether Daddy and I were going to hell.

Mamma got mad and began to cry. I was concerned. Later I slipped out of the kitchen to talk to Daddy about that.

"Are we going to hell?"

"NO" he said gruffly.

"Granny Duck says we are."

"Well, we *aren't.*"

And in my mind, all of that was settled because I always believed everything Daddy said was the truth.

Mamma began to teach Sunday school to children when she herself was in the seventh grade and continued to teach young children the rest of her life ... even when we moved to the Washington, DC, area. And my daddy taught the Men's Bible Class from the time he was a young adult until he was over seventy-five years old. He "knew his Bible," that was for sure.

Mamma's School Days

Mamma never talked much about her early school years. Apparently she made good grades and had good friends. Throughout her life she kept in touch with Etoille, Kate, Hilda Sue, sisters Alice and Sibbie, Florence, Lottie, Mauda May Shanks and Herbert Meyer Risher. Her grades were not as high as her sister's but Mamma's motto was "Make B's and Have Fun!" (Daddy preferred A's and didn't like her to say that.)

Rebellion!

Mamma was a rebellious teen-ager. Her dating curfew was 10:00 when her friends were staying out later. Her parents often told her that she wore too much make-up. Once, when Mamma was dressed to attend a party, her father told her to remove her lipstick.

Her fourteen-year-old brother Hubert laughed at her and said, "Your lips look like a fox's arse in dewberry time." (Dewberries, loosely related to blackberries, are seldom seen growing these days.)

That comment made Mamma so mad that she, all dressed up for her date, chased Hubert through the house, grabbed him, wrestled him to the floor, put her hands on his neck and screamed, "Take that back; take it back or I will kill you."

He took it back!

Then Mamma smiled, calmly and carefully reapplied her red lipstick, and told her parents good-bye as she strolled from the house.

Rebellion 1926 – Ethel on right

Mamma, Did You Ever Kiss A Boy?

In high school my mamma, Ethel, had a steady boyfriend, Jim Eaton Carlyle, whom she thought she loved. When I asked if they kissed each other in those days, she grinned, pointed to Granny Lou's couch and said, "Well, I surely am glad that couch can't talk."

"No, really!" I pursued the topic. "Did y'all really hug and kiss?"

She laughed. "Now what do you think?" But she never said one way or the other.

Once I asked Granny Lou if she and Granddaddy kissed before they were married, like maybe when they were riding in their horse and buggy.

She smiled and said, "Go ask your granddaddy!"

I would never have done such a thing.

We Almost Lost Ethel

When Mamma was in the ninth grade she was already driving a car. One day in early spring, she and three of her girlfriends slipped off to swim in the Leaf River near Taylorsville. Mamma, Mauda May, Etoille, and Lottie often swam with the boys and adults in that river. They would swim out from the river bank to the center of the river, tread water, and then swim back to shore.

Several days before Mamma and her friends arrived for their swim, some heavy spring rains had swollen the river, rendering it higher and deeper than usual. When the young women swam out, all four girls were swept along by the current. They became afraid as they realized they weren't strong enough to swim back to the bank. They were about to float under a bridge when they grabbed and held on to the bridge supports.

They began to scream … and scream … and scream. Finally a field hand heard them and rushed to get help.

The townspeople in Taylorsville heard the screams and drove their cars to the river. The four girls were rescued. It was reported

that Granddaddy Duckworth closed his store, came to the river bank to see Mamma and her friends on the bank. The girls were crying, shaking and covered with towels and blankets. Granddaddy took one look, saw they were safe and, without a word, returned to town to open his store. He never said a word to Mamma about it. But it was extremely quiet around the Duckworth table at dinnertime.

Later that evening Granny Lou told Mamma that when Granddaddy Duckworth came home from the store he came into the kitchen with tears streaming down his cheeks.

"We almost lost Ethel today." Then he audibly sobbed.

Thank goodness there is no more to that story!

The Storm Pit

In those days Mississippi neighborhoods had storm pits to shelter citizens if or when tornados came through the area. Mamma was always afraid of storms. Whenever there was excessive rain and wind, she would streak across the yard and run into the storm pit. It was said that neighbors would look out and calmly say, "There goes Ethel again."

To my knowledge she was never in a tornado, but she remained afraid of storms throughout her life.

* * *

The intent of the following story, "It Happens Every Saturday," is to describe a typical Saturday in my grandparents' town of Taylorsville, Mississippi. My granddaddy, Benjamin Silas Duckworth, owned the dry-goods store located in the middle of town. I always looked forward to spending the day in town on Saturday.

IT HAPPENS EVERY SATURDAY

1940

Taylorsville is a lazy friendly town of just over one thousand people located on Highway 31 in southern Mississippi, about twenty miles from Mize and Sullivan's Holler. One side of the highway is composed of a line of stores almost one-half mile long. On the other side stand the cotton gin, a small jail, the depot, and endless railroad tracks stretching far beyond the town. A stranger, who may take the time to wonder, might think of Taylorsville as being a dull, little country town. However, it actually becomes a colorful, interesting spectacle one day each week.

Most cities are asleep early on Saturday morning, but not the citizens of Taylorsville. Mr. Hinshaw, who wants to be the first to hear the news, rushes to get to town before the crowd arrives. He chooses to sit outside on the spot in the center of the window ledge of Mr. Ben Duckworth's Dry Goods Store, the usual meeting place of the group of men that will soon arrive.

The heat is stifling and the roads are dusty. The farmers in their pick-up trucks are driving into Taylorsville with their children of all ages in the truck bed, their wives and babies in the cabs. Most are farmers who have driven to town for the day. Teen-age boys quickly hop from the back of trucks before their fathers have even parked. The boys move away, embarrassed at having to ride with their younger, giggly sisters. The wives seem to give their husbands a few last-minute instructions

regarding the time to meet to return home. The family separates for the day.

From the east end of town appear three brilliant yellow school buses containing the Choctaw Indians from the reservation eight miles away down the highway. Their dark straight hair, wrinkled brows, slow movements, and colorful clothes are characteristic of this Mississippi tribe. They say little to one another as they descend from the bus, but their expectant, sparkling; dark eyes reveal their excitement about the unfolding day. After purchasing their farm supplies, fabrics, food supplies and beads they congregate in a small Methodist church behind the dry goods store.

By ten o'clock the streets of Taylorsville are teeming with townspeople. The weather is warm but not stifling.

The shopping is done first. The smallest children receive their chewy caramel sucker which is intended to keep them content for a while. Then the women gather at Walker's Dry Goods Store because Mrs. Walker (Delphia, as she is called by the women) is always willing to share the town gossip.

The menfolk may be found along the walk in front of Mr. Ben's store. They are content to sit until dusk, exchanging stories, spitting tobacco juice, and laughing more loudly than necessary. A nice girl always coughs or speaks loudly before passing to prevent being covered with tobacco stains or being within hearing distance of the punch line that follows the low murmur of one male voice.

Mr. Ben always looks forward to Saturday when he usually "has a good day at the store." In the far back of the store is a large round wooden

container holding fresh cheddar cheese where, in the summer, moist droplets form on the top of the cheese. He gives his potential customers (and always his little granddaughter) a taste of cheese, and the family groceries are selected for the week.

The women shop for cotton house dresses or purchase material for sewing the children's school clothes. Most of the children try on a pair of Buster Brown shoes to get ready for school. The men shop for hardware and tools. At the store's entrance there is a long showcase filled with orange slices, licorice sticks, jelly beans, caramels, hard candy, peppermint sticks, bubble gum, and jawbreakers so large they can't even fit into the mouth of a small child. Every Saturday Mr. Ben gives each of the children one piece of candy while their mothers shop!

One Saturday a woman came into the store to order a Baldwin upright piano! Mr. Ben also has a catalog that contains pictures of fine jewelry. He claims to be the first in town to know who is getting engaged. He never tells anybody who is buying the ring. Mr. Ben can keep a secret.

Some of the young children are at the Pix attending the Saturday movie matinee to see *The Carson City Kid* staring Roy Rogers and Gabby Hayes, along with *The Son of Frankenstein*, a Wonder Woman serial and two cartoons. The noise inside is a composition of the sound projector, a few crying babies, the crunching of popcorn, and the popping of bubble gum. There is a steady stream of footsteps to the water fountain and bathrooms, with a rush return to seats to assure they don't miss much of the movie.

As night falls in Taylorsville, square dances are in progress for the young adults. The teen-age

crowd is in Martin's Café, where the juke box is blaring the sounds of the latest hillbilly tunes. Couples are either dancing in the open space or talking quietly in the brown, initial-scratched booths.

Outside, a few of the men are becoming noisy and boisterous as they gather around the parked cars (Mason jars in hand) in the dry state of Mississippi. The soft sound of the opening and closing of trunk lids can be heard in the darkness.

Twelve o'clock midnight nears. Families begin to gather at their cars, trucks, or buses. Some missing members may need to be bailed out of the tin-roofed jail next to the depot. Tired, irritable, dirty children are trying to sleep in their mother's arms. A blonde stringy-haired girl with tears in her eyes rushes from behind the stores, reluctant to leave her Indian boyfriend.

Vehicles begin to load. The Indians, having hardly spoken a word since their arrival, walk in single file to the yellow buses carrying bags containing brilliant material for next week's costumes.

Car lights flash on in Taylorsville, Mississippi, and disappear down State Highway 31. The little town is quiet once again. Sidewalks are cluttered with candy wrappers, tobacco stains, and a puddle of melted ice cream. As the midnight train rumbles noisily through town, the sound of its whistle dims in the distance. The mournful howl of Herbert Myer's dog is faintly distinguishable across town.

Taylorsville is asleep for another week.

Mr. Ben Duckworth is closing up. As he gets in his dusty brown Chevrolet Business Coupe he's smiling. He had another good day in the store.

Mamma Goes to College

On April 25, 1928 Mamma graduated from Taylorsville High School, and in the fall packed her trunk to enroll at Mississippi State College for Women (MSCW) and depart with her sister Braddis who was a sophomore. Mamma chose to double major in primary education and piano (she was to become an accomplished musician). She registered for courses in visual art where she created some beautiful floral and bird pictures. At MSCW students were required to wear only navy blue and white. At home, she had dresses of every style. She became so sick of wearing navy blue and white she vowed never to wear those colors again. And she never did!

Mamma told me two college stories that I remember. The first was when she and her girlfriend went to the Mississippi State–Ole' Miss Football game. Their dates were from Mississippi State and she had figured out which team to cheer for. She was having an amazing, fabulous experience on a cool fall day. She felt excited to be attending her first football game ever, though she was still just a freshman. At half-time more than one hundred musicians in the Mississippi State band marched out onto the field. The music was electrifying. Afterward the Ole'Mis band came onto the field.

"Well, here comes the Salvation Army," her date scoffed.

Later, driving back to campus, Mamma said, "Wasn't that Salvation Army Band just wonderful?!"

Of course, they all laughed. She remembers being sooooo embarrassed when she didn't get the joke.

Another college story she told me was when she and her girlfriend, Etoille, were invited by their dates to spend a week-end in the mountains. (Where the mountains are in Mississippi, I don't know.) The men had rented two cabins for the overnight trip. Mother and Etoille assumed that the women would stay in one cabin and the men in the other. She said she felt stunned, dumbfounded, ignorant, embarrassed and stupid when she realized that the men assumed they would be staying in the cabins with their dates.

She and her girlfriend stayed in one cabin together, but the week-end was a disappointment for all.

Mamma Plans Her Wedding

When Mamma was a junior at MSCW she fell in love with an exciting, handsome, cigarette smoking, drinking man (unusual for Taylorsville) who had moved from the Mississippi Delta to Taylorsville. His name was Prentiss. She adored him. She said he was fun, drank alcohol, could stay out all night, and brought her flowers on every date. His new fast car was a 1930 2-door tan and black sedan with side mounts for the spare tires. She was the talk of the women's college when Prentiss visited her at her college in Columbus, Mississippi.

Mamma came home for the summer after completing three years at MSCW and announced she wasn't returning to school. Instead she began plans to marry Prentiss.

Granddaddy was furious. He threatened to shoot Prentiss if he came to the house, resulting in Mamma sneaking off to meet him. Grandmother cried and prayed and prayed and prayed that her daughter would be safe and that Mamma would forget about Prentiss.

But Mamma loved Prentiss and refused to return to college to complete her senior year. She was determined to marry. Mamma managed to get her primary teaching certificate and was hired to teach fourth grade in the Taylorsville School System. She made final plans for her wedding.

There's a New Man in Town

THEN (in 1931) Elton B. Whitten, the young twenty-three-year-old brilliant new Superintendent of the Taylorsville Schools arrived from Pickens, Mississippi. He went to the Methodist church every Sunday and even taught a Sunday school class. Mamma used to say that she noticed Daddy, "but not much!" Daddy was not

classically handsome but he had great energy, perseverance and a twinkle in his eye when he was around pretty women!

It has always been the responsibility for principals to observe teachers in their classrooms as part of the evaluation process. Mamma noticed that Elton Whitten seemed to come into her classroom more often than he did the others! She began to enjoy the extra attention she was getting from the Superintendent.

As time passed Daddy and his best friend, who was the coach of the high school athletic teams, would call Mamma and the three of them would go out to a picture show at the Pix.

Once when Daddy called for a movie date Mamma said, "Is Coach Carmichael coming, too?"

"No! What do we need him for?"

A Diamond Ring

One month after Mamma and Daddy began dating, Daddy went to my granddaddy's store and ordered a diamond for mamma. He took the diamond to Ethel the day it arrived and proposed to her. She said "yes!"

The town talk was that Granddaddy was so happy that Mamma was breaking up with Prentiss that he gave Daddy a real good price on that engagement ring. Granny Lou dashed out to order the wedding invitations.

The Taylorsville Signal Newspaper printed the following:

> Thursday, August 18, 1932. The Rev. John Compere married Miss Ethel Duckworth to Mr. Elton B. Whitten at 10:00 in the morning on Thursday, the eighteenth of August, nineteen hundred and thirty-two in Taylorsville, Mississippi.
> At home

Granddaddy was overjoyed.
Granny Lou said, "God sent Elton to Taylorsville."

Mr. and Mrs. B. S. Duckworth

announce the marriage of their daughter

Ethel

to

Mr. Elton B. Whitten

on Thursday, the eighteenth of August

nineteen hundred and thirty-two

Taylorsville, Mississippi

At Home
Taylorsville, Mississippi

The Knock on the Door

My parents' wedding took place in the Duckworth parlor in Taylorsville, Mississippi, with approximately twenty-five guests present. The morning of the wedding there was a knock on the door. A stranger stood on the front porch holding a bouquet of two dozen red roses along with a note.

> *Dearest Ethel,*
>
> *I will always love you. I am sorry I am a man not good enough for you. I pray you and Elton will have a happy life.*
>
> *I love you,*
>
> *Prentiss*

Mamma and Daddy dashed off for a one-week honeymoon on in Gulfport on the gulf coast of Mississippi and then returned to their jobs in the Taylorsville Schools.

Many years later when mother was in her sixties, living in Arlington, Virginia, she got a letter from one of her best Taylorsville girlfriends. Etoille wrote Mamma that Prentiss was dead. He had married; he had divorced; and he "drank himself to death."

The end.

McLain, Mississippi 1935-1940

"It's a Girl!"

Mamma and Daddy lived in Taylorsville for one year in 1933 where Daddy served as the Superintendent of Schools, after which they moved to another school superintendent job in Waynesboro where I was conceived. The following year prompted another move to McLain (for yet another superintendent's job), where I was born and where the three of us lived until I was five-years-old.

Mamma told me that on October 19, 1935, she and Daddy were walking around their yard where they lived in the Teacher's Home with four other teachers (three female and one male). They were extremely grateful and happy that they had survived the crushing economic depression during which, for a few months, Daddy didn't even have a job. The leaves were beginning to turn, their golden hues characteristic of the fall of the year. Still, it was stifling hot.

Daddy was picking pecans from off the ground and placing them in the basket that Mamma was holding. They were delighted that I was soon to be born. Mamma remembers that she was "so pregnant" that she couldn't even bend over to pick up a pecan. As they walked around the yard they talked about how relieved they were that Daddy had a good job that provided them a nice house with a front porch large enough to hold four big rocking chairs. They were looking forward to becoming parents.

Mamma said she told Daddy that something different was happening to her body. With her suitcase already packed, they traveled the thirty miles to the Hattiesburg hospital to begin what was to be the ordeal of birthing their first child. My grandparents arrived from Taylorsville within a few hours and the wait began. Of course, I don't know much about this time, but I was told that "we almost lost Ethel" (my mother) and that my daddy went off alone to cry and pray during the birthing. In those days, no one entered the delivery room except the doctors and nurses. On several occasions a nurse came out to talk to Daddy to report that Mamma was having a difficult time but no specific information was provided.

Finally, Dr. Hunsher came out to tell Daddy that I was a healthy girl weighing over six pounds. I was quickly named Betty Jo, making me the namesake of Mamma's thirteen-year-old brother, Joe Duckworth. My grandparents Duckworth telephoned all close family members to report the news and all agreed that it was totally okay that I was a girl. As the years passed I was certain that I was the favorite grandchild because I was the first-born and also named after Uncle Joe.

Mamma and I remained in the hospital for two weeks before we were allowed to return home. Mamma was also "quite weak" for weeks afterward.

Three years later Mamma told Daddy if he wanted to "try for a boy" she would have another baby. She said he laughed, swept me up into his arms, danced around the house singing, "Just Ethel and me and Betty makes three. We're happy in our blue heaven." I wish I could remember that because Daddy could not sing very well nor did he have any rhythm. I am sure we weren't dancing in time to the music. And I'm sure that he was also remembering that horrible birth experience when I was born and didn't want Mamma to go through that again.

"Ethel and Me, and Betty Makes Three"

Maggie

Mamma was responsible for managing the Teachers' Home located next door to the school. Maggie, our Negro cook and housekeeper, came to help Mamma each day. I remember sitting on the back steps of our house each morning waiting for Maggie to arrive. She walked on a path through the woods to our back door. When I ran out to meet her, she would lift me in the air, laugh and call me "Betty Baby."

"No, Maggie! I'm not Baby! I'm Betty."

"No, you're my baby," and our daily argument would begin as she tickled me to make me laugh. I loved her. And I thought she loved me.

Mamma was an excellent cook. Thus, she preferred to cook for the teachers and let Maggie clean the house, wash and iron clothes, and play with me. Mamma's meals at the Teacher's home were delicious. Every day she insisted we eat on a pressed table cloth with a beautiful fresh flower arrangement in the center of the table. Our supper table was always set appropriately with the silver and other of Mamma's wedding presents. (And she continued to do this throughout her life.)

The Piano Arrives

My memories of McLain are few, but I do remember the day the piano arrived. Mamma knew it was going to be delivered. She found her sheet music, sat in one of the big porch rocking chairs, and waited patiently for the piano truck to arrive. The movers took the upright piano out of its box and placed it in the living room. Mamma walked slowly to the piano and sat down on the dark mahogany bench. Her face changed as she began to play… Strauss waltzes, Czerny, Mozart, Beethoven, Bach, and finally "Five Feet Two, Eyes of Blue," "The World is Waiting for the Sunrise" and, of course, "My Blue Heaven."

That was when I, barefooted, stood on Daddy's shoes and we two danced all over the house. I have never seen my mother any happier than she was on that day. And it was years later when I realized that "my blue heaven" was all about the love Mamma and Daddy had for one another. It wasn't all about me!

Buddy

Mamma loved pets, especially dogs. In McLain (before I was born) my parents had a beautiful collie dog named Buddy. When I was born Buddy seemed to understand that it was his job to watch over me. He would lie beside my crib when I slept. When I began to stir he would find Mamma and gently pull at her skirt. When I was able to walk and go outside to play Buddy would walk beside me always staying between me and any potential danger. And to Buddy, a potential danger might be another dog; one of the school teacher boarders; or any other person who might come into the yard.

I would also hold Buddy's tongue and walk around the yard. Mamma said he never seemed annoyed. If I wanted to hold his tongue, then it was okay with Buddy.

Buddy was poisoned, along with several other dogs in the area. Mamma was heartbroken. I don't remember that event. (Mamma continued to love dogs. The last one we had was Nicky, an Eskimo spitz that comforted her when I went away to college...and later when I married.)

I loved animals, too. But there were times I didn't really know how to care for them. I was a good climber and could shimmy up trees. On some days I might take my little ladder and prop it against the trees to reach the lowest limbs. I loved to be in the tops of trees where I thought I was invisible to my parents and I could look out over my part of the world.

Betty Jo

She looks worried because they say she looks just like her Daddy.
She thinks that means she looks like a boy.

The Robin's Nest

One day when I was high in the tree I found a robin's nest with three little just-hatched birds … mouths wide open. I ran into the house to get something to feed them. I found three raisins and ran back to the baby birds where I dropped a raisin in each little mouth. The mother bird was swarming toward me. I shimmied down the tree. When I went to check on them the next day I was shocked to see all three birds were dead. I felt so sad. I never told anyone about that, until now.

Dorsey Duck

When I was four-years-old I got an adorable little duck for Easter. I named him Dorsey (after the band leader, Tommy Dorsey). I would run around the yard and Dorsey would follow me. Our collie dog, Buddy would bark and actually run along with me. As I think if it today, I can't believe Buddy didn't try to kill that duck, but he didn't. One day, for some reason, there was a pan of kerosene on the back porch. I discovered our sweet Dorsey dead, floating in the kerosene. Daddy and I dug a little grave for Dorsey. I decorated it with moss and some twigs and flowers. The next day I went to check on the little grave. All evidence of it had disappeared. Perhaps that was just asking too much of Buddy.

I'll Just Run Away From Home

Mamma was the disciplinarian. Once, when I misbehaved (probably speaking impudently to her) she became angry with me. She got a switch off the crepe myrtle tree and switched my legs. (This would be called corporal punishment today!) I got angry and announced to her that I was going to run away from home.

I left in a huff and Buddy accompanied me as I marched off into the woods adjacent to our house. I sat on the log of a fallen tree to wait for Mamma to start to feel sorry for me and come to get me. As I was sitting in the silent woods, a snake slithered over

the log. I screamed; Buddy barked. I ran home as fast as I could run. I didn't tell Mamma what had happened because I was still mad at her.

Staying Slim

Mamma was beautiful and always wanted to be slim. She and I did exercises every day before Daddy came home. I didn't grow as tall as Mamma (five feet two inches for me; five feet five inches for Mamma). I definitely went through a chubby period.

Once I heard Grandmother Duckworth say, "Oh, she's so short; she's going to be like Papa's sisters, Aunt Madison and Aunt Ida."

My heart skipped a beat! Those two aunts were fat, wore little flowered pastel cotton dresses, with ugly black lace-up shoes and dark thick stockings. Even today I continue to try *not* to look like those aunts.

What's the "Depression?"

Although history reports there was a depression throughout the United States and especially in the south, I never felt any of that. Mamma was an excellent seamstress, always wearing beautiful stylish clothes. Our old photos indicate that she made pretty dresses for me, too.

We were able to take summer trips to the Gulf Coast with our Duckworth relatives … aunts (Braddis, Josephine) … uncles (Hubert and Craig) … cousins (Charlotte, Marion and Ben).

Daddy always had books. After my evening bath I would run to the front porch where he would be sitting in a big rocking chair waiting for me. He read to me every night.

I never did feel any effects of the depression.

Gulf Coast, Mississippi

Union, Mississippi 1940-1943

Moving Again

In 1940 Daddy had an opportunity to move to a larger school system in Union, Mississippi, where he would again be earning more money. Mother was pleased to be moving from the boarding house and relieved of the responsibility of preparing three meals a day for the four teachers who lived with us. She was also pleased not to have a maid. Mamma wanted us to have our own house. She liked cooking for just the three of us and even felt joy and accomplishment when she cleaned the house, and washed and ironed our clothes.

In Union we lived in the house designated for the Superintendent of Schools, and Mamma loved that house. She spent her time making curtains, reupholstering our old couch to make it look new, and designing and sewing my new school clothes. We even had a guest room for relatives and friends who visited us from Taylorsville, Jackson, and Memphis.

There were neighborhood children to play with after school and during the summers. It happened that most of them were boys. One of our favorite pastimes was climbing a tree that was just outside of Mamma's kitchen window. She could keep an eye on us and would occasionally intervene when she thought we needed some guidance.

The story that follows demonstrates Mamma's attitude toward my being feminine. She worried about me when I played "boy" games and had "boy" plans for my life.

ETHEL, LEAVE HER ALONE!

When did it happen?

How did it happen?

Why did it happen?

Who, today, could possibly understand that in my generation it was accepted as normal that girls were not equal to boys? I was born in the mid-1930's when women were supposed to be feminine. "Lady like" was the phrase used in my family.

"Betty Jo, that is not ladylike!"

From my first days of walking on this earth, I am told, I loved going outside to run, to climb, to ride. And there were more boys to play with than girls. We had races (foot, bike, and tree climbing) and I was competitive … not always winning, but enjoying the race. When I was five years old, just outside our kitchen window, a tall oak tree grew in our backyard. The tree was perfect for climbing with a few low branches that provided access to higher branches that, in turn, provided a view of the rooftops of nearby houses. I and the neighborhood boys would shimmy up the tree and pretend to be kings, airplane pilots, forest rangers, or, on this day, Tarzan.

Ray Mizell, who was tough, strong, and imaginative, showed up with a rope to tie on a high limb. He tested the rope by swinging away from the tree trunk, giving the Tarzan yell, and dropping about three feet to the ground. I took my turn and the rush was glorious!

When I got in line again for my turn, Ray told me I couldn't do "the yell" because I had to be Jane.

"No," I said. "I will be Tarzan."

"Ethel, Leave her Alone!"

"Then if you're gonna be Tarzan, you will have to take your shirt off."

So I took my shirt off, got in line, climbed the tree, grabbed the rope, pushed off into the air, and gave the loudest, most exuberant Tarzan yell of all.

Mamma looked out the kitchen window. She gasped – not because she feared I would be hurt (a distinct possibility) but because I had removed my shirt. She called me inside and told me that girls could never play with their shirts off ... and if that was a requirement for being Tarzan, I would just have to be content to be Jane. My lips trembled. My eyes watered. But I didn't cry.

When she told Daddy about it that evening, he said, **"Ethel, leave her alone!"**

That was the first time in my life I realized that some male privileges might not be available to girls. And for the next 70 years I have done what I could do to assure that girls who want to use the Tarzan yell can use it. *And they don't have to remove their shirts.*

Right? Left? Which?

A first grade skill is to know your right from your left.
"Raise your right hand!"
"Raise your left hand!"
"Raise your right hand!"

I just couldn't tell the difference. Finally Mamma got me a red plastic ring from the Cracker Jacks box. She put the red ring on my right hand.

"Remember, Betty Jo. Red on the right. When the teacher says right, just look at your red ring and you will know which hand (or) foot to use!"

She assumed that within a week or two I would know the difference and remove the plastic ring.

That was not to be. Years passed and I never could tell the difference. Finally, when I asked Mamma if I could have a better ring to wear, she and Daddy gave me a ruby ring for my birthday.

I never did learn the difference and continue to wear my ruby as an adult.

(*I later learned that less than 10% of the population don't automatically know this directional difference. But thank goodness I do know* front *and* back *and* up *and* down.)

The Pressure Cooker

World War II had begun. Daddy, wanting to be patriotic, decided we would plant a Victory Garden to grow our own food so we could do our part to send food to the troops preparing for war. We planted rows of butter beans, beets, potatoes, okra, corn and tomatoes. That year Mamma got a pressure cooker for her part in the War Effort … and we did enjoy eating her canned quarts of veggies during the winter.

One day Mamma was planning to can some tomatoes. She boiled the tomatoes, slid the skins off, put them in Mason jars and into the pressure cooker. The jars would sit in boiling water for the *allotted time.* After the jars cooled she placed them on our upper kitchen cabinets that had been freshly painted a pretty powder blue.

One Sunday night we were in the living room listening to Jack Benny on the radio and looking at magazines when we heard a loud, shattering explosion. We dashed into the kitchen to see tomatoes and shards of glass on the kitchen floor, sink, walls, ceiling, chairs, table, salt and pepper shakers, dish soap, Tide Box, newspaper, coffee cups, and hutch which held some special pieces of silver and china.

That night, my parents and I used every single one of our towels to clean up the mess. Then we had to hand-wash the

towels and hang them on the clothes line in the back yard. We worked late into the night.

Yes, it took days to clean. We thought we had finished getting all of those tomatoes out of the kitchen.

Daddy said, "Someday we will laugh about this."

But we never did.

We moved to another town two years later. When we were cleaning our house to prepare for the arrival of the next superintendent's family we were still cleaning up some of Mamma's tomatoes.

Mamma said even with all that mess to clean, she was always proud to be a "housewife, mother, and loyal American." And she was!

The Victory Bike

Continuing his effort to be patriotic, Daddy bought me my first bicycle, a "victory bike." The victory bike experience turned out better than the canned tomatoes. Those bikes had skinny tires (to save rubber needed for jeep tires in the Army) and there was very little metal on the bike (which was to save for Army tanks and planes). I didn't like the looks of that bike at all, but I didn't say anything negative when Daddy brought it home. I actually asked Mamma if we could take it back without hurting Daddy's feelings.

She shook her head when she said, "No."

As weeks passed I began to love that bike because it turned out that it was faster than any others in the neighborhood. I won every single bike race. I could actually beat all of the boys. I never did mention this to anybody but I did have the thought that because of the war, I got to be the winner of all of the bike races. I know I should have been ashamed of that thought ... but I wasn't.

Piano Lessons

Mamma was an accomplished pianist, having majored in piano at MSCW. She enjoyed playing for others and it was assumed that I, too, would have her talent. I loved music … especially singing and dancing and assumed it would be easy to learn to play.

In the beginning Mamma was my teacher. I loved getting the music books but I didn't like for my mother to be my teacher. The fact was, also, that Mamma didn't like having me for her pupil. I didn't like the exercises that were required in John Thomson's *Teaching Little Fingers to Play*. I hated to practice. Mamma became exasperated. She would raise her voice (not exactly shouting!) and I would whine and cry.

We decided that I needed another teacher, so she called Miss Mitchell who agreed to teach me. My new teacher was just a bike ride away from the house, and I enjoyed the independence of putting the music in my satchel (bought for the occasion) and going somewhere alone.

But I still didn't practice. And I didn't particularly like Miss Mitchell either. The piano situation was just not working out.

Jenny Lind

Mamma purchased and hung a large portrait of the nineteenth century opera singer, Jenny Lind, over the piano to inspire me. When she was a piano major in college Mamma had studied Miss Lind and she bought that picture at the "good" furniture store in Jackson. Jenny Lind seemed to be looking at me no matter where I went in the room. I thought she was ugly. (I continue to think she was somewhat unattractive). I would speak impudently to mother about Miss Mitchell, or Jenny Lind, or the silly little "baby songs" I was playing. I might even stop practicing before my thirty minute practice time was up. When that happened I would hear mother outside snapping a switch off the

crepe myrtle tree and she might come in the house and lightly switch my legs as they dangled off the stool. Then she would put the switch behind the portrait of Jenny Lind and I could see some of those crepe myrtle twigs sticking out.

I would cry.

Piano Recitals

My most terrifying times, however, were when I had to play in the fall and spring piano recitals in the school auditorium. Mamma always designed and made me a long dress to wear; one of white embroidered organdy; one of red velveteen; several of taffeta (one blue one, and another pink one with a white ruffle around the shoulders). I was always wearing the prettiest dress of any of the performers.

I was also the worst player. Once, when I got half-way through my recital piece, I stopped in the middle. I started over and stopped again in the same place. For the third time, I started and stopped. Finally, I stood up, smiled, curtsied to members of the audience, and walked off the stage. The crowd applauded, of course. When I got into the wings, I cried.

After that happened I was told *never* to stop playing…no matter what… just keep playing, even if it is wrong. So at the next recital I was determined not to stop. When I played *Chinese Lanterns* I started one piano key below the correct one. I knew what I had done and I could have started over and placed my fingers on the correct beginning keys. But I had heard so many times, "Do not stop." "Do not stop." "Always keep going."

So I kept going. I played the entire song one note lower than written. It was, indeed, the strangest muddle of sounds anyone could have ever imagined.

My performance complete, once again I (wearing the most beautiful dress) curtsied to the audience. Grinning happily I exited the stage.

I didn't stop. And I was proud of that.

It is hard to imagine how my parents weathered my piano playing. I continued taking piano until the end of my junior year in high school. My parents found teachers for me that didn't require a recital. I actually became an accomplished classical pianist. But no one ever knew it because of my terror of playing in public.

Often when I practiced and when I was playing well, Daddy would come into the living room to read the paper. When I heard him put the paper down (a sign he was listening) I was paralyzed with fear. My fingers would not move and discords were rampant.

I did, however, love singing and Mamma and I liked to sing together. She taught me to harmonize. Every night while we washed the dishes we would sing "Now the day is over, Night is drawing nigh" or "Tell me why the ocean's blue" and the dishes would be done in a flash.

An Anatomy Lesson

Every afternoon Mamma and I lay down for a short rest so she wouldn't be tired when Daddy came home. That is when we talked about *everything*. We would hold our legs up in the air, point our toes and look at them.

"Are our legs fat?" I was pretty sure they were.

"No, our legs are curvy. We have dancer's legs."

I smiled appreciatively at our legs.

"Am I beautiful?"

I knew I wasn't as pretty as Mamma was … and she knew it, too. We decided that I wasn't really beautiful, like Hedy Lamar or Veronica Lake. Instead, we agreed that I was amazingly cute, hysterically funny, and a wonderful dancer. I was more like Debbie Reynolds or June Allison. And that satisfied me.

We also talked about sex. I had never seen a grown-up penis. She tried to draw one for me and I began to laugh, and laugh, and laugh. I just couldn't believe that Daddy had something attached to him that looked like that. Then I started calling out the names of men we knew…

"Does Mr. McCarron in Daddy's office have one? What about Mr. Smith, the man next door. Even Mr. McPharland, our Methodist preacher?"

I would squeal as I called out each name. I just couldn't believe it. I asked Mamma if she could show me the actual size. She picked up the handle of her hair brush, held it up in the air, and I just fell across the bed with embarrassment and put my head in the pillow. I was approaching hysteria as I laughed and wondered how *it* all really worked. And Mamma was laughing, too!

My education continued. Mamma had a best friend who had a seven-year-old daughter named Florence, who was my age. Our mothers would take us along with them when they shopped or just visited one another. They also went to the same beauty shop at the same time. Florence and I would play in the back yard of the beauty shop while our mothers sat under the dryer and couldn't see what we were doing.

In the yard next door to the beauty shop lived a five-year-old boy. We would give him candy if he would pull his pants down. He took the candy, pulled his pants down, and ran around the yard to make us laugh. And we would laugh, and laugh, and laugh. I had never seen a boy naked before and I was amazed at what I saw. Florence and I always looked forward to going to the beauty shop with our mothers. And we always made sure we took plenty of candy with us! And I never told anybody about this until now!

I was in Union, Mississippi, entering the second grade in school and I had heard that I was to have a teacher named Miss Gibson. She had the reputation of being a mean, hard teacher. But I was never concerned about stories like that because I always loved going to school and couldn't imagine not liking my teacher.

But something did happen in school that made me hate my teacher because... I was an only child.

Only Child

ONLY CHILD

Laura Berk is one of the most respected Child Development professionals in our country. Her research on only children indicates that they are not spoiled but are advantaged in many respects; they have close friends; they do better in school and attain the highest levels of education.

And now the story...

Betty Jo is seven years old living next door to her grammar school in Union, Mississippi. She is an obedient, happy youngster who enjoys making others smile and laugh. She memorizes funny poems, makes up limericks, plays a few tunes on the piano and she always sings loudly. She loves going to school.

This year Betty Jo is entering the third grade. For the first day of school her mother made her a new blue dress that exactly matched her eyes. She is a good skipper; and today she is skipping to school. She skips down the sidewalk, into the hallway ("Don't skip in school!") and walks rapidly into room 21 to meet Miss Gibson, her teacher. Betty Jo has heard that Miss Gibson is a "hard" teacher who gives lots of homework; and she does not give extra credit for "trying hard"

But Betty Jo isn't worried about any of that. She's looking forward to receiving her new workbooks and hardback books. Her Crayola Crayons are new and her yellow number 2 pencils are sharp and placed in her new book satchel.

The bell rings. School begins. Miss Gibson calls the roll, assigns seats to everyone, and distributes some of the books they will use during the year. Betty Jo thinks the new geography books are beautiful and they smell delicious! The new arithmetic book, of course, is a necessity. Her assigned seat is next to her best friend, Nancy McNeely. This will be a wonderful year.

Then! Something dreadful happens. Miss Gibson asks each child to tell something about him or herself including whether there are brothers or sisters at home. Betty Jo reports that she has two cats, can play some tunes on the piano, and lives next door to the school.

When all of the children have reported, Miss Gibson asks all of the children without brothers and sisters to stand up. Betty Jo and Hubert Livingston stand up.

Then Miss Gibson says, "Children, I want you to take a good look at Betty Jo and Hubert. They don't have any brothers or sisters. We call them 'only children' and we must be very careful when we are with them. Only children are spoiled, selfish, and mean and they will cheat on the playground. Keep your own things close to your desk, because Betty Jo and Hubert think they can have everything that they want and they will steal your things."

Now Betty Jo never cries in public. No matter what happens to her she never cries until she gets home. But on this day she notices that her chin is trembling and one tear is beginning to form in her right eye. No matter how hard she tries, the tear begins to roll down her cheek. She and Hubert sit down. She has never been so confused or shocked. Her mother and daddy had never told her it was bad to be an only child.

The hours pass slowly throughout the day. She can't think clearly. It's hard to pay attention. When she goes out for recess she sits alone on a bench and watches the other children run around. Finally, school is out. Betty Jo runs home as fast as she can.

When she bursts through the front door she begins to sob. She cries so loudly that her mother becomes alarmed and rushes to her side. For a few minutes Betty Jo is actually retching as she tries to catch her breath. She tells her mother what Miss Gibson told the other children. Her mother holds

her, comforts her and says, "Yes, you will have to go back to school tomorrow."

That night when Betty Jo and her mother and daddy ate supper, they told her that Miss Gibson was rude, cruel, misinformed. They told their daughter that she was neither selfish nor mean. They gave her examples of when she had been kind and when she had shared with others. They named all of the friends that she had and reminded her that her grandmother thought she was the sweetest and smartest girl that had ever been born.

Soon Betty Jo and her parents began to laugh as they tried to imagine what kind of little girl Miss Gibson must have been. Then they began to make up funny stories about her, and they laughed so hard that they almost fell off their kitchen chairs.

Before Betty Jo went to school the next morning she and her daddy had a serious talk. He told her that when people try to hurt others it is usually because they aren't happy themselves. Miss Gibson may have had an unhappy childhood, or perhaps something happened yesterday that might have made her sad. She and her daddy agreed that when Miss Gibson was rude and cruel, Betty Jo would try to feel sorry for her rather than hate her.

He hugged her, smiled, and sent her off to school.

And that is how the year progressed.

About once a month Hubert Livingston and Betty Jo would stand up and Miss Gibson would warn the others. Once a month Betty Jo would come home and just beg her mother to have a baby.

"I am not going to have a baby so you will not have to stand up in Miss Gibson's room."

And she didn't.

One day, when Miss Gibson asked all of the only children to stand, the only one standing was Betty Jo. She glared at Hubert who was sitting at his desk and sneering at her.

"My mother had a baby last night."

And in that second Hubert was no longer spoiled and selfish. Betty Jo was the only one.

That afternoon Betty Jo went home and begged, and begged, and begged her mother to have a baby.

I am not going to have a baby because Hubert Livingston's mother had a baby. So you will just stand alone for the remainder of the year."

And that's how it went.

The next year Betty Jo and her parents moved to Jackson, Mississippi, and into a new house because her daddy had a new job. Her mother was happily decorating the house, sewing new curtains, reupholstering furniture and making new clothes for Betty Jo to wear to her new school.

School started the day after Labor Day… a hot day in Jackson. Betty Jo went to school with her mother the first day because this school wasn't within walking distance of their home. They checked in at the principal's office who seemed to be a very nice man. He walked them to the fourth grade classroom to meet Miss O'Cain who was pretty, seemed friendly, and had a nice smile. They said good-bye to Betty Jo's mother. Betty Jo was assigned a brand new desk in which she thoughtfully arranged her school supplies. The day was going well.

During the day Miss O'Cain called each student to her desk for a quiet conversation. She said she just wanted to get to know them a little better. She

said she would ask them a few questions about their families and what they liked and disliked about school. Soon it was Betty Jo's turn to approach the teacher's desk.

The teacher asked her what her favorite school subjects were; what kinds of books she liked to read; what were her favorite things to play on the playground; where she lived; whether she had a bicycle.

And then the question …"Do you have any brothers or sisters?"

Betty Jo knew what was coming next. She was going to have none of that! She knew that question was a trap!

So Betty Jo told the teacher, "I have one brother but he doesn't live with us. He lives in an institution." (She didn't really know what institutions were but she had heard of them and she saw one once when they were in the car going to Beaumont. She could see some children out playing and her parents told her they lived in that institution because they did not have parents who could take care of them).

And then the interview with Miss O'Cain was over and Betty Jo went back to her seat.

The school year was going smoothly. Of course, Miss O'Cain didn't ask the only children to stand up, but Betty Jo knew she was safe if that ever happened. The year passed peacefully with no embarrassing "only child" moments for Betty Jo or for any of the other children.

Six months later …

Betty Jo's mother, Ethel, loved living in Jackson. She had good friends, loved her new church, and enjoyed playing bridge and entertaining her neighbors. One day her mother

was sitting at home with her new best friend, Mrs. Lottie Mayfield.

Lottie gently took Ethel's hand. "Ethel, please tell me about your poor son who lives in Beaumont. Do you ever see him? What's his name? It might help you to talk about him."

Ethel was stunned. "Thank you, Lottie, for your concern, but I do not have a son living in Beaumont."

When Ethel got home that night she told Betty Jo and her daddy about that conversation. Betty Jo was scared because she knew that lying was wrong, no matter what. She expected her parents to be angry and that she was about to be punished. She started to cry and told her parents she was never going to stand up in a classroom again and listen to a teacher say that she was a spoiled, selfish, mean cheater.

But the next day all she had to do was to tell Miss O'Cain that she didn't have any brothers and sisters.

And as far as Betty Jo knew, neither her parents, nor Miss O'Cain ever mentioned it again.

Jackson, Mississippi 1944-1947

Our Very Own House

Mamma flourished in Jackson. She was delighted to live in the first house that she and Daddy had ever owned ... a little white house on Northside Drive. I had my own room with windows on three sides. Mamma and Daddy had the biggest bedroom and there was a guest room. We did, indeed, use that guest room because Mamma enjoyed having company. Uncle Craig, Aunt Braddis, and Charlotte came often because we lived in the "big city" and there was a lot to do. The shopping at the Emporium and Kennington's alone was worth the trip for out-of-towners. Every time we drove in our driveway Mamma would say with affection, "Oh, we are safely home to our sweet little white house."

And Daddy would smile at her.

Mamma loved living in the city. Jackson possessed beautiful downtown department stores for shopping. We attended a large, vibrant Methodist church where Mamma taught Sunday school, sang in the choir and belonged to a women's church circle. In addition, she served as President of her Federated Music Club and joined the American Auxiliary for University Women (AAUW). We visited art galleries and went to concerts. But perhaps most important, Mamma was invited to join several bridge clubs. She hadn't played bridge since her college days, but she caught on fast and became an expert.

The Movies

Mamma and I went to one picture show each week. I would look at my school schedule, arrange to do my homework and study for tests. Then we would pick the time and place for the movie. We loved Claudette Colbert, Jimmy Stewart, June Allyson, Judy Garland, Mickey Rooney, Walter Pigeon, Hedy Lamar, Betty Davis, Van Johnson, Bing Crosby, Bob Hope, Cornell Wilde, Charles Boyer, Edgar G. Robinson, Debbie Reynolds, Barbara Stanwick and on and on.

It helped Mamma, too, that I was becoming more independent. I could use the city bus system to attend my dance classes; my piano teacher was just a bike ride away; my dramatics teacher lived four doors from our house.

Mental Illness

In Jackson, something happened, that enabled me to begin to understand mental illness. Mother had a best friend, Mary McIlveen, whom she met at her music club. They had a great deal in common; including the fact that Mrs. McIlveen's husband was a good friend of Daddy's. Suddenly her friend went away without a word to anybody that we knew. She wasn't at home and none of her family members would talk to us. We were puzzled until we heard it whispered that she had gone to Whitfield, the institution for mentally ill patients. She received shock treatments. No one spoke about her illness.

At that time, to have a mental illness was considered a disgrace. Mrs. McElveen didn't come home again for about a year. When she returned to Jackson, she and Mamma resumed their friendship and once again enjoyed being together. Mrs. McElveen told Mamma about her experience in the institution, including shock treatments, which must have been horrid. Several months later Mrs. McElveen disappeared once more and mother never saw her again.

Throughout my professional life, I have thought of Mrs. McElveen when I've worked with youngsters or adults who had communication disorders along with mental illness.

Uncle Joe

Soon after we moved something horrible happened to mother and to our family. Her dynamic, handsome, brilliant twenty-two year old brother, Joe, was diagnosed with colon cancer. After a long and painful death, he died at Grandmother's house. I believe Mamma never got over the feeling that at any time Daddy or I could get sick and die "before our time". From that day on she seemed to have a layer of fear that changed the way she looked at life.

The following narrative is intended to give the perspective of death that occurred in a ten-year-old girl. I was that girl and I believe it also forever changed my life.

Joseph Preston Duckworth
January 26, 1922 –
April 23, 1945

159

WHAT'S IN A NAME?

In many families it is common to name a child after another family member. In my family I was named Betty Jo, the namesake of my mother's youngest brother, Uncle Joe. This concept of namesake can get complicated, even worrisome. This narrative serves as an example.

As the story goes, Granddaddy Ben liked the name Joe, a name used throughout the Duckworth family since the 1600's. When he was a young boy Granddaddy had a brother named Joe. When Joe was fifteen years old he died.

When my grandparents, Lou and Ben Duckworth, married they agreed that they wanted to have a large family, probably five or six children. In 1904 soon after their marriage Granny Lou became pregnant and she agreed to name her firstborn son Joe. The first baby boy named Joe was still-born; her second pregnancy produced another boy also named Joe, who died about one month after his birth. Thus, their first two children were sons, both had been named Joe and both had died.

Following their deaths grandmother had two daughters (My Aunt Braddis, and my mother Ethel) and finally, in 1913, another son. Granddaddy Ben begged to name this baby Joe, but she refused and named him Hubert. Granny Lou felt that the name Joe was cursed and that bad luck would come to any family member with that name.

"No, his name is Hubert and that's that!"

Granddaddy was disappointed but reluctantly agreed to name his baby son Hubert Benjamin Duckworth.

Ten years passed and in 1921, amazingly (she said), Granny Lou was pregnant again. In January 1922 she had a boy. The entire family was overjoyed and Granddaddy Ben said, "This time, this baby will be named Joe. And the infant son was named Joseph Preston Duckworth ... my Uncle Joe.

Everyone loved Joe. Mamma and Braddis (ages ten and thirteen) adored him. The sisters cared for him. They took him walking in his little stroller, pulled him in his little red wagon, and rocked him to sleep. It was reported that Joe never cried because Mamma and Aunt Braddis fulfilled his every desire. They called him "Joe Boy." I am certain no one would have disagreed that he was the most loved in all of the family.

Uncle Joe was twelve years old when I was born. And Mamma and Daddy agreed the perfect name for me would be Betty Jo, thus Uncle Joe had a namesake! And that was me!

I loved my name and believed that my grandparents loved me more than the other grandchildren because I carried Joe's name. And I knew Uncle Joe loved me the most because he would call me Betty *Jo* ... with the stress on Jo!

I remember him, too. When I was young he taught me to whistle. He loved to play baseball and I remember him coming into the house carrying his baseball bat on his shoulder and his baseball glove slipped over his bat. His Collie dog, Mike, followed him wherever he went.

I was told that when I was a baby Uncle Joe carried me around the house. And I can remember

when he would come through the house and teasingly mess up my hair. I would squeal and chase him through the house. Granny Lou would say, "Joe, leave that child alone!"

But she was laughing, too.

When Uncle Joe was twenty-one he married his only love, Mary Allin Eaton, who was the prettiest, sweetest young woman in the whole town of Taylorsville. Soon after they married and just before he was drafted to serve in World War II, Aunt Mary Allin announced she was pregnant.

Uncle Joe left for "the war" in 1943. Our entire family was distressed when we heard Uncle Joe was being deployed to some place in France. The war was reported to be nearing an end and we were hopeful that by the time he arrived in France the War would be over.

On the day he was to be shipped out, we got a call from Granddaddy Ben Duckworth. Uncle Joe didn't pass the last physical required to get on the ship. We all felt that was a good thing, never for a minute imagining he had anything as serious as intestinal cancer.

My Uncle Joe was given an honorable discharge from the Army and returned to his home in 1944. At that time, there was no treatment for cancer other than surgery and prayer and hope.

Uncle Joe came home to Granny Lou's house where he lived until he died. His dog, Mike, greeted him with his wagging tail as he was moved from the ambulance to his bed in the front guest room. Granny Lou and Joe's wife would nurse Joe during the week. On the week-ends my mother and I left our home in Jackson and went to Taylorsville so that my mother could help nurse Uncle Joe to give Grandmother a rest.

Every day his wife, Mary Allin (whose home was five blocks away) came to Grandmother's house to be with Joe, leaving her infant daughter, Mary Barron, in her own home to be cared for by her aunt, Tia. Although the nursing shifts changed, Joe's collie dog remained at the side of his bed.

Uncle Joe had a colostomy; he lost weight. Every four hours Thelma, the town nurse, would come to the house to administer morphine. I could hear Granddaddy's car leave in the dark of the night to retrieve the nurse. Uncle Joe was moaning with pain; Mamma and Granny Lou were crying. The nurse would arrive and give Uncle Joe a shot of morphine. Then Granddaddy's car would leave the house to take Thelma home. The house would be quiet for three or four hours. You could always hear the dog walk to and from the front door with Thelma, return to Joe's room, and once again take his place beside the bed.

My own parents had just moved to Jackson, Mississippi where I was in the fourth grade. I was never at my new home on week-ends, didn't make good grades, and didn't have any good friends. I often cried at night. My mother was grieving; my Daddy was trying to get accustomed to his new job. My Granny Lou was no longer funny or fun. And my Uncle Joe got sicker and sicker. The days passed slowly.

Joe died when we were at Granny Lou's house. Aunt Mary Allin ran from her house to Granny Lou's and arrived before the hearse. She was moaning as if she were in some mystical physical pain. I was standing with mother watching as the long black car came to take Uncle Joe's body away. Mamma held my hand as we walked to the hearse. We were silent as we watched it drive away with

Uncle Joe. Mike howled the longest howl I have ever heard from a dog. Then Mike returned to Joe's room to wait … for his return?

The whole thing was monstrous, too much to bear, impossible to understand. I went out on the back steps to sit with Mike. The house grew quiet; the chickens were purring and scratching in the dirt; every few minutes the rooster crowed.

In about an hour Aunt Mary Allin came out on the back porch with one of those Coca Colas in a little green bottle. The sunlight rested on the bottle and I remember that it seemed to twinkle like a green diamond. I didn't know what to say to her.

She said, "I will never love anybody again. There will never be another Joe Duckworth."

I remember that I tried hard to think of the right thing to say. All I could think of was how lucky I would be if I were one of those chickens and never have to feel this way again in my whole life. I didn't speak.

The next morning there was an open coffin in the parlor in Granny Lou's house. People took turns sitting in the parlor with Uncle Joe all day and throughout the night. I was horrified when the men sitting on the porch would sip from their Mason jars and quietly tell stories. Occasionally their laughter would permeate the house. How could they laugh when we were all so sad?

During the night I got up to go to the bathroom and passed by the coffin. A bubble of phlegm was coming out of Uncle Joe's nose. Was he breathing? I ran to Mamma.

"I think he's being raised from the dead. Hurry, Mamma."

She went into the parlor where she found a tissue and tenderly wiped Uncle Joe's nose. She sobbed.

The next day it was time for the funeral. The coffin was closed and Uncle Joe left his home for the last time.

The hearse took Uncle Joe to the First Baptist Church in Taylorsville where it was opened once again for all of the townspeople to file by the casket one last time. The church was filled, as is often the case when people die young. Audible sobs from men and women could be heard.

The coffin, closed for the last time, was carried out to the hearse that drove slowly to Fellowship Cemetery. Cars lined up to be escorted by a few policemen on their motorcycles assuring our safe arrival at the cemetery.

We gathered together again; this time near the open grave. There were more prayers. I could hear a squeaky sound as the coffin was lowered into the ground. It was late in the afternoon; the sun was setting; people returned to their cars motors revved up. And it was done.

The following day our family returned to the cemetery. The grave had been covered with flowers. Patches of loose sand and dirt were visible. Mary Barron, Uncle Joe's beautiful, blond little two-year-old daughter leaned over and patted the dirt.

"Daddy Joe is gone gone. Daddy Joe has gone to heaven."

I will never forget the sight and sound of my granddaddy sobbing, moaning, and almost screaming with agony.

Now you would think that would be the end of this story. But it continues. My grandmother

named three children Joe. All three died untimely deaths. And Mamma feared that I, Betty Jo, might also die early. One night I heard Mamma and Daddy arguing after they supposed I was asleep.

Mamma was crying and almost shouting. Daddy, who rarely raised his voice at anything (unless the dog got on the couch!) said, "We are not going to change her name. We will not change her name from Betty Jo to Betty Lou. The name has nothing to do with the death of your three brothers"

"Why would it matter? Betty Lou is a perfectly good name. I can't call her Betty Jo anymore."

My ten-year-old brain felt fear. Would I die early? Was I cursed? Was Mamma right?" Was Daddy wrong? What would they decide?

Nothing else, to my knowledge, was said about it. As time passed, I began to accept and love the name Jo.

<p style="text-align:center">* * *</p>

In 1977, when I was almost forty years old, I applied to graduate school as a candidate for the Ph.D. I decided that Jo would be a better name for a serious professional than Betty Jo. So I applied and was accepted as Jo Whitten May.

And that is my name today. And it is too late for the curse to have affected me!

I am a mother!

I am a grandmother!

The curse of the name Joe has finally left our family.

Mamma Returns to the Classroom

The second year we lived in Jackson a teacher in a near-by school had unexpectedly resigned. Mamma was certified in Mississippi to teach in the primary grades and agreed to teach the remainder of the year in a fourth grade class. Mother said the one condition for her teaching was that the principal dismiss her from school in time to be home when I got home from fifth grade at Duling Grammar School.

The principal, Mrs. Von Duer, was overbearing and cruel to Mamma. She berated the University Mamma had attended and called Mamma dumb because she didn't understand the school's report card procedures. Mrs. Von Duer would surprise mother by requiring her to stay after school for extra duties. This resulted in my coming home to an empty house alone after my own school had dismissed.

Mother was depressed. Daddy told her to go to school and resign. Mrs. Von Duer told Mamma she couldn't resign until the end of school year. Mamma, without saying a word, went into her classroom, picked up the materials that were hers, and came home. She never used that primary education certificate again.

And the two of us resumed our usual after school activity, when we would always drink a cup of Russian tea, eat one cookie, and talk about our day.

Birthday Halloween Parties

My birthday is October 20. Each year Mamma had a birthday party for me with a Halloween theme. She might dress up like a gypsy to tell our fortunes; or she would make cardboard black bats and hang them along the porch with our names on them predicting something scary would happen to us.

Cookies were served in shapes of cats, pumpkins, spiders, and witches. Perhaps she would hide Halloween treasures around the yard (similar to an Easter egg hunt) and the guest who found the most would receive a special prize. Mamma always had a smoking

(dry ice) black punch bowl with a stick to stir it. The punch might have something edible in it that looked like a little bug, or worm or snake. There was always lots of squealing and fun at my parties. One September, Mrs. Bradshaw, my friend Connie's mother, called Mamma to find out the date of my October Birthday party. Her family was planning a trip and wanted to be sure that her daughter would not miss our party!

Saturday Afternoon Movies

We had a movie theatre within biking distance. Finally the polio epidemic of 1947 had ended and my cousins, friends and I were allowed to bike to the movies. Every Saturday afternoon we saw the cowboy double feature, two cartoons, and a couple of serials. We were fans of Roy Rogers and Dale Evans, Gene Autry, Sunset Carson, Gabby Hayes, John Wayne, Johnny Mac Brown, Batman and Robin, the Cisco Kid and Wonder Woman. After the movie we went next door to the drugstore to sit in the booths to drink our cherry phosphates. It didn't occur to me until years (many years) later that when I went off to four hours of movies was when Mamma and Daddy were enjoying their "alone" time together.

Seventh Grade Gym Class

We were still in Jackson when I registered for the seventh grade at Bailey Junior High School. That was the first time I had changed classes and had my own hall locker to hold my books or other personal items. I had a combination lock and was required to remember a sequence of numbers to get to my assignments and gym suit. Everyone had to take "gym" and the girls were required to wear a purple gym suit that was all in one piece, romper style. We had to hurry to change clothes in the locker room so as to get to the playground on time.

During the first weeks I couldn't work my combination lock quickly enough. I wondered how others could open theirs open so

quickly while I was struggling with "go around and pass six again and stop at four…" I finally figured out I was the only one who actually locked my locker; the rest of the students just left their locks open.

I had one humiliating experience in gym class. I was short (five feet two inches). Most of the other seventh grade students were taller. It was assumed in my family that I would be as tall as my relatives so Mamma got me a gym suit that I would "grow in to." That gym suit was so large that it flapped around my knees as I ran up and down the field kicking the ball or jumping high enough on the basketball court.

I did not grow! Finally, in the spring during baseball season I asked Mamma if I could have a gym suit that fit.

I heard her tell Daddy, "I'm going to buy her a new gym suit. But I am so afraid that she will always be short and wind up looking like Papa's sisters, Aunt Ida and Aunt Margaret."

I knew those aunts. I hoped I wouldn't turn out like them either. They were short and overweight and wore tight little cotton print dresses with thick stockings and black lace-up shoes. Even today when I put on a little weight I think, "I'm starting to look like Aunt Ida and Aunt Margaret."

And I "cut back" on my eating.

The Junior High Dance

Junior High School was the beginning of school dances. For my first dance, Mamma made me a beautiful pink/purple/gray plaid taffeta dress with a purple sash around the waist. I remember coming home crestfallen to report that I was a wall flower. I was actually crying when I told her no one had asked me to dance.

Mamma asked me more about it and found that the girls stood on one side of the gym and the boys on the other. She took me to her dressing table mirror, told me to sit down for a "twinkle lesson."

She told me to always have a twinkle in my eye no matter how I felt. She demonstrated her face with no twinkle, and then her face with a twinkle.

Twinkle…no twinkle…twinkle… no twinkle…twinkle… no twinkle. I joined in. We practiced it over and over and over again. I caught on!

"Even when you are bored or sad, you can always put a twinkle in your eye. And you will not only be popular at dances but you will have a better life."

"And," Mamma continued, "You must always wear a bracelet. That just might be the thing that first catches his eye!"

And from that day to this, you'll never see me without a bracelet and seldom will you see me without a twinkle…even when I am bored, or sad, or sleepy.

Lessons On How To Be "Lady-Like"

Although I was considered by some to be a "tomboy" Mamma was determined I would become feminine…"Lady-Like" was the term she used. She wanted me to be pretty and act appropriately.

First, when I sat down my legs (I think she really meant knees) should be together. If I crossed my legs, it should be at the ankle.

Second, when laughing, I should never open my mouth much and my laughter should never make much noise. I'm still working on that one!

Third, she would roll her eyes and insist that any boy/man will tell you "anything" to "get what he wants." When you meet a man like that remember that what he says is "rubbish" and you should "turn tail and run." I have found most of that to be true.

" Keep a Twinkle in your Eye"

The Move To Washington 1947 - 1995

Are We Moving ... Or Not?

The Mississippi State Department of Rehabilitation was successful under Daddy's leadership. As a result he was interviewed for the position of Director of the National Rehabilitation Association. When he got the job, Mamma was expected to change her life once again. This was a great opportunity for Daddy. But this time Mamma said that she wasn't going to move. I heard them arguing. Mamma told him that he could just go alone; that she was staying in Jackson.

I heard Daddy say, "Oh, yes, you will go, because you need someone to make your living so that you can enjoy your club activities and bridge games."

I was shocked that he would say something so cruel. At that moment I knew I would never be in Mamma's position. I would get an education that would enable me to have a job so that I would never be as dependent on a man as Mamma was. And that has come to pass.

Daddy's mother, my Granny Whit, told him not to take the job. His six brothers and sisters had remained in or near Memphis. We heard later that all of the Whittens "felt hard" toward Daddy. I know that he sent money to his parents but he left for good. We continued to visit the Whitten's in Memphis twice each year until Granny Whit and Grandpa died. After that we seldom returned.

My Granny Lou Duckworth told Mamma she must follow her husband to Washington because that was God's will. We went. We heard years later that Granny Duck actually went to bed

in mourning for almost one week, but she never told us she was sad at our leaving.

The Trip to Washington

Mamma cried all of the way to Washington. I was crying, too, because I had to leave my white Spitz dog Nicky and my first boyfriend, Ennis Earle. Daddy was determined and very quiet as he drove for three days. We drove through the cotton fields of the Mississippi Delta, stopped in Memphis to tell the Whittens good-bye, through the Blue Ridge Mountains of Tennessee, the tobacco fields of North Carolina and the horse country of Virginia. Finally we arrived at the Fairlington Apartments in Arlington, Virginia in the summer of 1947. We had three months to find a place to live before school started. Daddy figured out where the best schools were located and we began looking for a house.

I believe that period of time was the only time my mother was ever clinically depressed. She felt so lonely away from friends and family and even our dog Nicky. Dogs were not allowed in the apartments.

Daddy had so much to do before he actually began his work in Washington. It must have been hard on him to know we were so disorganized and unhappy. But he did it. And because of him and his determination, both Mamma and I had an amazing life that could never have been imagined had we stayed in Mississippi. We both grew to love Washington!

Life in Arlington, Virginia

We found a house that Mamma liked on Sixteenth Street in Arlington, Virginia. The house was nicer than the one we had in Jackson, and the neighborhood was more beautiful. We joined a Methodist church that welcomed us. Mother Found an AAUW (American Auxiliary of University Women) group; kept up with her Mississippi Women's University and later received the MSCW award for fifty years of alumni support. She joined a music club

and took oil painting classes at the National Gallery of Art. She was amazed that she was also invited to attend Washington teas midst the congressional wives and she attended other events that we had only heard of when we lived in Mississippi. Once Mamma went to the home of Ethel Kennedy, the wife of Senator Robert Kennedy. She told us that all of those Kennedy children (who were Catholic, of course) seemed unmanageable and were "running wild" around that beautiful home!

Mamma found some new friends in Arlington for her bridge games. In fact, years later, at her "farewell party" when they retired and were leaving Washington for Winston-Salem, one of her friends estimated that while in Arlington Mamma had played 14,400 hours of bridge.

Mamma began to write poetry that was published in an anthology. She designed or purchased new clothes for herself and for me. She was an officer in the Ashton Heights Woman's Club where she was the winner of the Vogue Sewing Contest resulting in her picture being published in the Northern Virginia Sun. She began to play the piano again.

The Cherry Blossom Festival

Each spring we went to see the boat races on the Potomac and the cherry blossoms on the Tidal Basin. One year I was invited to represent Mississippi in the Cherry Blossom festival. Yes! I was one of the forty-eight princesses. Mamma made me a gorgeous pink new long formal gown to wear for the princess procession at the Shoreham Hotel. Things were looking up for me, too.

Porgy and Bess

Daddy enjoyed going with Mamma and me into the city to the National Theatre, and he particularly enjoyed the musicals. When I was in my early teens I remember being embarrassed when we three saw Porgy and Bess. The character of Crown was

standing behind Bess with his arms around her waist and as they were singing, in one passionate moment, he moved his hands over her breasts. I felt electrified, almost screamed and nearly jumped out of my seat. And another time was when we saw South Pacific. When that soldier lay down with the Polynesian woman, I knew that Daddy knew that I knew what they were doing. Daddy and I never talked about sex. That was Mamma's job.

When Daddy was out-of-town (which he often was) Mamma and I continued to enjoy productions at the National Theatre in downtown DC where we saw Helen Hayes and Ethel Barrymore. We went to the Washington Symphony and to the Watergate Shell at sunset to hear the Army, Navy, and Air Force bands play as planes flew over the Potomac to far-away destinations.

Mamma loved Washington. I did, too.

Mamma Helps Me Make Friends

When I moved to Arlington I felt I had no friends at school. I would come home and whine and say that nobody liked me. Finally Mamma got impatient with my complaining and told me that I would be required to ask two girls to come home with me after school. And if the first one I asked said "no" I would just keep asking until I found two that said "yes."

So after several attempts I found Alice and Margaret, two people in my class that seemed to have no friends. My daddy was proud that I asked them and Mamma could be counted on to have some nice refreshments for us when we got home from school. When Alice and Margaret and I arrived, my mother was shocked. They were dull, unkempt, had no manners, just sat on the couch and waited for Mamma to think of something else for us to do.

When they finally went home, mother said quietly, "Ask someone else next time!" And she hugged me.

As the weeks passed I found some wonderful friends that I continue to look forward to seeing at the Washington- Lee High School reunions. Alice and Margaret don't attend. I don't know what happened to them.

Slumber Party - 1950
Helen, Adele, Nancy, Pat, Janie, Dee, Shannon, and Me

Nicky Comes Home

We returned to visit in Mississippi twice each year. We saw our old dog, Nicky, when we went back to Granny Lou's house at Christmas time. Granny Lou told us that for six months Nicky sat on her front porch looking down the road. When a car turned onto the street, Nicky would stand up, perk up his ears, and when he saw it wasn't us, he would lie back down on the porch.

When we finally got back to him, he ran to us. He jumped on Mamma first, then ran to me, then to Daddy, then back to Mamma, back to me, then to Daddy and didn't stop this for about twenty minutes. And he never left us during our entire visit.

When we prepared to return to Washington, Nicky saw that our bags were packed; he was moving slowly; his ears were back. When we called him to get in the car with us, he (and we) were overjoyed. We were all together again.

Nicky is Home

Mamma's Life in DC with Daddy

Mother traveled throughout all of the contiguous United States and several parts of the world with Daddy as he spread the word about the rehabilitation movement. She attended Inaugurations of three Presidents, receptions at the White House and at the home of Vice-President and Mrs. Humphrey; more receptions at the home of the Mayor and Mrs. Wagner of the City of New York. Mamma received numerous invitations to attend meetings of the President's Committee on the Employment of the Handicapped to hear Daddy speak; and to the Capitol to hear him testify before Senate Committees. She loved to relate their experience when the Corporation of London, England, requested the *"honour of their company" to Guildhall on Tuesday, the 23 of July, 1957, at a reception to welcome the delegates attending the Seventh World Congress of the International Society for the Welfare of Cripples ... evening dress with Decorations, Dinner Jacket with Miniatures or National Dress ... Dancing ... Carriages at 12 o'clock.*

Their fabulous trip occurred just three weeks after I got married. I really don't know how she managed to orchestrate my beautiful wedding in Arlington, Virginia and still prepare to travel to London afterward. And I'm not sure if we ever found out what "decorations" meant on the invitation.

ADMIRAL SAMMS

We lived in Washington because my father had just been appointed the first full-time Director of the National Rehabilitation Association. The rehabilitation movement was becoming established as part of the spectrum of national and state welfare programs. For almost thirty years Daddy led an organization with a membership that grew to 35,000 as he propelled the phenomenon and

concept of rehabilitation to higher levels of political awareness, support and public acceptance.

One of his tasks was to organize the National Rehabilitation Association Annual Conference which was always held in one of the great cities of the United States. Thousands of rehabilitation professionals attended to become informed of the latest rehabilitation research and techniques, renew friendships, and make connections. An important part of the convention was for Daddy to arrange for a famous, successful, handicapped person to speak at the banquet.

One year it was Helen Keller, who requested specific food items for the days she was in attendance, including a special plate at the banquet. Her multi-room suite was to have a specific variety of fresh flowers delivered each day. She traveled with several attendants who also had their own special requests.

Another year the guest speaker at the banquet was Herbert Samms, a blind Four Star Admiral who was also Chair of the President's Committee for Employment of the Handicapped. Admiral Samms was wounded in active combat in World War II in 1945 which resulted in his blindness. He also served in the Korean War.

My mother was always at the Conventions sitting near Daddy at the head table and was usually seated next to the invited speaker. Mamma was beautiful, gracious, and a good conversationalist. She was a natural in her role as a national hostess.

She did not, however, enjoy her job serving as a hostess for disabled citizens. She just never in her entire life felt comfortable around disabled people. (There is a term, *aesthetic revulsion*, which is used to describe people who feel this way. It isn't their

fault; that's just the way they are!) Mother tried to overcome this feeling, but it was always difficult for her to be around double amputees, people with cerebral palsy, those who had contracted polio, had speech disorders or people in wheelchairs.

Another characteristic of my parents was that they didn't drink alcohol. Although mother was okay with other people who drank, she had no respect or patience with people who were drunk. That night everyone who attended the banquet noticed that Admiral Samms was drinking more than would be considered an appropriate amount for a banquet speaker.

Well, on this evening, Mamma had a two-fold challenge. Her assignment was to escort a blind and inebriated admiral from the reception hall, through a corridor, to the banquet hall, then up a few steps to the dais and finally, assist him in locating his seat.

When it was time to eat, Mother located Admiral Samms and extended her right arm to lead him to his seat. He was stumbling and slurring his words as he shuffled along the corridor. Mamma, dressed in her pink and gray lace formal gown, haughtily walked a couple of steps in front of the Admiral and a bit faster than was needed.

When Mamma and the Admiral reached the door to the banquet hall, she got through the door but the Admiral, who was on her right, slammed smack dab into the door frame and the wall. When Mamma heard the loud thump, she looked back in time to see the Admiral dazed and wobbling. He would have toppled over had it not been for two alert convention attendees who grabbed each side of the honored guest to keep him upright.

Mamma was horrified and humiliated; tears formed in her eyes. One of her friends rescued Mamma and sat her in a chair that was located nearby. Admiral Samms was assisted by others as he traveled the path to the dais and to his chair. Mamma wanted to return to her hotel room; but she, too, took her seat next to the Admiral.

Daddy, who often told the story, reported Admiral Samms made a speech that seemed rather confusing to the convention goers. But he was unsure if it was because the Admiral was a bit tipsy or because Mamma had walked him into the wall.

Years later, when the story was told and retold, midst great laughter, the story was never completed. The story teller was always laughing so hard, the final words were never spoken ... or understood.

Mamma never got over it!

Mamma is a Grandmother

Mamma loved being a grandmother ... and she was a good one. I had two little boys that loved leaving Winston-Salem, North Carolina, to visit Mamma and Daddy in the Washington area. There were so many activities for them to participate in. Mike and Gordon especially loved the Natural History Museum. They would ask Mamma and Daddy to take them to the "dead zoo" to see all of the stuffed animals.

Once Mamma and Daddy kept our sons while my husband and I went to the World's Fair. When they went to church they took Mike and Gordon (ages 5 and 3 years) to Sunday school. Mike and Gordon made up names...William and Justice White. When Sunday school was over, they were missing. The search party was checking every class room asking if anyone had seen the White brothers. When our sons were finally located, Mamma said she would never keep them again, and she never did.

Mamma, who always had fresh flowers in the house, would take her grandsons around the yard to select the flowers for the dinner table. She would demonstrate just how to cut the flowers so the plants could continue to grow to produce new ones.

Mike and Gordon enjoyed eating their granny's grasshopper pie (a popular recipe in those days). The two little boys would eat the pie with a great deal of concentration because they had been told to watch out for grasshoppers. They would laugh, pretend to find a grasshopper, chew it up, and say "yum yum." Mamma would laugh and serve them another sliver of that green pie.

Children Are In The Family!

Mamma loved to be around children. When my grown son (her grandson) was an adult he decided to marry a divorced woman with two young children, ages five and seven years. I must admit I felt some concern that Gordon was taking on a bit too much.

When I told Mamma about Gordon's impending marriage to Frankie, she exclaimed happily, "Oh, how wonderful. Now we will finally have children in the family again!"

And she loved Erik and Brooke from the day she met them.

Winston-Salem, North Carolina 1985

Mamma and Daddy moved to Arbor Acres Methodist Retirement Community in Winston-Salem, North Carolina, to spend their last years near me and my family. Daddy knew that his prostate cancer was making him weak and he wanted to assure that mother would be cared for after he was gone. Mamma had lived in the Washington area for almost forty years and the move was difficult for her. She did, however, make some wonderful friends in her new community.

She had been living in Winston-Salem several years when I was planning a trip to Washington to attend a meeting.

"Mamma, I'm going to Washington next week. Do you want me to call a few of your friends to tell them your news and to find out about them?"

"Yes. Tell them I never think about them anymore!"

Of course, she was teasing me, but I do believe she was one of the best adjusted women I have ever met. She was interesting, intelligent, energetic, a faithful friend, a loyal wife, and loving mother.

Daddy Died

In 1989 Daddy died with prostate cancer. Mamma grieved. She was loyal and sad as she sat with Daddy night and day during his last days. She did all she could to lessen his pain and carry out all of the other dreadful tasks that accompany prostate surgery.

But after his death, she continued her activities where she played bridge, went to church, attended parties and went on outings. I hosted her friends at parties at our home. I was proud of the adjustment she had made.

I knew that Mamma was going places with a widower in Arbor Acres, Dr. Frank Hamilton, a retired physician and a pillar in the Presbyterian Church. Our family would eat Sunday dinner with him and his sister. We enjoyed their company.

Dr. Frank was handsome, spry, and walked with a cane. When Mamma and I were talking about the couples at Arbor Acres, Mamma said that Estelle Shanks was the prettiest woman out there and she got a man without a cane. (*This should be a notice to all men. If you want the prettiest woman in the retirement home, try to walk without a cane!*)

* * *

Mamma called him Dr. Frank and we did, too. Dr. Frank was, indeed, an appealing, intelligent, slightly built gentleman who walked with his ivory-handled cane and always sported a twinkle in his eye. In fact, Dr. Frank was actually charming. I knew that Mamma was having a good time and I was happy for her.

You're Going to What?

One day Mamma telephoned to invite me to dinner at her home. This special invitation was unusual since ordinarily, if I was at her house around suppertime, we would just eat together. When I arrived she had set the table with her best dishes. I knew something was about to happen. And it did!

"Jo, I have fallen in love with Frank Hamilton. We will be getting married during the Christmas season."

"No, no!" I was devastated. "What about Daddy? How could you dare to fall in love with another man? Are you just forgetting all about Daddy? "

The next part of the story I do not expect the reader to believe. But I tell it anyway. I know that it happened.

On a quiet still sunny October afternoon I was alone at my home resting on my couch in the great room that afforded a beautiful view of our grassy slope to the pond. The month of October rendered the leaves of North Carolina maple trees as red and brilliant as I had ever seen them. Sunlight was streaming into the room, peeking through the vertical Venetian blinds and making a pattern on the gray carpet. My two Springer Spaniels, Katy and Fred, had sighed and plopped down on the floor for their afternoon snooze.

Tears were streaming from of my closed eyes and rolling down my cheeks. I was thinking of Daddy and of how devastating it was that my eighty-three year old mother had fallen in love again.

And I heard Daddy say, in his angry, stern, gruff voice, "Betty!"

All I heard was, "Betty."

That was the tone of voice he used when I had misbehaved or disappointed him.

I rose from the couch to telephone my mother!

"Mamma, if you and Dr. Frank get a pre-nuptial agreement, I will have your wedding at my home. I will send you off with good wishes and great joy. Our family and Dr. Frank's children will attend. We will call Dewey's to order your wedding cake. And, you are going to have to get rid of that stretchy girdle you wear because we don't want Dr. Frank to know you have such awful underwear."

We laughed and cried together. She told me she could never love Daddy less, just because she loved Dr. Frank today.

She was determined. Right away we went shopping for a beautiful new nightgown, a new girdle and an aqua silk wedding suit. And during the Christmas season she and Dr. Frank were married by my Methodist minister at my home where she and Frank cut the cake hand-over-hand and dashed (more like walked as fast as they could!) to their car with rice flying. Frank was carrying his ivory handled cane and Mamma was holding his other arm. My husband, children, and grandchildren attended, as did Dr. Frank's adult daughter, Mary Beth. His three adult sons didn't attend.

Mamma often remarked that she was quite fortunate to have married two outstanding men. She and Frank were together for over two years when he died and she was once again a widow.

A NOT SO SUDDEN DEATH

The telephone rings – waking me up. The red numbers of my bedside clock reveal it's 4:12 AM My heart beats rapidly – I let the phone ring three times – it's never good news when the phone rings at this time of night. Immediately I pray.

God, please let the children be safe. Give me the strength and wisdom to say the right words when I answer this phone.

"Hello."

"Jo, (my mother's voice) Frank is dying. You need to come."

"I'm on my way."

Mamma had married Frank Hamilton two years earlier when they were in their 80's. Today he has congestive heart failure and we knew his days were limited. I dash to the closet for clothes that will be suitable for meeting his family as well as appropriate to go to my University where today I am scheduled to teach two classes.

"Mamma, are you still at home? I'm on my way. The two of us can go to Frank's room in Long Term Care. Don't try to go over there until I get to your house."

I dress, feed the dogs, and back the car out of the garage. As the car heads toward Arbor Acres Retirement Community my thoughts reflect on the past three years and how it is that I am driving to the bedside of a man named Frank.

* * *

My parents, Ethel and Elton Whitten, moved to Arbor Acres seven years ago in order to spend their last years near me and their grandchildren. They had accepted that they were getting old. The time had come for them to return to the security of the family.

I was delighted when they moved into a patio home in my town of Winston-Salem, and even more pleased that they were enjoying their new lives as old people. They joined the Methodist Church, quickly joined bridge clubs and participated in many of the available activities.

Even better, our family celebrated holidays and birthdays together; something that we couldn't do when we lived so far apart from one another.

After living in Arbor Acres for four years, my daddy became ill and died. Mamma grieved; I did, too. Yet with her great support group of friends she continued to play bridge and attend the events at what she called "the Home." She enjoyed the bus rides to the theatre, symphonies, and the picnics at Hanes Park. She often mentioned her friend, Dr. Frank Hamilton, a retired surgeon, a pillar of the Presbyterian Church, who commanded great respect among members of the community. In fact, Mamma and Frank eventually married.

As time passed I was happy for Mamma and I began to love Frank.

But today - Frank is dying. This is going to be a tough day for Mamma and especially for Frank's children. With no hope of recovery Dr. Frank's failing heart required that he be taken to the hospital. Thus, we knew this day would soon arrive.

I got to Mamma's about 5:00 AM. She had on her blue silk dress; her make-up was applied carefully with her silver hair perfectly arranged. She checked herself in the mirror. When I told her she looked lovely, she responded that she wanted the last thing for Dr. Frank to see would be his beautiful, loving wife.

Mamma and I were the first family members to arrive in Frank's room. None of his children had yet arrived, although I was sure they had been called and two of them lived closer to the hospital than I did. The nurses in the near-by hall way were talking quietly.

Mamma and I walked into Dr. Frank's room to wait for death.

The minute he saw us Dr. Frank smiled, extended both his arms and embraced us. He was freshly bathed, had on clean crisp blue pajamas; his thick gray hair was parted and nicely combed. His voice was strong as he told us he loved us and thanked us for coming.

At his request his bed was on a 30 degree angle so that he could see the faces of his loved ones as we came to tell him good-bye. Mamma tentatively approached Dr. Frank, held his hand for a moment, bent down and softly kissed his cheek. She told him she loved him.

Dr. Frank had telephoned his four children. Mary Beth, who had moved into her father's lake house, had to drive in from Lake Wiley; Frank Junior and Richard lived in Winston-Salem; Aaron, a disk jockey at a radio station in Yadkinville, had sent word he would try to get there in time; but first, he had to get a substitute for his ten o'clock country music radio show.

Mamma was crying a little bit, but she also looked puzzled because Dr. Frank didn't look as deathly as we had anticipated. Through the years I have been employed in a variety of hospital and nursing home settings. I have seen death. Death does not look the way Dr. Frank looked.

Mamma and I sat down in two of the three chairs in the room. The parade of children began.

Dr. Frank's oldest child arrived about 6:30 A.M. Frank Junior attended Davidson College where there was a building named after his grandfather. Frank's job was "in stocks and bonds" and that is all we ever knew about him. The joke about Frank was that he was *"in his father's stocks and bonds."* No

one had ever seen him go to work, but today he was dressed in white shirt and dark suit. His face was ruddy and eyes watery which could have been the result of extreme grief or what was left of a hangover. I was surprised that once again, I would not be meeting his wife. Surely she would want to comfort her husband as his father died. Frank Junior didn't touch his father. He said "Hi" to Mamma; didn't even acknowledge me as he sat down in the remaining chair in Dr. Frank's room. We three sat quietly waiting for the others.

Thirty minutes later, Mary Beth and Aaron dashed in. The brother and sister had met in the parking lot and were afraid they were too late. Mary Beth had just come in from Lake Wiley and hadn't taken time to dress or apply make-up. Wearing Bermuda shorts and with tears in her eyes, she rushed to the bedside to embrace her father and to comfort him before he died. She spoke some inaudible words, her shoulders shaking with silent sobs.

Aaron, the disk jockey, made the one hour trip from Yadkinville and informed all of us he needed to leave the hospital by 9:00 in order to be the disk jockey in his 10:00 radio show. The message seemed to be that he hoped his daddy could finish things up in a timely manner so he could get back to work.

We knew that Aaron's dying father was disappointed that Aaron didn't have a more prestigious position of employment. But I liked Aaron well enough. He seemed to genuinely like Mamma and me. We appreciated his attitude toward us since Mamma and I seemed to shrink as the Hamiltons filled up the room. The three chairs in the room were all taken when Mary Beth and

Aaron got there, so the nurses added a fourth and fifth for the late comers. Thus, five almost strangers were sitting so close to one another that the wooden arms of the five chairs were touching.

The last to arrive was Richard Hamilton, the one I liked best of all. He had a real job with a construction company but was a disappointment to his father because he had rejected enrolling in any of the prestigious North Carolina universities. As there was no space for a sixth chair, I gave Richard, the construction worker, my chair and stepped aside to stand in the doorway.

So, here we are. The five Hamiltons and Mamma and I have come to the nursing home to tell Dr. Frank good-bye. I was still puzzled but keenly aware that Dr. Frank was relishing all of this attention as he took charge of the situation.

He began by saying that he was dying, that he loved us and wanted to die among the people who loved him best. And, furthermore, he wanted to make some special gifts.

First, to Frank Junior, the stocks and bonds man, he said, "Frank, I want you to have my car."

Richard, the construction worker shouted, "Daddy, I am the one who needs a car. Frank does not deserve the car. He's already figured out how to get most of your money."

Mamma and I were stunned.

Then Aaron the disk jockey shouted, "I wanted that car. I have the longest commute and Mary Nell is pregnant again and she's going to have to quit work."

Frank Junior said, "Shut up, Richard. Just shut up. Daddy's dying. Don't upset him!"

The dying Dr. Frank continued as he said to his disk jockey son, "Aaron, you can have my black

doctor bag and my Penn State Medical School diploma."

"Damn, Daddy. What in the hell do you think I'm going to do with your doctor bag? I ain't no doctor. You ain't never been proud of me. I don't want any of your old stuff. Just forget about me."

Aaron stood up from his chair as if preparing to leave. My legs were getting tired and I wondered if I could sit down in Aaron's chair.

The dying Dr. Frank was not to be stopped. "Mary Beth, I want you to have the television set."

My own mamma who seldom shouted said, "Frank, you know I paid for one-half of that television set and you aren't giving that to anybody!"

I was startled. Aaron sat back down. It was clear that I wasn't going to get a chair.

The room was quiet. Dr. Frank's four children and my mother, Ethel, sat in the five chairs wedged in that little crowded room. A moment later, I had to step away from the doorway to make room for Dr. Frank's Presbyterian preacher who came into the dying patient's room.

The Reverend McCallie asked if we could pray. He prayed for God to take Dr. Frank's spirit into his kingdom; he prayed that God would soothe the spirits of the grieving family in the room. He called out the names of Dr. Frank's children. He blessed my mother, Ethel, but called her "Evelyn." Then he looked at me with a puzzled expression and added, 'And bless any others in the room who are grieving."

Dr. Frank took a deep breath, sighed and tried to die. But he didn't. He said, "It won't be long now."

We waited in silence another fifteen minutes.

Finally, Richard the construction worker said, "Damn, Daddy, you ain't gonna die. I got to get to work."

He stood up and stomped out of the room. One by one Frank's other three children left without saying good-bye to one another, or to Mamma or me ... or for that matter, to the Reverend, who also left shortly thereafter.

Mamma was crying. I came back into the room and sat down with my Mamma.

I still don't know why, but I began to laugh. I laughed and laughed and laughed and I simply could not stop. I got hysterical.

Speaking through my laughter I said, "Frank, you aren't going to die today. Mamma and I are leaving."

I was still laughing. Mamma got up from her chair and said through tears of her own laughter, "Frank, don't you ever pull such a stupid stunt again. The next time you think you are dying, you had better die!"

We left arm in arm, both of us laughing so hard we could hardly breathe. The nurses looked somewhat puzzled and stepped aside. Mamma and I laughed all the way to our cars. We got control of our emotions as we hugged each other.

Then we cried.

Three weeks later Dr. Frank died. Mamma was the only one with him.

After the memorial service I wrote Aaron a letter to inform him where he could pick up his daddy's black doctor bag and the Penn State diploma. I never heard from him or the other Hamiltons again.

Remembering Daddy

Mamma was a generous woman and wanted Daddy to be remembered. They had an entire history together apart from me, and I knew she loved him. When they looked at one another and laughed I knew they were reminded of some memory I was never privy to.

Before Mamma died she asked me to assist her in contributing two memorials in Daddy's honor. The first was in Clarendon Methodist Church in Arlington, Virginia where they were members for almost forty years. A wheelchair ramp was built so that disabled members of the church would have easy access to the worship services.

After the death of both my parents, I arranged for the second memorial to be placed in Centenary United Methodist Church in Winston-Salem, North Carolina, where they lived until their death. They are buried there; and that is where I will be buried.

Centenary United Methodist Church
Winston-Salem, North Carolina

A wheelchair ramp was constructed on the east entrance leading into the front side of the church. It is beautifully designed, landscaped and did not, in any way, compromise the architectural integrity of the Gothic design church, built in 1931. The plaque with Daddy's name included the wheelchair symbol that was designed in Daddy's office when he first moved to Washington. The words on the plaque are: *In loving memory of Mr. And Mrs. Elton Whitten by their daughter, Jo Whitten May and Family, October 2000.*

No Citizen Will Enter the Back Door

Before the memorial to Daddy was approved and as often happens in churches, there was a great deal of heated discussion about the placement of this ramp. At one of the Administrative Board meetings (of which I was a member) someone said that the ramp should be constructed at the back of the church. The disabled people could enter at the *back* and then catch an elevator that would bring him/her up one floor to the sanctuary.

I said in a voice with more intensity than was really needed for all to hear, "The day is over when any citizen has to come to the back door."

It got quiet in that roomful of Christians.

The ramp was built at the front of the church.

Landscaping for the ramp included a memorial garden in honor of another church member, Gail Dewar Dunning. And I have noticed that many church members, disabled or not, choose to enter the church through the beautiful curved ramp that winds along the memorial garden up to the church doors.

Something's Wrong With Mamma

Soon after Dr. Frank died it became clear to me and to Mamma that she had Alzheimer 's disease. Both her sister and brother were stricken with the disease and she was well aware of the early signs. She was diagnosed when the two of us were still able to talk about it. She was assured that she would be well cared

for in the Alzheimer's Wing at Arbor Acres. I assured her I would see her everyday either going to or from my university work place where I taught courses in speech-language pathology .

Mamma didn't believe in bragging and criticized others when they frequently bragged on their children. But she did do something "braggy" after she moved to assisted-living in the Health Care Center.

I would see her each day. And each day when I left Mamma, I always passed through the dayroom where residents were waiting for supper. Every single night she would say: "I want you to meet my daughter, Dr. May. She teaches at Wake Forest, you know."

The patients with memory loss didn't remember being introduced the day before, or before that, or before that. They were always polite as we greeted one another, as if for the first time.

There were other residents who were in long term care who had physical disabilities but their cognitive skills were intact. And they would roll their eyes as if to say, "I know. I know. I know. You don't need to tell us again."

One day when I left and mother was completing her introductions, there was a new resident waiting for supper. He asked me, "What kind of doctor are you?"

"I'm not the kind of doctor that makes you well. I'm the kind of doctor that makes you smart."

"Well, we could sure use you around here!"

"Yes, I believe you could!"

One day as I was leaving Mamma said, "Jo, there will be a day when you come to visit me and I'll not know who you are. But don't you worry, honey. I may not know in my brain but I'll always know in my heart."

And I know that she did.

In her final days she expressed to me that she was at peace with God and she was ready to move on to her next life. She really did believe she was going to a better place.

Mamma's Memorial Service

Arbor Acres Chapel
July 16, 1998

At mother's memorial service, my dear daughter-in-law, Katherine Mahon Kay May, wrote and spoke the following words:

After Elton died, Ethel fell in love and married Dr. Frank Hamilton. She often remarked that she was quite fortunate to have married two such wonderful men. Ethel has given us a classic standard of what a lady ought to be. She is demure, pretty, attractively shy and at the same time uncompromising in her duty to her church, her family, and especially, her "E.B." They represented a shining picture of a Christian couple in a Christian home.

*Let your light so shine before
Men that they may see your good works..."
Matthew 5:16*

Mamma Returns

The reader can believe this or not. I write it because it happened.

Every afternoon it was the routine of my husband and me to take our two Springer Spaniels on a two-mile walk along the periphery of our golf course, across small bridges, through leaves, and along ponds. We always enjoyed the rabbits, squirrels, geese, ducks and blue herons that seemed to be aware of our presence as we walked among them. Even our dogs no longer pulled their leashes or barked when we passed the other animals.

A memorable event occurred after Mamma's memorial service. As we were walking along the path I was feeling sad. Silent tears were streaming from my eyes. Suddenly a white heron flew toward us and stopped about twenty yards in front of us. As we continued walking along our path and approached the heron,

her white wings would spread; she would fly about twenty yards ahead of us again, and again stop until we approached her.

This continued for most of the walk and I knew it was Mamma. I knew she was telling me that she was okay and that she had located Daddy. She said that Daddy and Dr. Frank were already playing bridge together, and since mother had arrived they had a foursome with the two men and Elizabeth Brazil. They were playing cards every afternoon before supper.

As we continued to take our daily walks the white heron would sometimes appear. And I continued to feel the comfort of my mamma. As the days passed the heron came infrequently, but I still saw her occasionally. On some days Ethel (we named her) was just walking the shore of the pond by our house.

Ten years later I moved to Columbia, SC. One of my concerns was that I was leaving the home of the heron…that Mamma might not be able to find me.

Silly? Of course. But I still had the thought.

One afternoon, about two months after our move, I looked in our backyard to see a white heron walk along our brick wall.

"Mamma, I'm okay now."

And that was our last earthly meeting.

So far.

The Locket

Betty Jo is not sleepy today. She wants to avoid today's nap by thinking of something to talk about that would interest her mother. Every afternoon three-year-old Betty Jo and her mother nap together in her mother's big bed. Betty Jo knows that if she asks a good enough question, her mother might talk to her and forget about going to sleep.

Today her mother is wearing her delicate silver cloisonné locket. The oblong locket's center is pastel pink enclosed by a pale green border; there are tiny pink roses at each of the four corners of the green border; the pink center has a miniature bouquet of blue violets painted on the pink oval.

Betty Jo held up the locket.

"Mamma, what's that?"

"A locket."

Betty Jo thought her mother, Ethel, was the prettiest woman she had ever seen. Young, slim, with dark wavy hair, her mother always wore dark red lipstick. Today she was wearing her *Evening in Paris* perfume that Betty Jo gave her for Christmas. Ethel always took a rest after her afternoon bath so that she would be relaxed and pretty when Daddy came home from work. When Daddy came home he would always burst through the door, and shout, "Where's my Flapper?"

Then her mamma would laugh and dance the Charleston around the house. And today she was wearing the locket.

"Can I have the locket?"

"Not yet." She continued, "Your daddy gave it to me before we were married. When he gave it to me it was the first time he told me he loved me. When I wear it, I feel loved and happy because it reminds me of your daddy when he is not here.

"Does Daddy love me, too?" The little girl asked.

"Of course. We can love more than one person at the same time. He loves me because I am a good wife and friend; he loves you because are his delightful smart little daughter."

"Then, why can't I have the locket?"

"Not yet."

Betty Jo moved closer to her mother. For the first time she examined the locket more closely.

"Oh! It opens. There are pictures in it. Why, that's you and Daddy! Where is my picture?"

"You'll be in the locket soon," said her mother.

The next time Ethel wore the locket there were still two pictures but they had changed. There, along with her daddy, was Betty Jo.

"Oh! That's my picture. Now that I am in the locket, can I have it?

"Not yet. This locket makes me happy. I wear it because when I open it I can see you and your daddy, the two people I love the most in the world?"

"When can I have it?"

"Not yet," her mother asserted.

As the years passed, the pictures changed. There was Betty Jo and her daddy on her first day of school; then Betty Jo and her daddy when she was in high school; and then her college graduation photo. Once Betty Jo opened the locket when she saw two new pictures; one of her in her bridal gown and on the other side was her new husband.

When Betty Jo saw those pictures she said, 'Mamma, I think I love him as much as you loved Daddy. Can I have the locket now?"

"Not yet."

Betty Jo's sons wanted tricycles and bicycles and cars. They didn't care about the locket. The years passed. The little girl had grown up, raised her two sons who had married. Now she had granddaughters of her own. She was so busy with her own life, she forgot all about the locket.

Betty Jo's mother, Ethel, was now living in the Arbor Acres Retirement Community. Even though she was losing her memory she continued to wear the locket.

One day the telephone rang when Betty Jo was at work. She answered the phone.

"Hello?"

"Betty Jo, this is Estelle, your mother's nurse. I'm so sad but I must let you know that I believe she is dying." The nurse began sobbing.

"You need to come as quickly as you can."

Betty Jo dashed from her office, drove to her mother's residence, and parked the car. She prayed that she would get there in time to tell her mother goodbye.

Betty Jo arrived with tears streaming down her own face. She rushed toward the nurse.

"Is she…" She couldn't say the word.

"No, not yet," the nurse said quietly.

Her mother seemed to be sleeping peacefully with a sweet expression on her face. She was wearing the locket.

"Mamma, I'm here. I love you."

Ethel opened her eyes and smiled. She touched the locket for the last time and died.

The little girl from long ago touched her mother as she opened the locket. There were two pictures: one of the little girl when she was a baby and the other of her daddy when he was a young man.

The daughter gently and tenderly removed the cloisonné locket from her mother and placed it around her own neck. She wore the locket to the funeral. And she still wears it today.

Yesterday, both of Betty Jo's granddaughters noticed the locket. They seem to love seeing their own pictures.

"Can we have the locket?" they asked.

"Not yet."

"Well, when?"

"NOT YET!!!!"

BETTY JO

BETTY JO WHITTEN MAY

1935 –

Betty Jo Whitten May

BORN OCTOBER 20, 1935

Me Do It Me Self!

When did it happen?
How did it happen?
Why did it happen?

How could anyone born in the 21st century possibly understand that in my generation it was accepted that girls were not equal to boys. I was born in the mid-1930's when women were supposed to be feminine. "Lady like" was the phrase used in my family.

"Betty Jo, that is not ladylike!"

From my first days on earth I loved going outside. I enjoyed sitting on the porch with Daddy; or being pulled or pushed in my stroller. I wanted to be in the yard riding my first little tricycle, or running through the leaves in the fall. Every day (rain or shine) I wanted to walk around the yard to see the flowers and check under the persimmon trees to taste the sweet pulp that fell on the ground. I could scoot down the hill in my Radio Flyer red wagon; or race down the hill on my ball bearing roller skates. A big day was when I rode my first big-girl two-wheel bicycle. And I could shimmy up the trees with low branches in an effort to reach the tree tops.

I always wanted to learn new skills but with no assistance from others. My parents told me that my first sentence was **"Me**

do it me self." I am continuously reminded by relatives and friends that I continue to be "that way."

There just happened to be more boys than girls to play with in my neighborhood and I was usually in some sort of race. We had races on foot, roller skates, bike, scooters and even tree climbing. I was competitive. I didn't always win, but I always enjoyed the competition.

Mamma always kept an eye on us as we played and she occasionally intervened when she thought we needed some guidance.

School Days – Union, Mississippi

Union, Mississippi 1940-1945

The Plight of the Working Woman

When I was seven years old I had two best girlfriends living in our neighborhood in Jackson, Mississippi. Betty Webb, Jeannine Wells and I would put our blankets under the oak tree outside our kitchen window to play with our dolls. We dressed them, strolled them in their little baby buggies, and pretended to be mothers. I would also take my "children" with me when I pretended to go to my job to be a doctor, teacher, plumber, or just to the office.

One day Jeannine told me I could not go off to work *because I was a girl.* I knew that wasn't true. Aunt Hermie and Aunt Lib went to work and so did Cousin Sophie. At the end of the day Mamma, Daddy and I were eating supper when I told them what Betty and Jeannine said, and what I said.

Mamma said, "Well, Aunt Hermie and Aunt Lib had to work because they weren't married and there wasn't a man to take care of them. And Cousin Sophie had to work because she was married to a man who was lazy and no good and didn't have a job."

"Well, I *am* going to get married and I *am **not*** going to marry a lazy man, and I *am* going to have babies and I *am* going to be a doctor."

Mamma sighed. "You can't be a doctor but you can be a nurse. You will have to have a job where you can stay home most of the time to take care of your children."

That was the first time I realized that some people thought girls were not supposed do the same things as boys. I wondered about it, but I never really believed it.

When Mamma talked like that Daddy always said, **"Ethel, leave her alone!"**

And so Christmases came and passed: one year I got a train and a doll; one year a wagon and a doll; one year a chemistry set and a doll; one year a bike and a doll. And I always liked one as well as the other.

And when it was all over and when Mamma was an old woman she finally told me that she was very proud of me and that she was glad she listened to Daddy when he said, **"Ethel, leave her alone."**

The Catholics

I was a devout Methodist (as were my parents) by the time I was eight years old. I studied my Sunday school lessons; I listened to the preacher and believed everything he said. One particular message I heard often was that you could not be a Christian if you drank any alcohol. The Methodists were teetotalers!

At that time, particularly in the South, there was prejudice against Catholics. Our preacher told us that all Catholics would go to hell because they prayed to Mary instead of praying directly to God, as we did.

My daddy, however, believed that all religions had value and that our culture would not be as interesting, or beautiful, or civilized without the benefit of all religions. My mother didn't share his belief. She talked about the "hocus pocus" of the Catholics who lit candles and went to a priest who was shut up in a little closet in order to get their sins forgiven. Then she told me that Catholics had to pay money each time they sinned and sin was free for Methodists.

One day in Union, Mississippi, a big moving truck arrived. A new family was moving into the neighborhood. My mother rolled her eyes when she saw that they had six children.

"Catholic! They *must* be Catholic with all those children!" Once again she rolled her eyes, this time straight up to our Lord.

Sure enough. The Kanes were Catholic. They had to go to a near-by town to worship. And word got around the neighborhood!

Neither I nor my neighborhood friends had ever seen a Catholic. We wanted to see one! So Jeannine Wells, Harriet Moody and I agreed that we would visit Mary Jane Kelly (who was our age) when her daddy was home. We wanted to get a good, close look at a Catholic. We went.

With some trepidation we knocked on the door. They seemed pleased to meet us and invited us inside. We liked Mary Jane; her daddy was real nice; her mother was very pretty and baked some cookies just for us. We were puzzling over what all of the fuss was about. They seemed be just regular people *until* her daddy went to the refrigerator to get a *beer!* He opened it and drank it right in front of our eyes. We had never seen a person drink alcohol before that moment. You see, Mississippi was a dry state; and Methodists and Baptists knew it was a sin to drink. At that moment I knew that Catholics were, indeed, sinners…and I knew why. They drank.

As the years passed it finally dawned on Methodist and Baptist children why, after dinner, some of the men folk went outside with their Mason jars, opened the trunks of their cars, and hung around their cars talking. Their voices and laughter would get louder and louder because they were also drinking alcohol. According to our preacher they were "paving their road to hell." Even before I entered Junior High School I realized that even the Methodists and Baptists might also be sinners and my uncle Franklin was definitely paving his road.

My own daddy, however, never drank any alcohol during his entire life. Mamma and I never really knew why he was so adamant about "no alcohol." There were whispers that his own father drank too much; but I was never sure about that.

Jackson, Mississippi 1944

When I was nine years old my parents and I moved again, this time to Jackson. Daddy had a better job with the Mississippi State Department of Education. I enjoyed living in Jackson. Things were looking up!

I had a best friend, Betty Webb. My victory bike was the fastest one in the neighborhood. I lived across the street from Mary McNeely who was one year older than I was. She was adopted and I had heard of children who lived in orphanages. I always wanted to ask her about the orphanage. But I never did.

Playing Games

I have never enjoyed playing games where there was always a winner and a loser. In fact, I dreaded them. I could never hit a softball. The basket eluded me in basketball. Even as an adult I thought playing badminton at our Lake Norman, N.C., house was boring. I was a good tennis player unless the weather was too hot. Croquet took too long and more than once I hit my foot when trying to "put someone away." I could win at checkers, Parcheesi, monopoly, bridge, hangman, Rook, and other card games. But I never, ever really wanted to play games, whether I won or lost.

I have reflected on this and I believe it was because I felt bad when I lost and also felt sad for others if I beat them. Spending time knowing that someone was going to be disappointed… perhaps even get mad or cry…was no way to spend time. There was always going to be a loser.

But I loved running, swimming, climbing trees, riding my scooter, skating at the roller rink or outside, singing in choirs,

acting in plays, participating in book clubs or writing groups, entertaining others, going to parties and dances. All fun. But at these events there are neither winners nor losers. I still feel the same way.

Every day at school we had to go outside for recess. We usually played games with the boys and I dreaded Fridays when, no matter what the season, we played softball. The following story about recess indicates my dread of the game and my solution to participating in a school softball game.

RECESS – OR GOD ANSWERS PRAYERS

"My stomach hurts. I don't want to go to school. I'm sick."

"You are not sick. You will go to school. Get up and get out of the house."

This is the conversation between Betty Jo and her mother every Friday morning. And this is the prayer that Betty Jo prays every Friday morning.

"Lord, please let it rain. Please, please Lord, let it rain."

Betty Jo is nine years old and has just moved to Jackson, Mississippi with her parents. Her Daddy has a new job; her mother has some new friends; and Betty Jo already has a best friend whose name is Betty Webb. They are known as the "two Bettys" when they are seen riding their bikes to school; and also when they walk arm-in-arm through the halls of Duling Grammar School. Betty Jo's teacher, Miss O'Cain, is pretty and is loved by all of the children.

So why does Betty Jo dread Fridays? Because that is the day that the boys and girls have recess together. And the boys get to pick what will be played. Today she is sure it will be softball. It

always is! She is also sure Buster Ladner will be the captain of the team because he always is. All of the other boys know he is the toughest and best player on the team and no one would have the courage to even suggest that anything should be different.

Today it's hot. The Mississippi sun is baking the playground. The grass has worn in places and the dusty red clay shows itself in the batter's box, on the pitcher's mound, and along the baselines. All of her classmates run outside; some are actually yelling and screaming for no apparent reason. They seem excited and can't wait to begin the game.

But before the game begins they must "choose sides." Buster and Lamar are the two captains. The bat is thrown into the air. The captains do hand-over-hand to see who chooses first. Lamar is first.

The two captains begin choosing team members. Of course, the boys are picked first, except for Jeannine Wells who plays all sports as well as any boy in the classroom.

Now it is down to the girls who must be chosen. Betty Jo knows she will be picked last. But being last is really not the thing she dreads most. She is just hoping that when she is the one person standing at the end, it will not be Buster's time to pick. She is hoping that it is Lamar. Lamar is always nice to her, even though he knows she is not a good player.

"Oh, dear Lord," she prayed, "please let Lamar call my name" when she hears Buster's voice.

"I'll have to take Betty Jo."

And he picks up a rock and throws it across the field in anger because he is so disgusted at the thought! And Betty Jo is disappointed again

because she feels God is not paying attention to her prayer.

The game begins. Buster's team is at bat. Betty Jo does not worry yet because she will be the last on her team to bat. She has some time to relax before it's her turn. She sits on the bench alone and slowly kicks up a bit of red dust with the toe of her shoe. She is still praying to the Lord that some way she can have a day without embarrassment.

When the opposing team is at bat, Buster Ladner sends her as far out in right field as she can get. No one ever hits a ball in that direction, thus no damage will befall the team. Although she is bored standing out there, she feels that this time the Lord has answered her prayer in the affirmative. No balls came her way.

She probably won't come up to bat until the third inning. She has decided not to even try to hit the ball. Perhaps she will get to walk to first base and the possibility of embarrassment will continue to elude her.

Now it is time for Buster's team to go out to the field. Betty Jo takes her usual spot far, far, far, far into right field. When all of a sudden, Lamar is at bat and – CRACK – he hits the ball high. It's not a foul but in-bounds and it is soaring directly toward Betty Jo.

Buster begins to scream.

"Catch it. You idiot! You dummy! You stupid! Catch it!"

Betty Jo sees the ball coming her way. This white sphere seems to be floating toward her in slow motion. She hears the words of Buster. She needs to think! What should she do? She already knows that she is an idiot, a dummy, a stupid girl.

"Oh, Lordy, Lordy, Lordy help me," she prays. "Please, please Lord."

<p style="text-align:center">* * *</p>

Later, as she reflected on the situation, she did not know just where the idea came from, but probably from the Lord. What she did was to become limp, slump to the ground and lie motionless. The ball thumped on the ground next to her. The children ran up to her. They were afraid for her. One child hollered for Miss O'Cain.

"Hurry up, Miss O'Cain. I think she's dead!"

"Go get Principal Sykes! He'll know what to do! She's still not moving! Yep, yep, she's dead, alright. She's a goner!"

Principal Sykes picked her up. He was strong and seemed concerned about her. He took her to the nurse's office where some damp cool cloths were placed on Betty Jo's forehead and on the back of her neck.

Betty Jo opened her eyes. She fluttered her eyelids the way she once saw Hedy Lamar do in a movie. The nurse called her mother to take her home.

When her mother arrived, Mr. Sykes gently carried her to the car and told her mother what had happened.

"We think that the sun was a little too hot for her," he said.

Mamma was driving home as she glanced toward Betty Jo.

"You didn't faint, did you?"

"No, Ma'am."

And nothing else was ever said about it. At that moment Betty Jo knew that God answers prayers.

The WWII Rubber Shortage

I didn't really enjoy my school experiences in Jackson. I wasn't among the "popular" crowd and not a particularly exceptional student. Arithmetic was especially difficult and boring. My teacher, Mrs. Fitzhugh, was fat, wore her grayish hair in a tight bun at the back of her neck, and never any lipstick. She yelled at us and punished us when we went to the blackboard to work arithmetic problems. I was always nervous when I attended her class. One day something happened that made all of my suffering worthwhile.

World War II was not yet over and it was difficult to get elastic or anything else that was made of rubber. Thus, substitutes had to be made. Girls' panties would have just one string of elastic around the waist and on occasion the elastic would break and the panties would fall down … resulting in extreme humiliation to the wearer.

One day Miss Fitzhugh was teaching in front of the class and, yes, her elastic broke. Her panties fell down and bunched over and around her shoes. She didn't lift her foot to step out of them, but instead, kept her shoes on the floor and scooted them, one and then the other, until she had crossed the front of the class, opened the door, and shuffled into the hall. When she was no longer in sight we students laughed, and laughed, and laughed. Before she returned to the room Buster Ladner hopped in front of the class and scooted his feet up and down the aisles between our desks in a perfect imitation of Miss Fitzhugh. There was more raucous laughter.

As Buster scooted, he recited his favorite poem: "Ashes to ashes, dust to dust, if you like her sweater put your hands on her bust." There were more shrieks of laughter.

From that day on I made sure I had good elastic before I stepped into my panties. And I forgave Buster for calling me stupid and yelling at me on the playground.

Dancing Class

There were "advantages" for me in Jackson. I went to Nancy McNair's dancing studio to take lessons in tap, ballet, and acrobatics. I did have lots of "rhythm" and loved wearing beautiful costumes and dancing in the recitals. One routine required that we have yellow and white parasols to twirl as we danced to "Twilight Time." Another was a wedding scene where I danced and was just a bridesmaid. The bride had taken *private* lessons!

The teacher told my parents I had exceptional talent and suggested I take private lessons. I wanted to do it, but Daddy refused. He thought it was just another way for Ms. McNair to make more money (which, of course, it was) and not because I was exceptionally talented. In retrospect, I do believe I had exceptional talent, but that was just not how my daddy was going to spend the family money.

President Roosevelt

When I think of Mrs. McNair's dancing studio, a special memory always comes to my mind. The studio was four blocks from North State Street where I caught the city bus home. One evening, April 12, 1945, my class had ended and I was walking up the hill to the bus stop. I began to hear car horns blowing; people were on their porches shouting to one another; neighbors were standing in the street; some were weeping. One house had a small flag pole with the flag at half-mast. I was puzzled. When I reached my bus stop on North State Street, traffic was bumper to bumper. Cars were blowing their horns; and several people told me the buses had stopped running.

"Why? What has happened?"

"Roosevelt has died!"

I didn't know what to do. I lived about ten miles away and couldn't possibly walk home. It was already 4:30 in the afternoon and would soon be dark. I was scared, shaking and in a panic.

A man driving along in his car saw me. He turned off North State Street and pulled up next to the curb where I was standing. I imagine he could see that I was in great distress.

"Are you okay?"

"I am trying to get to my home on Northside Drive. I don't know what to do! The buses aren't running."

"Get in my car. I'll take you home. I live near Northside Drive."

I was terrified because I had heard over, and over, and over, and over again from my mother, "Never, never, never, never…for any reason…get in a car with a stranger."

But, I did it. I sat against the door, with my hand on the door handle and my dancing bag between us. My plan was that if he stopped the car or turned off on a side street, I would jump from the car and run. It is strange the thoughts I had. My dilemma was whether to grab my dancing bag with my new tap shoes in it, or leave the bag in the car and run for my life.

The man turned off North State Street and took me to my house on Northside Drive. I never did know his name, or where he lived. I suppose I thanked him, but don't remember about that.

President Roosevelt died in Warm Springs, Georgia.

(In the summer of 2012 I sent all of Daddy's papers, the manuscript of the book he authored, and hundreds of photographs to a newly formed library on Roosevelt's property in Warm Springs, Georgia. Daddy was the first full-time Director of the National Rehabilitation Association. I felt that library to be the appropriate place for his professional belongings.)

Expression

In Jackson I had one experience that completely changed my life. In our neighborhood lived Mr. Bob and Mrs. Lou Trim, who were good friends of my parents. The Trims had a big back yard and every evening the men in the neighborhood would play croquet. The games were fun to watch for the wives as well as the children.

One evening, Mother told Mrs. Trim that I enjoyed writing plays and performing them for the other children in my back yard. I would set up eight or ten chairs, theatre style, before I went out in the neighborhood to announce there would be a performance. After I took up their "tickets" that I had given them prior to the performance,. I would sing, dance, and do a couple of magic tricks. The finale was when I would swing by a rope from the tree to the ground. My childhood friends always enjoyed the entertaining performance. They also liked eating the cookies Mamma served them when they arrived. Hmmmmmmmm!?

At any rate, I enjoyed entertaining others. Mrs. Trim told mother that she taught "expression" and, furthermore, she thought I would be good at it. So, once a week I went to Mrs. Trim's house who gave me narrative pieces to memorize.

One piece was "The Last Leaf" which was a sad story about the impending death of a young child and how an artist saved her life. Another reading was "The Littlest Angel" which was always appropriate for Christmas.

The performance that actually changed my life forever was "Betty at the Baseball Game," a reading about a woman who went to a baseball game with her husband. She described her puzzlement as she tried to understand the game. Gags such as thinking she had to wear white socks to the White Sox game; or trying to "catch a fly;" or the crowd's excitement at her getting a "run in" her stocking; or "sliding" into home. Each time I performed the audience always roared with laughter. I was amazed and totally thrilled at the power I had when I entertained an audience. I performed for numerous school programs; men and women groups; church meetings. I became aware of the power of good public speaking. I enjoyed making others laugh (or cry). And still do…

Even today, I remain grateful to mother and Mrs. Trim for allowing me to take "expression."

Piano Lessons

It remained important to Mamma that I continue to take piano lessons. During the sixth grade graduation ceremony at Duling Grammar School I was selected to play a simple rendition of "Pomp and Circumstance." Mamma made me a beautiful white organdy islet dress accented with a pale blue taffeta sash. I did a pretty good job playing that song over and over and over until every sixth grader had walked down the long path in the auditorium to the seats on the stage.

I do remember that when I got up from the piano to take my seat among my classmates there was polite applause…and not a resounding one!

Throughout the years, until I was thirteen years old, I continued to play in piano recitals at least twice each year, once during the Christmas season and the other in the Spring Recital. I was always terrified. But I always looked beautiful because my mother had designed and sewn a beautiful dress for me to wear.

Bailey Junior High School

Jackson, Mississippi
Seventh Grade

You're a Woman Now

Some life changing events occurred when I was eleven years old. That was the summer I got my first menstrual period. I knew it was coming because I was getting sort of "curvy" and Mamma told me to be keeping an eye out for it. When it happened I was at home. I called mamma and she got me some "equipment" and showed me how it worked. She smiled and she seemed somewhat wistful when she said, "You're a woman now!"

That night she and Daddy and I went to the movies. Afterward we sat in one of the booths at the drugstore next door to the movie house where I ordered a cherry phosphate. Although it was not stated, I knew that my family was celebrating something. And I knew that things were changing.

As we were walking along the street back to our car, I could see my reflection in the store plate glass windows. I did look different. I thought that I might really be pretty, an idea that had never occurred to me before.

As I glanced in the window I remembered an experience that occurred when I was five years old. Mamma had sewn me a new blue dress to wear when I sang at Daddy's Lion's Club banquet…

In my sweet little Alice Blue Gown
When I first wandered down into town
I was both proud and shy
As I met every eye
And in every shop window, I primped passing by
In the manner of fashion I'd frown
And the world seemed to smile all around.
'Till it wilted I wore it, I'll always adore it
My sweet little Alice blue gown.

I was pretty.

Taylorsville

One month after I got my menstrual period I went to Taylorsville, Mississippi to visit my grandparents Duckworth. A friend of mother's had a daughter who was having a boy-girl party. I was invited. Mother had just sewn me another pretty dress (off the shoulder, purple and pink) and she allowed me to use just a hint of her lipstick. When I got out of the car to join the party, a boy whistled and shouted, "Boy, they surely do grow 'em purdy in Jackson."

That boy was Dan Strongfellow, the quarterback on the local football team who had his own pick-up truck. After the party when I told Mamma I had met Dan, she said he was from a "good family." And "yes" I could date him if he called.

He did call for a movie date that same week-end. After the movie we got a cherry coke and hamburger on a fresh bun in the jukebox café next door to the movie house.

When Dan took me home he drove that pickup truck right out to the fifty yard line of that Taylorsville, Mississippi football field and kissed me. That was my first real kiss. We wrote letters for a while and then moved into our real lives again. (I heard years later that he "did well" and became a dentist.)

After that week-end I felt pretty for the second time! Hmmmmm. Is it possible that someday I could even be *beautiful*? I think I will try for that!

Finding her Talent

When children are born there is always speculation on just where their talents might lie. Usually future predictions are based on the past achievements of family members. That is, if her grandmother created beautiful quilts, so might the heir. Or if her mother was an exceptional seamstress, then perhaps the daughter would inherit that talent. The story that follows serves to describe Betty Jo's predicted behavior.

NOTHING'S WRONG WITH ME!

The first grandchild … a little girl … ten-day-old Betty Jo … comes home from the hospital with her mother and daddy. And before she even meets her new family her life has already been decided.

Betty Jo wears her pink newborn dress with the little tucks in the front and tiny handmade button holes in the back meticulously stitched by her Aunt Braddis. She is swaddled in the blue (a boy was expected) and white crocheted blanket with matching cap designed and made by her Grandmother Duckworth. Family members are waiting for their turn to hold her as they attempt to figure out which one of them she most resembles. Finally she is placed in her new crib on the amazing colorful quilt with yellow and green appliqued bunny rabbits lovingly sewn by her Grandmother Whitten.

They are rejoicing that "she's a girl!" So many hopes, dreams, and aspirations will be fulfilled as this baby girl takes her place in the family. In a few short years she will begin to demonstrate the family talent. Betty Jo has long, slender, graceful hands that will surely assure she will be a great pianist like her mother. Those same hands might carry on the talents of her great-grandmother, Virginia, who created quilts using fabrics of yellow, red, blue, and green with intricate and often original designs. New quilts will be designed by Betty Jo that will have images of floral bouquets, girls in sunbonnets, little teddy bears, or geometric prints. That is Betty Jo's destiny.

Or perhaps she will "take after" her Granny Whit who loves to knit and crochet. Every member of the family is using Granny's doilies, coasters, bed spreads, delicate table cloths and even crocheted dresses with colorful satin lined hats. Why, Granny Whit's bedspreads have covered infants, teens and the oldest members of Betty Jo's family. Yes, this new baby girl will do that! We are so blessed.

Or wait! She just might design and create fashionable clothing from luxurious fabrics. Her mother, Ethel, could see a dress in a movie or a fashion book, sketch it, and make one for herself.

Yes! Family members are already anticipating the new hand-made creations this talented little girl will create.

The years passed.

Today Betty Jo is eight and old enough for Granny Whit to teach her to crochet. Granny Whit tells her the first step is to "gather your supplies." She has her crochet hook, some colorful yarn, scissors, and a large-eyed needle. They will begin

by crocheting a six-inch book mark. (Betty Jo does not want a book mark, but she does want to please her Granny Whit.) She cooperates.

"Start with the single stitch. Next week we will move to the popcorn, shell and triple stitches. Today you will begin by casting an even chain of stitches. Hold the tail end of the yarn in the off-hand and hold the ball of thread in the dominant hand; bend the tail of the loop across the ball end. Part of the tail extends under the opposite side of the loop from the cross point ... and then you...."

"Nooooooo ..." Betty Jo moans. "Boring, boring, boring!"

She drops the needle on the floor; her fingers are sticky from eating a sucker; the thread is dingy and grimy. She wants to finish it in one day. She can hear the children outside racing on their roller skates. She stops. She is a good fast skater ... and she runs outside to play.

Betty Jo's mother and her Aunt Braddis discuss the situation.

"Let's try knitting. The needles are bigger and she will see her handmade results faster."

"I want to knit a sweater."

Aunt Braddis thinks this might be a difficult first project.

"What about a scarf or some "easy knit" slippers?"

"I don't wear scarfs. I already have slippers. What's the point?"

But Betty Jo sighs and struggles to master the easy garter stitch. The yarn is too loose and slips off the needle.

Knit, purl, knit, purl, knit, purl...

"Any new hobby takes time and patience and practice. You'll see your skills and confidence

increase. You'll enjoy doing this when you learn to relax."

"Knit, purl, knit, purl, knit, purl...This is boring, too!"

Betty Jo doesn't know what it means to "go crazy" but she knows why it happens. She is certain that knitting is causing all of the craziness in the world. Once again she makes a break for the door, runs outside, jumps on her bike, and peddles as fast as she can to catch up with her friends.

It is time for a family intervention. Her mother, one grandmother, and her aunts just don't know the best ways to teach Betty Jo.

"Send her to Taylorsville to spend the summer months with Grandmother Duckworth who has created quilts that win blue ribbons at the state fair. Granny Duck will teach her to quilt. She is a famous quilter in those parts."

Betty Jo packs her suitcase and boards the Trailways bus to Taylorsville. Granny Duck meets her at the bus stop downtown in front of Granddaddy's store where they can buy material. Betty Jo selects three of the brightest colors (red, blue, yellow) from the bolts of cloth. When they arrive at Granny Duck's house she first learns to thread the sewing machine...which is harder than it looks.

Granny Duck begins by saying that "accuracy is important. Leave one-fourth seam allowance on each of the cut pieces. We will use two shapes (square and triangle). *Be sure* to join your shapes, the right sides must go together when you place them on a flat surface and then put the layer of batten under the top part of quilt. Be *sure* to sew at the first corner where you have pinned the cloth together and *be sure* to backstitch your first stitch

for added strength ... *be sure* to baste ... *be sure* to extend for four inches ... *be sure, be sure, be sure, be sure* to remember how to assemble the quilting frame and begin quilting."

But Betty Jo can't cut the strips straight. She refuses to measure anything. The batten hangs out from the stitches. She wants to finish it in one day.

"No, no. Honey! You are supposed to enjoy this."

Boring, boring, boring... Before her grandmother has completed the last set of instructions Betty Jo has disappeared.

Family members are concerned. It seems that Betty Jo gets impatient with anyone who tries to help her. Perhaps there is something else they could try.

But wait! Wait! We have an idea! There is a new home economics teacher at the Junior High School. The students really like Miss Varnadoe and we hear she is a great teacher. She will teach Betty Jo to sew. Yes, Miss Varnadoe will be just the ticket.

"We will make a ballerina skirt."

Miss Varnadoe is young and pretty. She smiles all of the time and is thrilled to be teaching another group of young women the art of sewing. Betty Jo chooses blue fabric to match her eyes. The pattern looks easy and the skirt will be perfect with her ballerina shoes. She selects some "flowing" material that will look great on the dance floor.

But this is boring, too. Miss Varnadoe said to *carefully* measure the radius of the circle; *carefully* measure the elastic for the waist; *carefully* put her pencil in the hole at the end of the measuring table; *carefully* hold the tape in her left hand and the

pencil in the right. "As you begin to treadle *carefully* ease the elastic into the waistband."

But Betty Jo can't sew straight. She doesn't measure. It takes too long to baste the hemming tape so she doesn't base the hem. Instead, she just folds that hem down and starts peddling and sewing. When the fabric skips from the needle, Betty Jo won't "undo" her errors. She backs up and keeps sewing. She peddles that treadle as fast as she can. She just *lets her rip! And she finishes first!*

When Miss Varnadoe sees Betty Jo's skirt, she starts laughing. She can't stop. As the students reflected on the situation, the teacher's laughter was more like hysteria. Miss Varnadoe took Betty Jo's skirt to the principal's office. The students were quiet as they listened to their teacher laughing as she walked downs the hall.

The teacher didn't return to the classroom … ever. Principal Miller announced that she had resigned.

But there were also rumors that she was off in some hospital in Hattiesburg.

Nothing much else was said about it.

Knitting, crocheting, quilting, sewing … none of these talents were inherited by Betty Jo.

Two weeks later all of Betty Jo's aunts, uncles, and cousins were celebrating Thanksgiving at Granny Duck's house. The meal had been served and the dishes were done.

The men were outside. Some went hunting, others were smoking cigars and others were taking their pint Mason jars and going to and from the trunks of their cars for something or other. Their laughter could be heard all the way inside the house.

The women were talking quietly in the dining room. Betty Jo's aunts, grandmother and a few grown-up cousins were sitting around the table drinking their last cup of coffee. When the voices get low Betty Jo knows to listen. That is when things are discussed that adults don't want children to hear.

Betty Jo's mother, Ethel, said, "I just don't know what's wrong with her. She simply can't sew. She wants to be a doctor. She wants to climb trees and ride bikes with the boys in the neighborhood. She says she is not going to college at an all-girls school. Neither is she going to stay home her whole life to raise her babies. She talks too loudly. She opens her mouth too wide when she laughs, and she has some unusual friends. She dreams about having a 'career,' whatever that means."

Betty Jo appeared in the doorway. With a determined expression and tears in her eyes, she announced, "Mamma, leave me alone. And don't worry. You will see that there is nothing wrong with me."

And as the years passed … her Mamma agreed.

―――――――――――――――――――――

In spite of the sewing situation, my life in Jackson was "looking up." The seventh grade at Bailey Junior High School allowed students to select some of their classes and to have more than one teacher. I enjoyed walking the halls to change class. There were a couple of boys I liked and I figured out how to assure I passed them during the class change.

I was surprised and felt nervous when I saw the posters in the hall announcing the *Fall Frolic, a dance*. I knew that to go to the dance a boy had to ask me.

What if nobody did?

FIRST DANCE

Two months after my first kiss in Taylorsville I enrolled in the seventh grade at Bailey Junior High School in Jackson. We got our calendars for the year and one of the first events was the fall formal. Mamma had already sent me to Floretta Baylin's ballroom dancing class in the sixth grade, so I and twenty-six other neighborhood school mates had learned several dance steps. We also knew our manners (girls wait for boys to open the doors, and boys had to lead in dancing).

The wait began. I wanted to go to the dance but also knew that I couldn't go unless a boy asked me. What if no one did? What if I took all those lessons and mamma made me this beautiful lavender, purple and violet checked taffeta dress and no one asked me. When I went to school I started talking to more boys; I could not bear the thought that no one would ask me. These were feelings I had never had before.

"Betty Jo, you have a phone call." Mamma was calling me home from the church playing field across the street from our house. I threw down my baseball bat and darted inside. Whoever it was would just have to talk to me in a hurry because it was my turn at bat and our winning run was on third base. Before I picked up the phone, I stopped, noticing Mamma had a funny look on her face. I stared at the phone. Then I got a funny feeling in my stomach and my heart began to pound! Could it possibly be someone asking me to the Bailey Junior High Fall Frolic?

Yes! It was Donny Healy. He was the fastest boy in school; that is, he was on the track team. I remember cheering for him when he ran and won

the mile. He seemed nice. I immediately accepted the invitation, swooped through the living room to tell Mother and Daddy the news, and ran back outside to continue my baseball game.

I really wasn't particularly excited about having a date. But I was relieved that I could tell others I had one and I was also proud that it was Donny Healy. I knew that I couldn't outrun him, but if he tried any of those "post office" games I had heard of, I knew I was strong enough to push him down. So… back to my ball game.

Daddy smiled when he heard that I was going on my first date. I thought he acted very sensibly.

Mamma, on the other hand, began uttering phrases concerning my "growing up" and decided the dress she had already sewn would not be appropriate since she heard from her friends that most of the girls were wearing long dresses. So, she began sewing again. This time she designed a pink full length taffeta with a blue off-the-shoulder ruffle at the top. When I tried it on we also "experimented" with a little lipstick and eye shadow. I was pleased at my transformation.

The night of the dance Mamma was determined to make me look as feminine as possible. I put on my pink and blue ruffled formal, my first pair of nylon hose, my own Revlon Fire and Ice lipstick. I whined and squirmed when Mamma stuck a pink bow in my hair. The last accessory she presented was a bracelet for me to wear.

I said, "No!"

"Remember, Betty Jo. Don't forget to wear a bracelet. That might just be the little extra sparkle that catches a boy's eye." *(And, believe it or not, from that night until this very day, I have worn a bracelet!)* Although Mamma was ruining in one night my

distinction of being the toughest girl on the block, inwardly, I was pleased with the effect.

The night of the dance, Mamma had it all planned out. When Donny rang the doorbell, Mamma would answer the door. When she called me I would gracefully descend the stairs. This was known as "making an entrance." I played her game because I didn't want to spoil Mamma's fun. Actually, I was beginning to enjoy all of this myself!

Donny arrived and I was summoned according to Mamma's plan. I'll never forget the appearances of the three people I saw in the living room. My mamma was beaming ridiculously at her daughter who had "grown up." Donny was dressed in a suit and bow tie with his hair slicked down and parted! He looked miserable. I knew what he had endured. We looked at each other and seemed to share one another's feelings at that moment.

Daddy was eating an apple and was resting comfortably in his old bathrobe and slippers. For only a moment I wished that I could curl up in his lap for a cozy evening of good old man talk or some reading of Mark Twain.

Donny awkwardly helped me into my coat and we started for the dance. Forgetting to properly lift my skirts, I began jumping down the front steps two at a time. I never got past the first two steps. My legs went sailing over my head and I landed in a heap in the midst of our marigold bed. Donny laughed and at first I wanted to silence him; then I realized it was, indeed, funny and I began to laugh, too. Hearing the commotion, Daddy came outside, set me on my feet again, and pointed me toward Donny's daddy's car. No harm was done to my dress. As Mr. Healy drove us to the dance not a

word was spoken by anyone in the car. We silently made the trip to the Bailey Junior High School gymnasium.

The fall formal dance crowd had gathered by the time Donnie and I arrived. I was relieved to see some of my girlfriends who had congregated along the left wall. Rushing toward one another we admired all our new dresses, and then dashed to the bathroom mirrors for one last look at ourselves.

The music began. Donnie approached me, asked me if I could do "two to the right and one to the left." I could. This was our step for the duration of the evening. We never spoke during our dance. Each time the music ended we parted. I went to the left wall as he met his buddies on the right.

After what seemed hours of small talk with the girls, the refreshments arrived. Although there was food enough for everyone, the usual crowd was pushing for first place in line. I was relieved and pleased that the old gang still had a little spirit left. We party goers spent the remainder of the evening munching doughnuts, and, when the chaperones weren't looking, throwing food across the room at the opposite sex.

The band played its final number "Good Night Sweetheart" as we continued doing "two to the right and one to the left." I spied Donnie's dad in the doorway who had returned to chauffeur us home. Donnie and I, relieved at his presence, hurriedly left the dance floor, grabbed our coats, and raced to the car. I think I could have beaten him if I hadn't been wearing a pink ruffled formal.

The next morning I awoke to the shout of "slide in home!" A baseball game was already in progress in the church yard. I ran down the stairs,

grabbed a few Cheerios, and joined the game. Mamma shook her head in resignation. My daddy winked at me as I sailed through the kitchen. He and I both knew it would take more than the Junior High School Fall Frolic for me to "grow up."

Moving Again

One day Daddy came home and dashed into the kitchen to tell Mamma some great news. He was excited, thrilled and honored to have been offered the job of Director of the National Rehabilitation Association. We would be moving to Washington, DC. That night I heard Mamma and Daddy arguing. Mamma said she wasn't going to move up north.

"Oh, Yes, Ethel, you will move because our family must stay together. And I am going."

At that very moment I knew that when I was a grown-up I would always be prepared to "make my own living" just in case I didn't want to move.

Thus, my seventh grade year turned out to be my last year in Jackson. In some ways I was sorry about leaving because I was getting my first taste of popularity, thanks to "Betty at the Baseball Game" and my interest in drama.

I do believe, however, that it was best for me to leave Jackson. Although mother loved that city and didn't want to move again I was becoming aware of social class differences that could have been problematic. There were wealthy families in Jackson who had lived there for generations and who had attended the same exclusive colleges together. Occasionally there were parties to which I was not invited. I was fun and funny and popular and I could get a party going. But even then I recognized that I might never be in the "in" group.

Arlington, Virginia 1946

Washington Did Have Some Advantages!

After I completed the seventh grade, my parents and I moved to Arlington, Virginia, where my daddy had a new job in Washington, DC. The nation's capital was a wonderful place to live. There were no obvious social class differences. (In my world I was never aware of the "other Washington" where some children were enduring extreme poverty and attending sub-standard schools.)

Everyone in the DC area was from some somewhere else. There were no "select" families who ran the schools, churches, social groups. I did not realize until years later what a great environment this was for me. If I could do the job, I got the job! It was of no interest to anyone who my parents were or who my Mississippi grandparents were. Everyone who lived there had an important Daddy. We all took that for granted. You could be in the "in group" if you were fun, and friendly, and nice to everyone. That is who and what I tried to be; and it worked.

Washington was an amazing city filled with monuments, galleries, museums, the Potomac River, Mt. Vernon, Arlington Cemetery and the Tomb of the Unknown Soldier, the National Theatre, the Smithsonian Museum and Museum of Natural History, Great Falls, the zoo and botanical gardens. The breath-taking beauty of the cherry blossoms along the tidal basin was a "sight to behold." Mamma and Daddy wanted to hurry to see it all! Every weekend we went someplace special...sometimes just for fun. At times it was educational (for my benefit) which wasn't as interesting!

Television

Television

But what amazed me the most was having a television set. This new invention had not arrived when we were in Mississippi. Daddy bought us an Emerson with a 10 inch screen and we looked at everything: Kookla Fran and Ollie; Name that Tune; I Love Lucy; Dave Garroway; Jackie Gleeson; Jack Benny; Sid Caesar; Captain Kangaroo; $64,000 question (until we were devastated to know that corruption had entered the television arena). In order for me to get "snow" out of the picture I learned

how to work the rabbit ears for the different weather conditions, times of day and the individual programs on the schedule.

Southern Accent

I enrolled in the 8ᵗʰ grade in Swanson Junior High School, Arlington, Virginia. My parents bought a house on Edison Street in Arlington Forest and I rode the school bus to school. (*One year later we moved to another house on 16ᵗʰ street. When I completed college, they built a beauty (!) on Forest Drive in McLean, Virginia.*)

When I moved from Mississippi to Arlington I didn't realize that I had a southern accent. I just reveled in all of the attention I was getting. I do admit when I realized what was happening I began to exaggerate my southernisms! One day when I was riding home on the school bus I was being teased by the other students on the bus.

"Say something! Say something!"

"Wale, wha' ch'all want me to sa-ay?" I just loved it.

Once on the bus when I was being teased, someone shouted, "I bet you never even had any shoes 'fore you moved to the big city."

"Yep, thaaa's rite! When we knew we wuz-a coming to Warshington, Daddy took Mamma and me to town to buy us a pair of shoes!" And, of course, everyone laughed again.

When I got off the bus at my stop, my new girlfriend Jeanne and I were walking home when she said with great and sincere compassion, "Betty Jo, didn't you have any shoes until you moved here?"

I was stunned. "Of course we had shoes! Yes! Yes! I wore shoes from the day I was born!" Imagine that. And I believe that even today there are still feelings that southerners are uneducated and uncivilized when compared to citizens in other part of our country.

The Fall Picnic – Ronald or Billy?

The first dance at Swanson Junior High was coming up in October. I needed to get myself a date. I seemed to be getting off to a successful beginning at school. Thus, I believed I could attract a successful, popular, good-looking date. Ronald Johnson was my ideal. Yep, he was the one I was going after. Ronald was a tall, handsome track star who already knew my name. No doubt he would be my perfect date for the first dance.

"Hmmmmm, now how am I going to meet him? I know I can attract his attention if we can just get together."

There was to be a "fall picnic" to be held three weeks before the dance. The planning committee for the picnic was announced. Ronald was on the committee, but I wasn't. I asked Miss Elliott if I could be on the picnic committee, too. She smiled and was very pleased that I would volunteer. Furthermore, I asked Mamma if we could have the first planning meeting at my house (along with a party). She agreed that our recently renovated downstairs recreation room would be perfect for the occasion.

The committee members and Miss Elliott were pleased to be invited to our home. Mamma and I were in a quandary preparing the battleground (?) for my certain conquest. She made a big chocolate cake to serve with ice cream, and we selected some good records to play on our phonograph. Everything was ready.

Ron was the first to arrive. That *must* mean something! Perhaps that indicated a sure sign of his affection. He smiled at me. I could detect the hidden meaning in his smile. The other committee members arrived and the last to appear was Marie Kelly, a silly not-so-smart girl who had just moved to Arlington from Sacramento because her Daddy had just been elected to Congress. Well, she was very pretty (prettier than I was!), and was already wearing a D-Cup. Ronald's eyes left mine and they were never to return again. He pursued Marie vigorously; she gloated over her victory. I was furious and sad. All of my plans had failed. Ronald Johnson left early and Marie along with him.

Well, he wasn't all that great anyway. As soon as I ate the left-over chocolate cake, I would just turn my attention to Billy.

Billy

Billy Green invited me to the dance and he liked me. I had heard through the eighth-grade grapevine that he was considered a "dreamboat" and the girls assured me he would be a good date. In those days it was always a good idea to date athletes and Billy would be on the basketball team in just two more months.

Billy was afraid of my daddy. Whenever Daddy spoke to him, he would either flinch or jump. There was little Daddy could say to him so Mamma and Daddy agreed to carefully plan their conversations ahead of time in order to be gentle and not frighten him away. I told them that a boyfriend was hard to find these days and they should be careful not to interfere in any way.

Mamma's first question about a potential boyfriend was always "Is he from a good family?"

That was the standard question in Mississippi and it was always possible to answer. Family was important in Mississippi. The wonderful thing about Arlington was that everybody was from somewhere else. So there *was* no answer to that question! But I can report the Greens were a wonderful family. (*Billy later married a beautiful, intelligent, gracious woman who was in my high school sorority (Argo) and I continue to still see the two of them at high school reunions.*)

Hayrides and a Promise to God

After dating Billy a few times I realized I really liked him! In fact, I loved him as much as a girl in Junior High could love another boy. He took me to the Hot Shoppe for hamburgers and milkshakes. My corsages were always the nicest and the most beautiful when we went to the Junior Recreation Club (JRC) dances. Billy was on the basketball team which also enhanced my social position ... resulting in even more parties and dances to

attend. Billy's father was always present to drive us wherever we went. Mrs. Green (his petit beautiful mother) and his cute little sister always welcomed me into their home. Yes! I was a success.

Billy and his family taught me that what you think you want (Ronald) might not be as good as what you eventually get! My first boyfriend, Billy Green, turned out *great*. Yes, he was much better than that shallow Ron Johnson could have ever been.

During the fall of the year going on hayrides to Great Falls were popular week-end excursions. I had never heard of hayrides and, wow, they were amazing. About fifteen couples rode in the back of a huge truck, snuggled under blankets, to arrive at Great Falls, Maryland, for wiener roasts. We would hug and kiss all the way to Great Falls, hop out of the truck, build a fire, and roast and eat a couple of hotdogs out on the shore of the falls. After a "quick bite" couples disappeared into the darkness as they placed their blankets out on the rocks to watch the water rush over the rocks. That was the first time I had ever really kissed a boy…in the hay…in a truck…by the fire…on the rocks. When it was time for the truck to return to Arlington we heard the sound of our truck horn (two longs and one short), and we would run to the truck to hug and kiss all the way home.

When we got back to the school, Billy's parents were always waiting to pick us up to take me home. I always wondered if others could tell that I had been hugging and kissing.

An unfortunate result of my first kissing episode was that I got poison ivy all over my face resulting in puffy lips and eyes that swelled shut. I had to stay home from school for five days. I prayed and prayed for God to make me normal again. I promised God that if he would just keep me from being deformed, I would never kiss a boy again.

Once a month the JRC (Junior Recreation Center) had a dance. After the dance Billy and I and others would walk the six blocks to the Hot Shoppe for A&W Root Beer (5 or 10 cents) and a hamburger on a fresh toasted roll (25 cents).

1948

FAMOUS FOR

A & W ROOT BEER...5c & .10
FROSTED A & W ROOT BEER, Extra Thick with Rich Ice Cream...... .25

Soups and Appetizers

Hot Shoppes Oyster Stew with Saltines .. .60
Fruit Cocktail.............. .25 Chilled Grapefruit Juice10 & .20
Today's Soup, Bowl20 Chilled Tomato Juice10 & .20
Orange Juice10 & .20 Fresh Shrimp Cocktail......... .35 & .65

Hot Sandwiches

TENDERLOIN STEAK SANDWICH on Grilled Roll,
 French Fried Potatoes, Tomato Garnish................................ .65
CHEESEBURGER on Grilled Roll .. .35
HOT SHOPPES BARBECUE PORK
 with Hot Sauce and Special Slaw on Hot Roll....................... .30
HAMBURGER on Toasted Roll.. .25
Hamburger Royal on Grilled Roll with
 Special Dressing, Lettuce and Tomato.................................. .35
HAMBURGER STEAK SANDWICH with French Fried Potatoes,
 Sliced Tomato and Onion45
Steamed Frankfurter on Hot Roll with Mustard or Special Relish15
Fried Egg Sandwich on Soft Roll.. .20
Fried Ham and Egg Sandwich on Soft Roll................................ .40
GRILLED AMERICAN CHEESE... .20
HOT MINCED BEEF SANDWICH with Gravy,
 French Fried Potatoes, Tomato Slice Garnish55

Toasted Sandwiches

Made with Enriched Rye, White or Whole Wheat Bread

Tuna Fish Salad with Pickle Sticks.. .35
Bacon, Lettuce and Tomato .. .40
Cream Cheese and Jelly.. .25
Egg Salad with Lettuce... .20
Sliced Chicken, Pickle, Radish Rose Garnish and Potato Chips......... .75
Small Club .. .85
Ham Salad on Toasted Roll, Lettuce25
Lettuce and Tomato.. .25
Liverwurst.. .25
Chicken Salad with Lettuce .. .35

Hot Shoppes

The first night after the hayride and after the JRC dance I thought about my promise to God. But I kissed Billy four more times anyway. I prayed and waited and prayed and waited to see if God was going to punish me again. But he didn't.

Billy and I dated for almost two years. One Christmas he gave me a short sleeved, pastel blue cashmere sweater and a small bottle of *Chanel #5* perfume. I was so happy that night I have worn *Chanel* since that day. Each time I wear it I continue to feel some of that adolescent happiness.

The Swanson Log

Swanson Junior High had a student newspaper named *The Swanson Log*. The paper included items about the current national and state news and a few advertisements. But the part we all loved was when we found our names in the paper.

On October 21, 1949 (the day after my birthday!) the Swanson Cheerleaders were announced and "introduced." **Betty Jo Whitten** *is our Southern Belle who likes cheering to let out steam. She dislikes getting sore muscles from cheering (who doesn't) and thinks the skirts are "snazzy." Hello Central is the best cheer by her standards. This cute little blue-eyed gal was born in Hattiesburg, Mississippi, on October 20, 1935. Since then she has lived in McLain, Union and Jackson, Mississippi, besides Arlington, Virginia. Her favorite animal is Nicky, her Spitz dog. Her favorite sport is Ping-Pong. Betty Jo's ideal boy must be five foot nine inches, have real dark brown hair and long eye lashes. Her favorite pastime is going out with Billy Green, preferably to the JRC to dance and to Hot Shoppe for a milkshake. They also like going on hayrides. Her favorite subject is definitely not algebra but home room. She is very fond of Gussie (Mr. Gustafson, the science teacher.) When she grows up she plans to go to Yale University and study to be a dramatics teacher before she becomes a housewife.*

And in the section called SWANSON STEADIES, *Betty Jo and Billy seem to be quite a steady couple around the halls of Dear 'Ole Swanson. They met when they were in their 8A-5 Homeroom and started going steady one year ago, this last October 20, which happens to be Betty Jo's*

birthday (nice present). Their favorite song is "Stardust." She calls him Billy and he calls her Speedy. Best of luck to this cute couple.

Swanson Junior High Cheerleaders

I was thrilled to be elected a Swanson Cheerleader. Of course, Mamma and Daddy were at the first football game to watch me cheer. I felt beautiful as I was jumping and twirling and doing cartwheels as the football game progressed. At one point when the home team had the ball I was cheering, "Push 'em back! Push 'em back, waaaaay back."

When I got home after the game I dashed into the house to hear Mamma and Daddy tell me how great I was at cheering. But instead my daddy said, "Thunder, Betty. Don't you know how the game is played? You don't cheer 'push 'em back' when your own team has the ball." Then he sat me down to teach me the game of football. I continue to enjoy attending football games. And thanks to my daddy, I understand the game!

Betty at the Baseball Game

I wanted to be popular and continued to make the most of my southern accent. I resurrected 'Betty at the Baseball Game' and performed in school and community talent shows where I continued to "bring down the house."

Television was just becoming popular when the Shoreham Hotel in Washington, DC, sponsored a talent show. All of the area schools could enter one contestant and I won for Swanson Junior High enabling me to advance to the next level of competition. I made it through to the finals where there were five contestants who would perform on television. The "public" could vote and there was money to be awarded the winner.

Mamma made me another beautiful long taffeta dress. I went to the television studio and for the first time saw my competition. There was no audience at the TV station; and that was important for me. When people started to laugh during my performances, the laughter would be contagious and soon everyone in the auditorium would be laughing. I do believe my timing was off when it was my turn to preform; but I did my best. The next week, the votes were in and I lost…second to a great Negro quartet. That was a great experience for me. For a short period I talked to one member of the quartet several times on the telephone. That stopped. I don't remember why.

Popularity

I sacrificed some of my principles to be popular. I played the role of the puzzled, sort of dumb, pretty (I was just realizing that was happening), and funny girl. I was elected an officer in my home room and was not particularly disturbed that a boy was president and I was secretary.

Betty at the Baseball Game - Shoreham Hotel, Washington, D.C.

I was also elected Miss Swanson Junior High School and some of my "friends" said that I didn't deserve it. They reported that I wasn't really the most popular girl in the 9th grade, but because I was nice to the students in the eighth grade who voted for me. And all of that was true.

My Red Velvet Dress for the Valentine Dance at the JRC

Mamma Designs My Clothes

Mamma was an excellent seamstress and designer of clothes. My clothes were always originals and my red velvet dress was a beauty. If I went to the movies and saw a dress I liked, Mamma and I would return to the movies. She would sketch the dress, and sew one for me when we got back home. Usually the dress she made was even more beautiful than the one in the movies.

She had a wonderful influence on me and I still think of her each day when I wear a bracelet…a requirement when I lived with her. Still today, whenever I get noticed by anyone, I always assume it was the bracelet that first commanded attention.

Mamma made my most beautiful dress when I was in the ninth grade. I went to a movie, *My Foolish Heart,* starring Susan Hayward who was wearing the most gorgeous dress I had ever seen. I dashed home to Mamma, she grabbed her sketch pad and we returned to the movie.

"Mamma, pay attention! Here it comes!"

And when Susan began to sing, Mamma sketched. The very next day we went to the sewing shop to purchase the fabric. The skirt had three layers of net (pink, grey, and blue) that literally shimmered as Billy and I swirled around the dance floor. I have never felt as pretty as I did that night. In fact, I thought that I might be beautiful.

Within one week three mothers had called Mamma to see if she would make their daughters a dress. Mamma was very nice when she told them, "No."

Junior Prom Formal

Washington-Lee High School

ARLINGTON, VIRGINIA 1950

Washington-Lee High School enrolled 3,600 students and was one of "the best" in the country. The first year I attended there was an article in *Newsweek Magazine* about our school. The student academic scores and personal achievements were exceptionally high. The levels of teaching were considered exemplary. Many of the teachers had a Ph.D. I really didn't realize what an advantage we had. We just went to the neighborhood school and thought no more about it.

As soon as I enrolled at Washington-Lee High School there was sorority rush. I do not remember much about the rush process. I thought that the "best" one was Argo and I was thrilled that I was selected. There were other "good" ones, too. At the time I did not think much about how exclusive all of that must have been for other students. For sixty years I have remained in contact with a few Argo members. We always had a great deal in common...and we still do.

249

Boyfriends

I had three boy friends in high school. The first was Tommy, an exuberant red-headed guy who went to our church, loved tinkering with cars, and my mother really liked him. She told me not to tell anyone in Taylorsville, Mississippi, that I was dating a Sullivan. Granddaddy Duckworth always said that he "didn't have much for the Sullivans." There is an area named Sullivan's Holler near Mize, Mississippi that has been written about in literature, whether truth or fiction I never knew. Probably a little bit of both.

Three months later I had another boyfriend, also named Tommy (Daddy called him "Tommy Two) whom I really loved. He was on the student government (president his senior year), and was captain of the W-L rowing crew that practiced and raced on the Potomac in the spring time. It was great fun to go to the Potomac Boat Club to watch the practices. The crew members always had a spring party at the boat club. I was one of four nominated for crew queen. I thought I had a good chance at this one! When the queen was crowned…alas, she was not me!

One of my unforgettable heartbreaks was when Tommy Two broke up with me and shortly afterward asked Ruth Morton to be his date on the crew team hayride. I loved him more than I had ever loved any boy up to that time. For the first time I understood what is meant by a broken heart… and my heart was truly broken. I was sure I would never get over it. And although I did get over it, I never forgot it. I think the lifelong lesson for me was that at any time *"it"* could be over. I have never felt really secure or totally safe in any relationship since that time.

At the very end of my sophomore year I met Jim. I really, really, really fell in love again. I will never call high school romances "puppy love." Jim was the fun-loving co-captain of the high school football team and a class officer. He owned and drove a little green Crosley. There were days when he would leave football practice and some of our gang would have picked up his car and placed it on the sidewalk.

Maryland Crab Feasts

Jim had attractive fun-loving parents. His grandparents lived on the Eastern Shore of Maryland where all of his family members looked forward to events where they would catch and eat crab. Or at least, his family and friends were eating crab. I had never seen anyone tear into an animal like that. Looking at the entire event made me nauseated. The first time I went to his family crab feast his grandmother approached me and whispered, "Would you like a hamburger?" And I said, "Yes, mam."

Jim and I dated throughout high school and for the two years I was at William and Mary. We loved each other as much as any two young people have ever loved. The time, however, wasn't right for us to be married. I wanted to be a speech therapist and he had plans to attend graduate school. We parted after our sophomore year in college.

I continued to see him at our high school reunions. He married an appealing woman and as far as I know he had a happy marriage. I continue to feel great affection for him whenever I see him or hear news about him. I guess timing is everything!

Extra-Curricular Activities

I knew that I needed to make good grades at W-L in order to be accepted into a good college. Our school counsellors informed us that extra-curricular activities were also important. These activities were listed under our names in the Annual Yearbook Publication *(The Blue and Gray)* and were a part of our college application forms. I joined everything (and so did two Billys… Armbruster and Wildhack).

The Blue and Gray Yearbook Staff

I greatly benefited serving on the Board of Editors of the yearbook staff. The organizational skills of getting out a yearbook, meeting deadlines, and writing with accuracy served me

throughout my life. (When I was an adult employed in a University setting I was assigned to write the documents for accrediting teams. I always remembered some of the skills I learned on that yearbook staff.)

I was pleased to be elected Best All Round Senior Girl in the superlative section of the Blue and Gray yearbook. The write-up in our school paper also emphasized I that I was a cheerleader, a Thespian (drama), the Spanish Honor Society, the Tri-Y and Y-Teens club, the Interclub Council, Kalagethos (leadership and scholarship), Junior Play, and the Inner Club Council, I went to Girls State at Virginia Polytechnic Institute in Blacksburg, Virginia, where I was elected Mayor of my city.

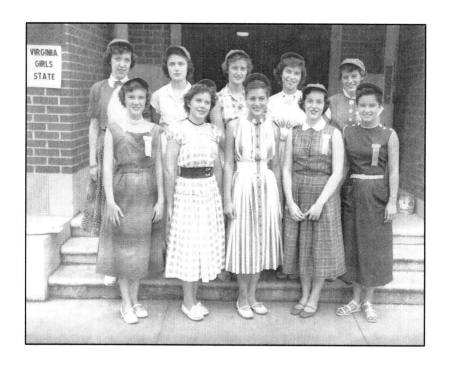

Virginia Girls State
Virginia Polytechnic Institute, Blacksburg, Virginia

The Student Council Election

In the spring of 1952 I conducted a great campaign to become elected to the Student Council. My best girlfriend, Marjory Helter, was my campaign manager and she was terrific. She just knew how to do it.

The most important high school officer was, of course, President. I knew that would, for sure, go to Tommy Thayer. I did not want to be the secretary because that was always a girl. So I would run for Treasurer.

Mamma said, "No, Betty Jo. You won't win treasurer; that always goes to a boy; boys always handle the money in life and that is also true in school."

"No, I will run for Treasurer."

"Betty Jo, just stop fighting it all of the time. Be happy with Secretary. You could win that one, and you know that you cannot beat Ross Canady. Why his Daddy is a banker! Of course, he will win."

"Ethel, leave her alone," said Daddy.

Election Day I ran against three boys; then there was a run-off with me and two boys; another run-off with one boy (Ross Canady) and I won. I beat a boy for treasurer which was unheard of in that day.

One of the great shocks and disappointment of winning that election was that Miss Evanston (she never liked me, really she never did) told the other teachers I "had" too much. She wouldn't allow me be a cheerleader my senior year. I tried out for cheerleading, the ballots were counted and I made the cheer squad. But Miss Evanston stood firm. She would not let me cheer. And that was that!

The only reason I really ran for the student council was to get my name "up" so that I could be a senior cheerleader. When I went to the tryouts, my whole body was actually shaking when Miss Evanston told me I couldn't cheer. I know that I missed so many exciting and fun experiences by not being allowed to cheer for my co-captain boyfriend, Jim.

Washington-Lee High School Student Council – 1952-1953
Top row – Fletcher, Ebert, Maines, Lynn, Huppuch
Bottom row: Whitten, Whitten, Thayer, Stump

I haven't yet forgiven Miss Evanston for that. Perhaps I will get over it in a few more days.

Jack Jeglum, Pasadena Playhouse

MR. JACK JEGLUM

UNIVERSITY OF ALABAMA AND THE PASADENA PLAYHOUSE
@
WASHINGTON-LEE HIGH SCHOOOL

I had a continuing interest in Theatre and was tentatively making plans to go to Yale to study drama. (I hadn't yet realized I had no chance of attending Yale because Daddy's philosophy was that there were more good schools in Virginia than

in any other part of the country and I would pick one of them.)

I made an attempt to get rid of my southern accent because I realized it limited the type of role in which I could be successful. I had a great drama teacher, Jack Jeglum, who wrote a character in a play just for me.

I played a southern woman named Apple Blossom Bryson in *Korean Rhapsody*, a play in three acts focusing on women who were in the army during the Korean War. There was a national and political controversy regarding whether women should be fighting on the front lines. Jack reveled in the controversy.

"My name is Apple Blossom Bryson"

There was a great deal of humor in the play as well as some political information that I didn't understand even though I was in the play. As the

play concluded, the actors exited the stage one by one after which a shot was heard that was to have killed each one of us. The play was controversial; the audience was stunned at the finale. Some attendees said the play was just too "rough" for high school students to see or to act in. One night we got a standing ovation. Another night there was some applause but no curtain calls. Mamma attended each of the four performances.

Mr. Jeglum was the most stubborn, self-centered, egotistical character one could ever meet. Yet I could not help liking and respecting him. After holding class for one week, Mr. Jeglum was known to each of Washington-Lee High's 3,600 students. Jack's class (yes, he wanted us to call him Jack) was always interesting and unpredictable which was an unusual situation in high school. The jokes he told in class were refreshing and often risqué, and he immediately became one of our high school crowd, an unusual position for a teacher.

Jack modestly admitted that he was a genius. He had attended the University of Alabama and Pasadena Playhouse. Furthermore, he had played the leads in all of the productions of both institutions. He had been (he said) a big hit in several Broadway plays, not to speak of the hundreds of radio and television plays in which he had taken part. Yes, he admitted, he was the most talented showman he had the fortune to meet and he had met them all.

Their names were Helen, Lionel, and Mary rather than the conventional Miss Hayes, Mr. Barrymore, and Miss Martin. And he knew of their private lives. None of his theatre friends wasted time being faithful to their own mates, but did all possible to "broaden their horizons." Jack

answered all of our questions about these "greats" we cared to ask, but there was one question he would not answer. That was, "If you are so talented, why are you teaching in high school?"

It seemed clear to me that he deserved the high school expression of the time. "Heap big smoke, but no fire."

Still, I was curious to know his ability as a director. Try-out time arrived for the first W-L production. There were perhaps one hundred young hopefuls trying out for the role of leading lady. Mr. Jeglum announced that the lead would be a curvaceous female and told the undeveloped girls to return in a few years. Needless to say, this remark was the cause of fiery reactions from irate mothers.

The play was cast and as a director Mr. Jeglum proved to be always strict...even mean and cruel at times. One rehearsal missed and the actor went on probation; two missed and he/she was removed from the play.

Jack worked to perfection. When his first production was presented the audience was amazed at the professional qualities his play contained. Mr. Jeglum presented more and more plays...dramas, comedies, musicals, fantasies and even a dance pantomime...each tops in its category. He was proudest of the two productions he had written himself. Oh yes, he was a playwright, his pen name was George Stone.

Jack Jeglum hated tradition. While at W-L he abolished class plays and the Elos play (the annual production of the literary society). He insisted that if, on the first day of school, the principal fell flat on his face coming in the door, that for the rest of

the duration of all time, all principals would follow the same pattern.

His disrespect toward his fellow faculty members was evident. He made fun by naming them animals which, he thought, suited their personalities. There were old crows, panthers, kangaroos, and jaybirds roaming our halls. The students enjoyed this as much as the faculty resented it.

"Southern accents make people sound and look stupid." He said this frequently. So frequently, in fact, that I believed him and worked diligently to lose mine. I succeeded, and now I am sorry I lost my most powerful weapon against "man" kind.

When the school musical was being cast and I tried out for the comic role in Good News. I didn't get the part because Shirley Beaty was chosen. I was extremely disappointed and told everyone it was because she was a senior and I was just a junior. As time passed I started to feel better about that. She just might have been more talented than I was! She later changed her name to *Shirley McLain!!!*

And yes, I did know her brother, Warren Beaty, who was a couple of grades behind me. He was on the football team, and when our high school sorority took their annual summer trip to Virginia Beach he would come to the Argo Sorority House and play the piano while we sang. I didn't know then what a special time that was to be growing up.

Always in the Court – Never a Queen

In High school I wanted to be Queen of everything…the football queen, the crew queen, the basketball queen. I figured that if I found a boyfriend who was on the team I could be nominated for queen. I did find Jim who was very popular, co-captain of the football team, and I thought I had a good chance of becoming football queen. I stood there year after year as they were going to announce the queen, hoping my name would be called. In three years of high school I was in nine courts and I was never the queen…always in the court. My daddy told me if they had a queen of the ones who were never queen, I would win "hands down."

Daddy also told me (too late) that to be a football queen I should not be dating a guard (my boyfriend, Jim, was a guard) but instead the guy in the backfield who makes the touchdowns. Daddy was right. Jane Arny was queen and she dated Doug Sedgewich, who was in the backfield making touchdowns!

Mamma said, "**Elton, leave her alone.**"

I needed a good supply of formal dresses to be in so many courts. My Aunt Hermie was the buyer for the Junior Department at Goldsmiths Department Store in Memphis. She sent me a beautiful red net formal my junior year. My senior year another big box arrived in the mail from Goldsmiths, this time a white formal with a lace bodice and lace panels in the net. It was the prettiest dress at the prom, and there was no question about that. We wore hoops or crinoline petticoats under our dresses.

Mamma designed and made me other dresses made from taffeta or layers of net. They were all beautiful and several girls at the prom asked me where I got them. When I told them "Mamma made it" our telephone began to ring once again with mothers asking Mamma if she would make a formal for their daughters.

Once again, Mamma politely said "no".

The Gold Key and Kiwanis Writing Awards

My greatest academic high school honors were the Gold Key Writing award from the Washington Evening Star Newspaper and the Kiwanis Club Citizenship Award.

My topic for the Washington Star Gold Key was titled "Speak," about speech therapy, a new field of study. At that time I thought that might be interesting to me since Daddy wasn't sending me to Yale.

The topic for the paper I wrote for Kiwanis was on cosmetic face lifts, available for movie stars but not for regular people. The title of my paper was *A New Face*. The last line suggested that by the time I (the writer) was fifty years old, facelifts would be affordable and available for everyone. I knew then that I would get one when I was fifty. And I did…when I was fifty-nine years old.

When I went to the doctor for the evaluation I showed him the paper I wrote in high school so he could assure himself that wasn't just a "fly by night" decision! (*Tom Jones was also a recipient of the Gold Key. We met again forty years after graduation. We both had Ph.D's and were teaching on University faculties. We renewed our friendship and it continues to this day.*)

The Kiwanis award was presented during a lengthy student assembly a few days prior to graduation. I had stopped listening to the speaker as she told us that today our presence in America was a favored one, secure and high enough so that one can see the distant horizons. She warned that we must select our own foundation for the future from which to build and told us of our social responsibilities…to seek for inner peace…and to become aware of the role we must play in today's society…and on….and on…and on. It was a boring assembly program and I was drifting off. When she finally finished her speech she announced the name for the girl's Kiwanis Citizenship Award.

"Betty Jo, that's you."

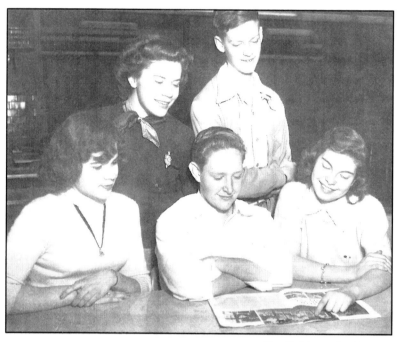

The Washington Star Newspaper

The Gold Key Awards – Whitten, Wells, Parkin, Jones, and Pike

Thank goodness Wanda Williams poked me and I was not completely asleep. When I received my award I saw my mother sitting out in that auditorium. She had already been informed about the assembly and, once again, came to support me. I had wondered why she had sewn me yet another beautiful pink and white seersucker dress to wear for that day. (Guy Allen received the award for the boys!)

Clarendon Methodist Church

In addition to Washington-Lee High School, church was an integral part of my high school life. My dad, mother and I attended Clarendon Methodist Church which was one of the most vibrant churches in the area. My daddy taught the Men's Bible Sunday School class and often chaired the Administrative Board or other committees. Mamma taught Sunday school to young people, sang in the choir, and many of her best friends were in WSCS (Women's Society of Christian Service), a group of women who served the church in numerous ways.

BILLY GRAHAM

There was a vibrant high school youth program at Clarendon. There were approximately thirty high school students in the Sunday morning class and as many as sixty came to the evening program, MYF, (the Methodist Youth Fellowship) where I served as President during my junior and senior years. Students from all over Arlington County met at our church or in homes of members. There were a variety outings, such as miniature golf, swimming, taffy pulls, visits to community programs. One evening Billy Graham was in town and we all boarded a bus to go into Washington to the Uline Arena to hear him preach. I, along with my best friend, Marjory Helter (her parents were as active and influential in the church as mine), had

seats together on the bus and we also sat together in the enormous civic center.

Well, Billy Graham preached. He was amazing, wonderful, spiritual, dynamic, and handsome. At the end of the sermon Rev. Graham invited all who wanted to accept Jesus as their Lord and Savior to come forward to pray at the altar. Margi hopped up.

"Come on, Betty Jo. Let's go!"

"No, Margi. Stay here. You've already been baptized!"

"I'm not getting baptized. He said, 'If you love Jesus, come forward.' I love Jesus and I'm going!"

She slipped out of her seat into the aisle and trouped down to the altar to pray with Rev. Graham. Before any of us knew what was happening, she was snatched away by some of Rev. Graham's workers and was whisked down a long hallway. The Christian meeting ended and it was time for us to board the bus. I was worried that Marjory wasn't with us. Our youth Councilor, Al Dixon, called the roll on the bus, and, of course, Marjory did not answer.

"Where is she?"

"She went off to take Jesus as her Lord and Savior. The last time I saw her she had walked down a hallway in the Auditorium with one of those Billy Graham workers," I explained.

Al looked stricken. "I am going to find her." To the bus driver he said, "Do not let anyone off this bus."

I and the rest of the young passengers remained totally quiet. Thirty minutes later Al returned with Marjory. I had, of course, saved her seat next to me. She sat down and didn't speak. We rode home in silence.

Several days later Margi told me about it. She said when she got in that long hallway she told Rev. Graham's workers that she had already accepted Jesus as her Lord and Savior but they did not seem to understand. They just kept praying with her. They were still praying when Al found her to take her home.

After that experience Rev. Graham's local missionaries visited her house to meet her parents, and tried to tell them about Christianity. The Graham organization kept sending her literature until Mr. Helter (who was a judge and a pillar of the church) sent Rev. Graham a letter and told him to "cease and desist" contacting his daughter.

We all learned something from that experience!

The Methodist Youth Fellowship (MYF)

My senior year I was the president of the MYF and was responsible for organizing the youth activities for the Sunday evening meetings. There was a "youth pastor" hired by the church who was in charge of the meetings. He had no idea whatsoever how to manage a group of high school students. I began to organize the year by selecting books for our study groups, arranging off-campus activities, inviting people to our meetings to speak. Our youth pastor would cancel our activities without our knowledge; said some inappropriate things to us; would agree to accomplish a project for us and wouldn't do it. We also began to realize that he lied to us; and used our dues money for things that we did not authorize or want.

So! I did something that I am still remembered for in some circles. I stood up at a Methodist Board Meeting of adults and suggested that Rev. McDuren deserved to be fired because he was not a Christian. I then listed several behaviors that had occurred,

paired a Bible verse with each of them, indicating that his actions were sinful. I concluded that if the Bible was to be believed, Rev. McDuren was going to hell. I was shaking when I made the speech but I also knew it was all true and someone needed to know.

Before I got home, Daddy's phone was ringing. Some church members had already heard that I suggested one of our preachers was not a Christian and that he belonged in Hell. Daddy was rather pensive and quiet that evening. Later we had a private conversation. He told me that no matter what a person did or said, I was never to suggest anyone belonged in hell.

Mother was horrified. Daddy said quietly, **"Ethel, leave her alone."**

Rev. McDuren never returned to the church and lost his church position. I didn't have the knowledge or maturity to realize that he was mentally ill. Later on he was hospitalized at St. Elizabeth's. I expected to receive a severe punishment. But it was never mentioned again in my home or anywhere else, as far as I knew. When I think of that I feel sad and wish I had not said the things that I said.

Choir Practice

The Youth Choir practice at Clarendon Church was well attended. Dr. Wigent our youth choir director was an accomplished musician who also taught at one of the near-by Universities. We were extremely fortunate to have him as our director.

One night at practice when he left the room, I convinced our high school choir to play a joke on Dr. Wigent. Instead of singing, "As we fall on our **knees** with our **face** to the rising sun......" we should sing, "As we fall on our **face** with our **knees** to the rising sun..." We changed the words of that beautiful, prayerful communion song. Dr. Wigent was furious. He gave us a lecture on the importance of music to other Christians. And that we had blasphemed! Whew! I was so ashamed and prayed and prayed to

God to forgive me for that one. No one in the choir ever told him it was me who had the idea. I appreciated that.

The Ride Home

Our parents would take us to choir practice and we would usually find some of the older boys who had driver's licenses to take us home. One night after choir practice I was flattered that Tom Rockwell and Jim Burnett offered to drive me home. They were seniors and very popular. When I got into the car they began to laugh as they drove in the opposite direction of my home.

Several times trying to sound composed I said. "No, really. I have to go straight home."

They drove out on a country road and stopped the car. They acted as if they were going to grab me. I was terrified. When I screamed they laughed and drove me home. They told me that I deserved to be scared because I was so conceited. They said I just wanted to be in charge of everything and they were teaching me a lesson. Furthermore, I could use a bit of humility and needed to change my attitude. I believe that night had some effect on me.

I saw them about twenty years later at some event in Arlington and reminded them of that experience. They said they did not even remember it, but it sounded like something they might have done.

Sitting in the Back of Church

Every Sunday, after Sunday school, my parents and I always went to preaching. I was allowed to sit with my high school friends and we always chose the very back pew. One inappropriate activity I remember is the time when we had a preacher who paused between his words. I believe he thought he was more profound and effective when he did this!

For example, he would say: " My brethren (1 sec, 2 sec, 3 sec); the good Lord Jesus (1 sec, 2 sec, 3 sec) wants you (1 sec, 2 sec) and allllll your loved ones... (1 sec, 2 sec, 3 sec, 4 sec)...."

Well, you get the idea. During his pauses we would see how many pages of the song book we could turn with the hope of completing the entire Methodist Hymnal by the end of his sermon. We were required to stop all of this because we were making too much noise as we laughed and flipped the pages. From that Sunday on, we were required to sit with our parents.

Hooks Haven

Church activities continued during the summer with opportunities to attend camp at Hook's Haven. Mr. and Mrs. Hook owned some property about forty miles from Arlington in the foothills of the Virginia mountains and located on the Capon River. There was a large lodge where the girls could sleep and rustic cabins for the boys. Hiking trails, a beautiful swimming pool, a crafts lodge, and a recreation center provided all that was needed for a perfect camp experience. We always took lots of pictures with our Kodak Brownie Hawkeye camera. I could play a few tunes on my ukulele during the evening when we sang around the camp fire.

Summers when I was not a camper, I was fortunate to work as a Camp Counselor. I loved being a Junior Counselor to the younger children and also enjoyed attending as a camper. The camp director told my parents that I was particularly helpful in working with children who were very shy or afraid to leave their parents. They told me I could "bring them out" and I believe that was probably the beginning of my later career decision.

One summer my camp duties were to lead the singing in the evening, to teach creative dramatics during the day (preparing a skit to follow supper each night), and to arrange for a swim show on the last night of camp to which the campers' parents were invited.

I was also asked to teach in the craft shop but I refused. I never understood why so many people enjoyed making lanyards. I wanted no part of any of that.

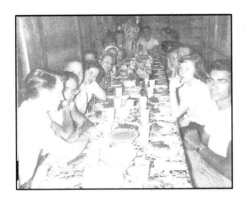

Hook's Haven

The Mess Hall *"I think I see something."*

One memorable event occurred on the last night of camp which was on the 4th of July weekend. I decided on a patriotic theme that included a May pole swim with red, white, and blue streamers. We figured how to get the pole anchored in the center of the pool and we practiced with cloth streamers during the week. While patriotic music played on a scratchy record over the public address system, the swimmers practiced intertwining their beautiful red, white, and blue streamers as they swam. It worked great in practice.

The day of the performance we went to town to purchase some cloth streamers ... seersucker was the fabric. We attached them to the pole and kept them rolled up until the patriotic music began to play. The swimmers swam to the pole, secured their streamers, and drifted back into place. I am not yet sure what happened but the streamers began to stretch when they got wet (they were not supposed to touch the water)...and they stretched and stretched...and the red and blue colors faded in the water which in turn took on a purple hue. It was such a mess that some swimmers just dropped their streamers and swam to the side of the pool to watch the streamers sink to the bottom to get clogged in the drain.

By this time the "Yankee Doodle Dandy" routine was over and the swimmers were supposed to get their flashlights to wave during the "Stars Spangled Banner." They never got to do that. By that time the Camp Director had stopped the routine and sent some adults to dive down to the drain to get the streamers before permanent damage was done to the drainage system. The audience laughed and cheered. The swimmers and I were particularly humiliated.

Now, the interesting part of all of this is that my swim show is the only swim show which has been remembered throughout time. The rest have been forgotten. Just my luck they still remember who was in charge.

A Fire Alarm

Hook's Haven was a great camp for teen-agers. Mrs. Brazil went with us every summer to serve as the cook. She was fun and could ignore some behaviors that our own mothers would have not allowed. We girls slept in the lodge, the boys in near-by cabins. Our great counselors knew we were slipping out and doing a little kissing but they just let things slide unless someone got in the swimming pool or started a car. We knew the rules, and for the most part we high school campers behaved. Our Youth Counselor, Al Dixon, was a great person who seemed to enjoy the time he spent with us.

Hook's Haven had a bell that would ring when it was time to rise in the morning, turn out the lights at night, come to meals, and attend evening vespers. One night my best friend Marjory and I slipped out about 3:00 in the morning and rang the bell. We roared with laughter when all of the lights went on in the lodge and cabins. Our laughter subsided when the fire trucks and police cars arrived from the near-by village. Cars also appeared from the nearby village with townspeople who just wanted to see what was happening.

How were we to know that ringing that bell indicated an emergency to townspeople? Al Dixon walked out and we could hear him talking quietly to the police chief and the fire chief. We

were sitting quietly in the kitchen with Mrs. Brazil who had made some coffee and hot tea for any who wanted it. Al called Margi and me out on the front porch and told us that he should send us home immediately, but he had such respect for each of our parents that he did not want them to be disturbed at this time of night. He further informed us that early in the morning we would each call our parents to inform them we were coming home early. Margi and I were truly contrite; we cried, apologized and begged Al not to tell our parents. By morning we had all calmed down and our parents were not called (they were informed after we returned home). We had to write letters of apology to the Hooks, the Fire Chief, and the Police Chief. In addition, we had to apologize to all of the campers the next morning. The worst punishment was that we were prohibited from swimming the next day. Marjory and I decided that the reason we were not sent home was because our fathers were "pillars" of the church. Whatever the reason, we were relieved not to have received severe punishment.

Today this story has become part of the "church lore" when people talk about the old days at Hook's Haven.

The Haven Hookers

At Hook's Haven, there was always a talent show on the last night of camp. This year Marjory, Pat Clary, and Ann Richart and I formed a quartet. We were all good singers (I was an alto) and we were all show-offs, hams, and attention getters. We had such success at camp that when we got home we found appropriate costumes and continued to sing together. The name we chose for our group was (get ready now) the Haven Hookers.

"Let's hear it for the Haven Hookers!"

From the little theatre we obtained beautiful Victorian dresses with matching hats adorned with feathers that waved in the breeze as we dashed on to the stage to sing. We sang "By the Light of the Silvery Moon, Wait 'Til the Sun Shines Nelly, Let Me Call You Sweetheart, I'm Just Wild About Harry, Cuddle Up a Little Closer,

Come Away With Me Lucile, Ma She's Making eyes at Me, Blue Moon, Five-Foot Two," and more!

Yes, the Haven Hookers were very much in demand. We sang all over Arlington County. The Lions, Rotary, and Kiwanis Clubs particularly seemed to enjoy us. We also sang for church and school programs, women's clubs, hospitals and rehabilitation centers. We sang all through our junior and senior years in high school and less often in college. Marjory and I attended William and Mary and we would try to get together with Pat and Ann during summers and on holidays. But it became too difficult to schedule performances as our lives became more complicated.

I honestly believe that the term "hooker" did not mean then what it means today. Although as I have spoken to others about it, they say we singers were the only ones who did not "get" what we were doing. We loved being Haven Hookers…we just loved it!

And today, when I return to Arlington to reunions or other events, I might walk into the room and have someone laugh, cheer, and ask if any other hookers are around for their entertainment.

Al's Girlfriend

Al Dixon was our adult counselor at our Church. He was a "dream boat." When we went swimming in the river, at times we would sit on the bank and ask him why he was not married.

He would grin, "I'm just waiting for one of you to grow up!"

"Which one of us?"

"You will see!"

We thought he was kidding. But in fact, he did marry Sally Higgins when she grew up!

Summertime at Virginia Beach

My high school years also provided great summer memories. Each summer the high school sororities and fraternities went to Virginia Beach for a week. My sorority rented a large house and we took two adult women chaperones with us. I had never even seen the beach until I was fourteen years old; my parents would never have vacationed at the beach; they liked to travel but always inland.

I will never forget how I felt when I saw the ocean. I was amazed to hear the sounds of the waves; to see the sunrises and sunsets; and to realize that you could really love someone at the beach more than you loved them at home. We were supposed to have a curfew but our chaperones didn't seem to pay much attention to it.

We had a piano in our beach house and almost every night Warren Beaty came over to play the piano as we sang. (Yes! THE same Warren Beaty, Shirley McLean's little brother.)

We stayed on the beach to get the perfect suntans (I didn't even know about suntans until then) so that we would be attractive when we went to the pavilion during the evening to play the games of chance with our boyfriends. I had an athletic boyfriend who could accrue enough points by the end of the week to win a big stuffed animal for me. The two of us actually lay in the sand on our stomachs with towels over our heads and kissed in broad daylight! It did not take me long to catch on.

There was no drinking of alcohol anywhere in the sorority house; and, for the most part, our dates did not drink in front of us. The high school drinking that occurred was seldom in public. In one generation all of that changed. I cannot imagine a beach

trip with hundreds of high school students where alcohol was not visible. I have tried to understand just what happened that changed things. There was such excitement in all of our innocence. I wonder if my grandchildren feel the same.

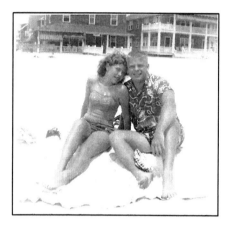

Virginia Beach The Potomac River

The Potomac River

Summers when we were not at the beach we would gather on the Potomac River to rent canoes and paddle up and down the river. Occasionally, we might get in a rapid current that we couldn't manage and would head for shore. But generally we were able to launch our canoes...get in the middle of the Potomac...stand up...rock our canoes...and tip over. We didn't worry about pollution in the river, or drowning. We didn't wear life vests. It is hard for me to believe that we were so foolish. Of course, our parents didn't know.

My Dog Nicky

Throughout high school our family pet was Nicky, a large white Spitz. He barked at every car that passed and every neighbor that came to the door. Some of our friends would not get out of

their cars until we secured our dog. There were no leash laws in those days, so all dogs roamed the streets and protected their homes. My boyfriends had to be brave to get to my door. Nicky bit one person, our postman, and only did that when the postman kicked at him. When I left for college Nicky became Mamma's dog. She always did love him more than I did. *(When I was in college, Nicky died at age thirteen. Mamma's heart was broken.)*

Mamma and Nicky -

College Applications

My senior year in high school meant that I needed to apply to attend college.

"I am going to attend Penn State or Ohio State or Yale."

"No, you will attend a school in Virginia. There are more good schools in Virginia than any other state in the United States. You will apply to Mary Washington, Randolph Macon, Mary Baldwin, Sweetbriar, Hollins, Longwood, or the College of William and Mary."

"I will not go to a girl's school. I guess I will *have* to apply to William and Mary because that is the only co-ed college in Virginia."

So I applied to only one school and was accepted. Shortly after that my parents and I received an invitation to visit the school.

"Why bother?" I said. "That's where I have to go anyway"

"Don't you want to see the dormitory, the library, the historic buildings, the sorority houses?"

"No, there is no reason for me to see things early, since I have had no choice in the matter."

I didn't see the College of William and Mary until the day I registered as a Freshman in Williamsburg, Virginia.

High School Graduation Parties

The week of high school graduation night there were rounds of scheduled parties. I had never taken a drink of alcohol (my parents were Methodist teetotalers) and at one party all of the party goers were served champagne. I refused the champagne. About one week later I received a letter from my Methodist minister who told me that he had heard about my action and that I had set examples for other students at the party who did not have the courage to say "no" until they witnessed my behavior. I have always wondered if that were true; or if my daddy just called the minister to tell him what had occurred.

In the years I went to school the abuse of alcohol was rare. We knew that some of the students who "hung out" at the Blue and Gray (a little store just off of the campus) were smoking cigarettes, drinking beer, and smoking dope. I never went down there but I knew who did.

High School Graduation

Graduation! The end of my high school years. I thought then that I would never be so secure, happy, smart, pretty, energetic and confident again in my life. And I was right!

My parents were sitting together in the huge Washington-Lee High School gymnasium to see me and 649 other students walk across the stage at graduation. My name was called out along with a few others for having received some special honors. And then…..

The graduation parties began. Mamma and Daddy finally agreed to let me stay out all night after graduation. We had parties scheduled every two hours throughout the night ending at a breakfast at Pat Wrinkle's house. Then Jim and I and Charlie Huppuch and Dee Alexander drove to the beach for a day at the ocean.

We all had summer jobs. Our high school days were over. They were the best they could have been. But now we were adults. That summer, I began my first real job working for the Air Force as a Clerk Typist in the Pentagon.

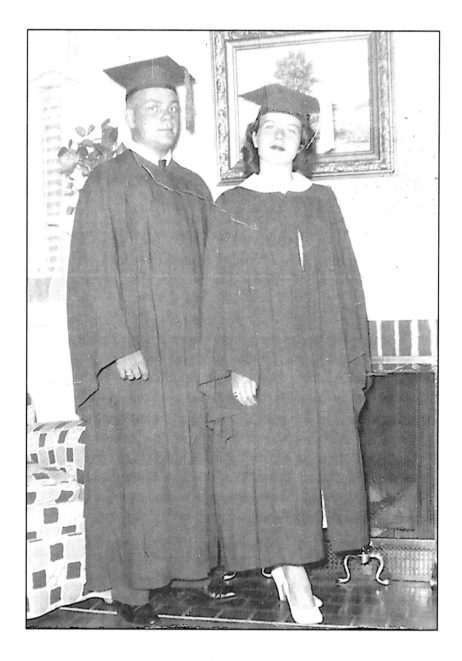

High School Graduation
Arlington, Virginia
June 12, 1953

The William and Mary Years 1953-1955

In August 1953 I arrived as a freshman at the College of William and Mary. I had never before been to Williamsburg. I had not seen nor visited the school. My parents and I packed the family car and off we went to William and Mary. I had no appreciation for the school's history (the oldest school in the United States; no it is not Harvard, but that is another story); no appreciation for Thomas Jefferson; no pride in its scholastic standing (among tops in the nation). No, I was an unappreciative, ungrateful, stubborn, difficult seventeen year-old adolescent. There are a few phases in my life that I regret; that period is one of them. I was rude and spoiled, lacking appreciation of my loving parents and all of the advantages that I had.

The morning we left for Williamsburg I got up early. Crying I went out to Daddy's garden and dug up a little plant, planted it in a small flower pot and put it in the car. That was the first and only time I have ever taken an interest in gardening.

Jim and I felt sad and unsettled. Jim had been accepted at the University of Virginia. We would be living 125 miles apart. Not having a car I would have to take the Trailways bus to Richmond, Virginia and then wait to transfer to the Charlottesville bus. The trip would take most of the day. We realized our time together would be limited. Our lives were changing.

On the trip to Williamsburg, I cried most of the way. On one occasion Daddy had to stop at a filling station in Fredericksburg in order for me to get out of the car to vomit.

When we arrived on the campus I was assigned to Chandler Dormitory...an old, old, old (at William and Mary old is good) dormitory with old, old, old furnishings. I was rooming with Dee Alexander, a good friend from high school. We were placed in a suite to share a bath with four other women (Joanne Saunders, Betty Ann Jones, Janet Whitehead, and Barbara Hawley) We had never before met one another and we quickly became good friends.

Suitemates

As I observed the students in Chandler Dormitory they seemed to really fall into three categories: those who had loved; those who had loved and lost, and those who had never loved at all.

BETTER TO HAVE LOVED

Thassie is a new friend who lives on our hall. She is a tall, slow-moving coed from Columbia, South Carolina, who has loved and lost. At all times she carries a large box of Kleenex to care for her ever-streaming ever-red eyes and nose. She bursts into wild sobs when the strains of *"Don't Talk About Me When I'm Gone"* are played on her roommate's phonograph. She makes a general nuisance of herself, telling her new friends of her lost love ... over and over and over again. She was jilted at the age of sixteen (a tragic story). Bertram, her lost love, was a worker on her father's estate. He won the cotton picking contest and as a result went on a tour of the country. After being gone several months, he wrote her a "Dear Thassie" note which she still carried in her bra next to her heart. She always wept when she touched her left breast.

On the opposite end of the hall lives the smooth blonde sophisticated Allison from Baltimore, Maryland. She is always wearing three fraternity pins on her cashmere sweater...around her neck is a gold football. She completes the jewelry display wearing the names of two more boyfriends on silver identification bracelets on each of her wrists.

Allison has definitely loved. Her thoughts are continually with her Annapolis man, except when she dreams of her fellow at the University of Virginia or the one she saw the week-end before at Harvard. Allison is, perhaps, less popular than Thassie, because the Chandler girls are insanely jealous of a girl with one boyfriend, much less six of them. In contrast to Thassie's sobs at hearing

one sentimental record, Allison swoons at every piece of music, regardless of the tempo or volume. The Samba was playing when she received her Sigma Beta Phi pin, "You're Mine" was the background for her once silver friendship ring, and "Joshua Fit the Battle of Jericho" was the theme for her football conquest. On one occasion she came in from a date, looked down at her sweater, and screamed with terror! Her fraternity pin was gone. We girls on the hall gathered to help her look for it until Janet found it … pinned safely to the *back* of her sweater. We all roared with laughter! Allison was relieved but not embarrassed. Allison never worries about friendships. She has one dear friend, and that is herself.

Pandora also resides in Chandler Hall. A short chubby happy-go-lucky gal, Pandora has never loved at all. At regular intervals she is seen at Chowning's Tavern sipping a thick chocolate milkshake, relishing a couple of cheeseburgers and some potato chips. Pandora dates often and on each occasion she plans to fall desperately, hopelessly in love with her escort. This, however, is never the case. She always returns from her dates laughing with a candy bar in one hand and some popcorn in the other.

"What?" She exclaims when asked of her evening, "I could never love that one!"

Pandora's musical tastes indicate that she enjoys everything. She is never reminded of any pleasant or unpleasant incident by any piece of music she hears. Pandora is the girl on the hall that everyone loves because of her sincere natural personality.

Of the three girls, Pandora says she is the happiest. She hasn't lost nor has she loved at all!

I have wondered about all of this. I have loved. I have lost. And I have been without any love at all. I would rather be who I am. I know what I'm missing, at least, when I have no one to love.

I was surprised that my academic progress at William and Mary (W-M) would be such an effort. I had always made good grades. Thus, I figured my social life would continue to take precedence over academics. Not so.

European History (easy in high school) was agony. My first English theme earned (?) the grade of C. Physical Education was tortuous as I ran up and down the hockey field. I couldn't even bowl a ten-pin score of 80 (necessary for passing). But Physics Lab at W-M was the most intimidating of all.

PHYSICS LAB AT W-M

Oh, lordy, lordy. It is the fate of each freshman at W-M to become an active part of the science department. The freshman guidance counselors advise the new students to take physics 103 if he/she is completely devoid of a scientific brain. The sophomores report that Professor Herger gives credit for class attendance and getting your work in on time. He evens gives credit for trying. So I enrolled.

The lectures and discussion periods depressed me, but the real heartbreak didn't come until I entered my first laboratory session. My outside impression of the science building (built in 1701) was a pleasing one. When I entered, however, I saw that I was standing in a long dark corridor, not unlike the appearance in other W-M buildings...old, old, old. Students who had already

arrived were seated along the wall on benches waiting for the professor. The professor strolled in, unlocked the door to the lab room, and the students filed into their "physics" home.

I, a freshman, was horrified at the room's appearance. The walls were painted a dull orange. At the top of the room were located several small, narrow windows. (We were told they were placed high in that old room so that the arrows of the attacking Indians could not endanger the students!) Bordering one side of the room was a cabinet which contained numerous foreign instruments. The cracked glass of the musty cabinet lent a scientific atmosphere to the room.

All students were provided a seat—a three-foot stool at the black laboratory tables. When I finally figured out how to perch on my old, old stool I got my first impression of my professor. Doctor Herger was the tall blond monarch of the physics department. Sitting on a table that also served as his desk he began the explanation of experiment number one. He removed his horn-rimmed glasses, gave them a couple of wipes, and continued his lecture. Hmmmm, he was so brilliant and handsome I found it was difficult to think about incline planes.

Dr. Herger's forceful personality was demonstrated to us by showing great disrespect toward the text book. To illustrate a particular point, he would throw the book to the floor with great force. I couldn't figure out the point he was making but it got my attention.

The student is expected to find some sort of forces by using the formula Fg = sin 30 -1# Z;.Vf – 17 Gm/sec/sec/. Of course this formula is good

only when the velocity of the text book is constant and when the mass varies with the time involved.

"Yikes."

Glancing around the laboratory I analyzed those who might be available as a lab partner during this first semester. The most confident students were the "repeats," those who endured physics 103 the previous year. They sat calmly smoking their cigarettes, flicking their ashes on the floor as the frustrated freshmen did all of the work. The repeats were not interested in making an impression on the professor. They knew that with this particular college professor the whole impression is the grade made on the bi-monthly tests.

I was puzzled by the student who seemed to thoroughly understand pulleys and velocity. How is it that this freshman is so advanced? Ahhh, there is one answer. This pest had physics in high school.

"Why" asks the pest, "do you use that formula. My teacher last year said that only old-fashioned teachers still use that one."

The professor ignored his exclamation, but the prodigy continued. "This sure is a rotten inclined plane. Too much friction for the experiment to be correct…silly to try when you know it's not going to work."

My classmates realized he was the type to be ignored. The experiment was underway. Pulley systems became complicated instruments. The car on the inclined plane moved too fast with a ten gram force and not fast enough using nine grams. The diameter of the axle was not proportional to that of the wheel. The data sheet was filled out

incorrectly and for the sake of accuracy new calculations must be made.

The hours slipped away. The pretty blonde coed now had a bedraggled appearance; the fellow in the letter sweater was perspiring freely; the pest who had "it" last year seemed to be the most frustrated of the lab students.

I finished my experiment and wondered if the guidance counselor had misled me. As I left Rogers Hall, I carried with me my first impression of the Physics 103 Lab Session, September 1953.

Low Grades

My history professor, Dr. Fowler, taught freshmen in a huge lecture room holding about two hundred students. He always held our attention. Every lecture was interesting and exciting. Each year when he lectured on Henry VIII townspeople from Williamsburg would line the walls to hear his lecture. I always made good grades in high school and was stunned when I made a D on my first history quiz; and another D on my second quiz. I was making C's in my other classes.

I telephoned Mamma and Daddy to tell them I was not "college material" and that I was quitting school. I was crying as I

begged them to come pick me up and allow me enroll at another school.

My daddy said, "You most certainly *are* college material and you will stay at William and Mary as long as it takes you to find that out."

I was a student at William and Mary with no other alternatives! Classes continued to be difficult. I was always an excellent writer yet I was even making C's on my English themes.

My good friend from home, Marjory Helter, had a mother who frequently came to the College. When Mrs. Helter arrived she usually visited me, too. She might take us out to lunch, or do something else nice for us. When she came, I always told her how miserable I was. After one of Mrs. Helter's visits I received the following letter from Daddy.

Monday, Sept 28, 1953
Dear Betty Jo,

How is our miserable, wretched, forlorn, homesick, forgotten, overworked, and otherwise dejected daughter by this time? Mrs. Helter told Ethel today what a desperate condition you were in, how all the elements conspired against you, how your little heart yearned for parental consolation and other such tripe. While this story did not appear to jibe with your recitation of dates by the dozen and hours of concentrated study, we must consider Mrs. Helter's report.

It seems to me it's about time you begin demonstrating a little maturity along such lines, and I'm sorry that maturity does not always accompany adulthood or even old age. You mentioned in one of your letters studying five hours for history. This is about the correct amount, I suppose. Five hours per day on each subject would leave you one hour for eating and eight for sleep. This would make a very good schedule. If you only have two subjects on Saturday, you would have five whole hours for sheer relaxation and all day Sunday for meditation and prayer, which, I daresay, you could use.

Seriously - I guess it comes as a little of a shock to find that some of the professors consider a college an institution of learning.

This morning on the bus I saw Shirley, still working at FHA, right next to my building, and Martha Robinson on her way to begin training at the Washington Secretarial School. Both seemed in good disposition and both asked about you.

Give my condolences to Margi and Dee.

Love,

Daddy

I continue to believe that his letter, totally devoid of compassion, was too tough to send to me.

When I made a D on that second quiz, I believe Daddy felt guilty about being so hard on me because this time he wrote me a compassionate, loving letter giving me some suggestions on the best ways to study. He told me I had always been successful in every classroom I had ever participated in and that soon I would be comfortable at William and Mary. As the months passed my grades did begin to improve and I was on the Dean's List every semester. The truth was I had never before been competing with so many brilliant students. I also realized that the high schools in New York, New Jersey, and Pennsylvania were much more advanced than the Virginia schools. It took me one semester to catch up and pass some of my classmates!

Social Manners Required for Women

Bermuda shorts and pedal pushers were becoming fashionable for women and were the usual dress for casual events. We also wore Villager blouses and weejun loafers. Smoking cigarettes was usual social behavior for women. The rule was that if you smoked you had to do it sitting down. And if you wore shorts or jeans outside of the dorm, wearing a raincoat was required. At any time you could look out a window and see women in raincoats running from one dorm to another; and quickly sitting down to take a quick drag on a cigarette.

But rules are rules and we obeyed.

We don't have anything to wear!

What is a homosexual?

Shortly after my arrival at W-M there was an event that, at the time, I and my girlfriends didn't understand. There were two students on our hall that had been expelled. We just got up one morning and they were gone. No one on the hall knew what had happened.

A few days later we heard they were discovered in the shower with four other girls and all six of them had been expelled. We sat in our room puzzling over what they could have been doing. They

seemed to be so nice and smart and fun. Weeks later we were told that they were homosexuals. I can honestly say I didn't know such a thing existed…and neither did my friends.

I include this because today it would be against the law to expel any student from a University because of homosexuality.

Times do change.

Sororities

William and Mary is a co-ed school and I didn't expect discrimination there. But there was some invisible discrimination that I had never before experienced. This was the first time I had been in an environment where women were discriminating against women. Women seemed to be choosing sides to announce to others who belonged in their group; and who did *not* belong. I was not aware until several years later what had happened, or what was happening to me. I didn't know there were groups of women with whom I would never be friends.

Soon after I arrived at W-M came sorority rush week. All of the freshmen had the opportunity to attend parties at the sorority houses. One question that was asked of me was "Who are your people?" I did not have a clue on how to answer that one.

In Arlington, Virginia where I grew up, there were no obvious social class differences. Everyone in the DC area was from somewhere else. There were no "select" families who ran the schools, banks, churches, social groups

It seemed that everyone who lived near us had a Daddy who was important. The Director of the CIA lived across the street and was chauffeured to work each morning by the secret service; the National Director of the Red Cross was in my parent's bridge club; the head of the Food and Drug Administration was in Daddy's Sunday school class; the two men who lived down the street worked at the Kennedy Center and if there were no sell-outs for productions, they would give us tickets so the theatre would look sold out (Mamma and I would quickly dress up and head to the Center); our next-door neighbor was Director of the National

Trucker's Association. And my daddy was Director of the National Rehabilitation Association. We just took all of that for granted..

I did not realize until years later what a great environment that was for me. If I could do the job, I got the job. It was of no interest to anyone who my Mississippi grandparents were.

Rush Week

The first week of rush, I was invited to attend nine parties, one at each of the sorority houses. As rush week proceeded I realized that for the next round of parties I would select six invitations. There were three invitations for the last round of parties. I attended the three parties and waited for the final bids, assuming I would get three bids or invitations. But I was invited to only two of them. I was "cut" from one of the sororities. I was stunned when only two (of the three) sororities gave me a bid to join. I had never really been rejected before.

(I was told later it was because my family was not from Virginia. In that sorority natives of Mississippi and/or residents of Washington, DC, did not measure up to Virginia standards. Also my mother went to (MSCW) Mississippi State College for Women where there were no sororities; thus, I could not have been a legacy. I don't know whether any of that was true or not.)

I was pleased to be invited to join two "good" sororities and I picked one.

Parts of this chapter discuss the topic of *discrimination* of women. And when we hear the term discrimination it is usually in the context of sex or race or economic discrimination. But in this case I was experiencing discrimination of another type. As the year progressed I realized that it was expected that my sorority friends were to be my best friends; and that if there were social conflicts I would attend the sorority event. On one occasion my drama club (I was also in the theatre group, the writing group, the

modern dance club, the Mermettes, and the foreign language group) was having a party on the James River, to be held on the same night as the Sorority White Party. At the White Party the party room was decorated in white…the floor, walls, all chairs, lamps, ceiling. I think it had something to do with virginity, but I was never sure about that because I didn't go. I went to the James River with that raucous theatre crowd.

Afterward, I was called in to some sort of sorority council where my allegiance to the sorority was questioned and then clarified. I received some sort of demerits that could have prohibited me from participating in the final sorority initiation. I was properly contrite and somewhat confused. As the semester progressed it was also suggested that I date men in one of three fraternities.

Jewish Prejudice

At that time I was attracted to and dating a man in a fraternity other than the three fraternities recommended. This fellow was tall, dark, handsome, brilliant, clever, and funny with beautiful dark flashing eyes. I was once again called in to the sorority council and questioned about why I was dating a man belonging to a Jewish fraternity. I said I did not know that some fraternities were denominational; and wasn't Jewish just like Methodist, Baptist, Presbyterian? Just another denomination? What difference does that make?

And the sisters laughed and said, "Just listen to that little Christian goody-goody."

I did not know until that moment that there was something called "Jewish Prejudice." And I got another lecture; more demerits; and was told I had better improve my behavior or I would not be initiated.

Once again, I was confused. When I was born in 1935 we lived in a small town where there was one Jewish family. On Saturday he closed his store and went somewhere else to "church." I suppose there were Jews in Jackson, Mississippi, but I

had never heard they were "different"....at least not different enough to prohibit me from being initiated into my sorority.

When I returned to my dorm room, I telephoned my parents. I was furious. And I was crying.

"Why didn't you tell me about Jewish prejudice? I should have known about that."

Mamma got mad at me for being impudent (a word often used in the 50's). Daddy said, **"Ethel, leave her alone.** She didn't know about Jewish prejudice. I am sorry she had to learn about it. **But just leave her alone."**

Sorority Initiation Night

Somehow I made it to the night of sorority initiation. My list of demerits was growing but not enough for the final "blackball." I was told that the initiation was confidential and I must never talk about it. I signed the pledge saying I would not reveal any information or any part of the experience in the initiation. And I am going to keep that promise. But there are some general impressions I will share.

The initiation in the spring of my freshman year was for me a strange and really puzzling occasion. On a warm April evening we dressed in long white robes with something like a white shawl on our heads. There were eighteen young women in a room in the stifling hot Christopher Wren building. We were told how special we were; there was some talk about loyalty, honesty, truth, scholarship, virginity and beauty.

Then we moved from station (location) to station, each representing one of the ideals: I can clearly remember standing in my Grecian Robe, thinking this was somewhat silly, and wondering what in the world I was doing there.

The room seemed to be getting hotter; my legs were aching and almost trembling. How much longer would I be expected to stand up? When we got to the station on virginity, I heard a feminine moan, and a loud thud. One of our initiates, Sue Lane

Carson had fallen over; she had passed out on the floor right next to the pedestal representing virginity. The "sisters" carried her out.

The initiation was complete. I was a sorority woman.

Sorority Woman

Swimming at William and Mary

Parts of my sophomore year at William and Mary were wonderful. The drama, dance, and swimming departments literally "saved me" from clinical depression. I was a good swimmer and passed all of the requirements for the Physical Education class. The Mermettes were a group of women swimmers that presented a spring program. They swam in synchrony as they created beautiful patterns in the water as the lights lit up their colorful caps and parts of the swimming pool.

I had absolutely no interest in being a Mermette. However, for the recital they did not have enough swimmers and asked me to participate in the annual spring program. I told them I would participate under one condition. That was, when they stopped to point their toes or did all of that leg waving in the air to make designs, I would have to be in the shallow end of the pool so I could stand on one foot. They were so glad to have me, they complied. Thus, for the group numbers I was pointing my toe, making the figure eight with my curvy leg, with my other foot flat on the bottom of the pool.

At William and Mary you had to pass swimming to graduate. (I know of at least one instance where a student did not graduate because of this.) My roommate was afraid of the water. She was able to swim across the shallow end of the pool. The requirement, however, was to swim the length of the pool where one would have to travel over the deep end. I asked our instructor if I could walk along the edge of the pool as she swam and hold a pole out just in in front of her. The idea was that if she panicked, she would have something to hold to while I saved her from drowning by pulling her over to the side. The instructor agreed.

The pool was cleared. Lois swam. I walked beside her as she swam the length. When she touched the wall everyone cheered. We had a party that night.

Lois was the most intelligent woman I have ever known, but she would not have graduated from William and Mary had she not passed swimming.

The Dance Recital

Spring was also the time for the Orchesis dance recital. Our routines were precise. I was a good dancer and I could perform all of the dance group numbers. We would leap, and pirouette wearing filmy flowing gowns. I also was chosen to do a "duet" dance with a male dancer who was a gorgeous, muscular football player who was taking dance to get some "easy credits" to pull up his Grade Point Average (GPA). My dance (that I choreographed) required that I assume the role of a flirty little girl prancing around this good looking guy trying to attract his attention. At the end of the dance I slid down his leg. The crowd roared, hooted and whistled. I did not realize that it might have been a bit too risqué. My parents traveled from Arlington to Williamsburg to see my solo! Mamma thought it was too suggestive and started to tell me so.

But Daddy exclaimed, **"Ethel, leave her alone!"**

The Theatre

I enrolled in as many theatre courses as I could in order to have the privilege of being taught and directed by Harold Scammon. He was a fabulous teacher and director. Throughout the years he received much deserved national recognition for his work.

Restoration Comedy

During my first semester at William and Mary an announcement was made that the Williamsburg Restoration Association was having auditions for Oliver Goldsmith's play *She Stoops to Conquer*. Professor Scammon suggested that if several of us wanted week-end jobs that paid more than the minimum wage, we might want to go to the try-outs. I auditioned and got the part

of a maid that had one or two sentences in the entire play…one was "I have a message for you, sir." Other actors would write risqué messages on the paper and give it to me at the moment I was to go on stage. Some of the time we would all get so tickled that it was hard not to "break up." But we never did!

The drama played two nights each weekend for the pleasure of the tourists. Each of the two nights I would walk the six blocks to the theatre and then walk back to the dorm when the play was over at night. One night as I was returning to my dorm I became aware that a car was following me. There were no sounds coming from the car and the stores on the street had closed. I began to walk faster…and faster…and faster. The car increased speed to continue to follow me. I was scared.

Suddenly a group of men students that I knew jumped out of the car yelling and chasing me. I was terrified. They thought it was funny. I was still trembling when I reached the dorm.

After the play had completed its run, I did not try out for any of the other restoration comedies.

Musical Comedy

Each year William and Mary produced a musical that was written by students majoring in theatre. George Burns and Dick Femster were the writers and even though I did not participate in the writing, I got the comic lead the 1954 and 1955 spring musicals. I acted, sang, danced, and was told I "brought the house down." In the first production, in spring of 1954, I had the role of a sexy vamp who seduced the preacher in *Here's How*. There was one line in the play where the preacher was asked why he would lower himself to "be" with a woman like me. I looked at the audience in a puzzled manner and said, "Why … I can't conceive!" The audience roared with laughter. I honestly didn't understand why that was funny until the second night (of the four) that we played.

Reviewer Praises 'Here's How' Show

By Russ Redmond

Anybody within earshot of Williamsburg would do themselves well to beg or borrow (we don't steal) the admission price to Here's How!, the Backdrop Club's major production for 1954. This musical comedy is excellent in all respects — plot, comedy, romance dialogue, dance — whatever the theatregoer prefers.

Depending upon the talents of George Burns, Dick Fensterer and Giles Quarles for the bulk of the melodies, lyrics and dialogue of Here's How!, the cast of the Backdrop Club had very little else to do but pre—

staging, eye-rolling techniques, and Mickey Hanft, the king of frustration. The best actress is the clown queen of William and Mary, Lulu McDow. But Pat Ewell, as Mrs. T. Totaler, need not lament the fact that her excellent performance was second to that of Lulu. Betty Jo Whitten and Rev Michael round out the major cast, detracting nothing from the excellence of it.

Each character in the major cast is indispensable in his position and could serve no better in anybody else's role. Clulow must be allowed to express Clulow, Hanft must be Hanft and Lulu McDow

Wayne Marshall made a perfect partner because of his versatility, changing from a Charleston in the first act to Lou Biggs' tango partner in the last scene.

Every once in a while, a good musical comedy must be able to produce a singer in its story who is capable of capturing a solitary mood and expressing it to the audience on his own. Burns found three such people in Mel Hines, Lavinia Pretz and Barbara Pharo.

All-in-all, the effective technical skills of Burns, Fensterer and Quarles in directing and writing the story and music, Mickey Mig... hell as choreographer, Bill ...below ...hting, ...e pro- ...show ...inti- ...entire ...Wil- ...more ...than ...mate ...or its ...Club ...n its ...title,

May 10-11-12, 1954 HERE'S HOW

Scenes From "Here's How"

"Rehearsal Isn't All Work!" Report D. A. Danger (Mickey Hanft) and Tessie (Betty Jo Whitten).

The following spring, 1955, I had already been accepted as a transfer to the University of Virginia. The spring musical was *Be My Guest* where I played the role of Blanche and sang two solos: *A Case of Love* and *Hillbilly Mamma*. After our first night of production George Burns, the director, re-wrote the play and I got to sing one of "my songs" a second time during the finale. After the opening night I heard some students singing *A Case of Love* outside my dorm room. When I peered out my second floor

window, there were more than a dozen cast members singing to me. When they completed their song, I walked downstairs and out on the portico of the dorm to receive a beautiful bouquet of roses.

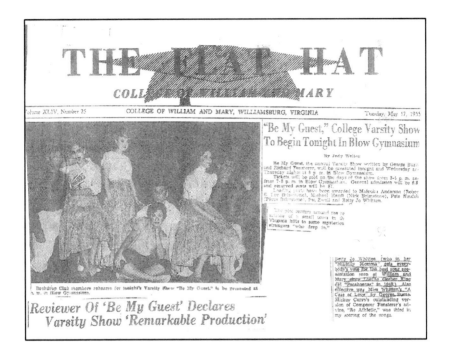

I have tried to look up some of the actors I knew at W-M. I am certain some had great careers in the theatre, but I was never able to find any of them. They probably changed their names...especially George Burns!

Following the production of *Be My Guest* the *Flat Hat* campus newspaper reported:

> *Betty Jo Whitten (who in her "Hill Billy Mamma") gets everybody's vote for the best song presentation seen at William and Mary since Lucille Gerber King did "Pocahontas" in 1949). Also effective was Miss Whitten's "A Case of Love" by George Burns.*

That for me was "rush week." I was so honored, pleased, jubilant. That was, without a doubt, my most wonderful

experience at William and Mary. I almost decided to be a drama major and to remain at William and Mary.

But I didn't!

Pan-Hellenic Council Resignation

Looming always were my sorority responsibilities. I must have demonstrated some leadership ability because in the spring I was chosen to be the representative to the Pan Hellenic Council (something like the student government of sororities). And furthermore, it was my sorority's turn to have the presidency of the PanHellenic Council my senior year. It went like this: I would serve as Vice-President my junior year; then my senior year I would be the President of the Council. I was told this was the greatest honor any woman student could receive at William and Mary. As the news got out about this I received letters of congratulations from members of the sorority; mother's friends; my friends. Why, then, was I so ambivalent about this honor.

Well, by that time I had participated and endured sorority rush from the other side. I was the group rushing the in-coming freshmen. As names came up, my "sisters" would reject rushees for their religion, the clothes they wore, what part of the country (or state) they were from (not good to be from The North), how much money their families had, whether any other family members had been in the sorority, their weight, their hair styles. Although I had been in a high school sorority, I had never heard women talk that way about other women. I knew that I didn't belong in a sorority.

So! I resigned from my Pan Hellenic position and announced that I was transferring to the University of Virginia. Apparently this seldom happens. This letter from one of mother's friends was typical of others that I received.

March 1955

Dear Betty Jo,

I hope this letter finds you well and that you are beginning to study for your final examinations at William and Mary. I was delighted to hear from your mother that you have the opportunity to serve next year as Vice-President of the Pan Hel Council and to serve as President your senior year. Congratulations on having received <u>the highest honor for women at one of the most revered schools in the country.</u> Your mother also informed me that you are contemplating leaving William and Mary this year to resume your studies at the University of Virginia.

My purpose in writing is to urge you to stay at W-M to accept the sorority honor. Your serving as President of the Pan-Hellenic Council will not only serve you in your future plans, but <u>will be a great attraction and advantage to your future husband as he begins his career.</u>

Think carefully about turning down <u>one of the greatest honors you will ever receive.</u>

Sincerely,

Three days later I received this letter from Daddy.

Dear Betty Jo,

Ethel called me this morning to tell me about the honor you have received from your sorority. We are proud that your talents are being recognized and sympathize with you as you have to make what may be one of the hardest and most important decisions of your life. You understand, of course, that we are going to back you in the decision you make and there will never be any "I told you so's" if the decision would later appear to be the wrong one.

With the foregoing in mind, may I say a few things?

In the first place, you know how fond we are of Jim. We cannot imagine you ever finding anyone we would rather have you marry. If we thought that a decision to finish four years of college at William and Mary would result in separating you and Jim, I would tend to advise you to go ahead and transfer. But I know that this will not happen. Two people who have shown their affection for each other over a period of four years are not going to be separated as a result of a decision on this matter.

As you know, we have all along tended to feel that it would be better for both you and Jim if you both received your BA degrees before you married and also that you attend different schools. You understand full well some of the hazards of two people so much in love being together on the same campus for so long a period without being married. We have, of course, always felt that you and Jim are exceptionally strong people and able to control your emotions better than many might, but there is no questioning the difficulty in such conditions.

Neither is there any doubt of the difficulties involved in so long a period of marriage with Jim in school and you working. The shorter this period is the better for both of you; although I feel that you would make a go of it if you had to do so. When Jim is actually in medical school, liberal loan funds will be available and with your help the road would not be too terribly difficult.

All of what I have said is without regard to the honor that might fall to you your senior year in college. This honor merely strengthens our convictions that you stay at William-Mary. It is not the cause of our feeling this way. There is no doubt, however, that the experience you will gain in Pan-Hellenic work and the people you will meet will mean a great deal to you. The experience should make you capable of living a fuller life and should enable you to be a more effective partner with your husband in your joint life work.

Your problem at this time is really a very simple one, although it may not seem so. It is simply whether reason or emotion will speak more effectively. I say this without any reflection upon the value of emotions in life. It would be a pretty dreary world if emotions should be erased but a surely chaotic one if reason should depart. Fortunately, in your case, emotion does not have to be submerged whatever your decision is. A judicious use of reason now will probably result in a more positive emotional life later.

I have the feeling that all along you have not been absolutely certain that it was best for you and Jim that you transfer to U.Va. next year. If you decide to stay at William and Mary now, I believe that your honor is only partly responsible. In fact, if the self-glorification that might go along with campus honors should be the only factor in the decision, I would be fearful.

Well, you know I love you and hope that this justifies this little epistle.
Love, Daddy

Transfer to the University of Virginia

I put Daddy's letter away and went to the registrar's office to get the application forms for transfer from W-M to the University of Virginia. When I approached the registrar's office there were hundreds of William and Mary students in the transfer line.

I could not imagine what was going on. And it was over beer. I was informed that William and Mary's Chancellor had issued a decree that only 3.2 beer could be consumed in the sororities and fraternities on the campus. University of Virginia had no alcohol limit. My classmates were angry, protesting, and even threatening to cause a riot.

I stood in that line almost one hour until it was my turn to obtain the forms. When that tired woman in the Registrar's office looked at me, she said, "Not you too!"

"I had been planning to transfer all along. I am going to become a Speech Therapist."

"Right." She was wearing a scowl of disapproval.

She shoved the forms toward me and said, "Next."

I was applying to a men's school that had just been "ordered" by the State Legislature to accept women if the female applicant wanted to study a curriculum that was not available anywhere else in the state of Virginia.

And I thought of something.....speech therapy. I went home to Arlington that week-end.

The Announcement

"Mamma and Daddy, I am leaving William and Mary. I will be transferring to the University of Virginia to become a speech therapist."

Nicky, our white Spitz slowly rose with ears back. He left his place from under the kitchen table and walked out on the adjoining screened porch. His sigh was audible in the kitchen as he plunked down on the floor.

"No, you will stay at William and Mary. I will not pay your tuition to go to a male school. That is not in your best interest."

"If you don't let me go, I'll marry Jim and move to Charlottesville anyway. I will get a job as a secretary and figure out how to pay my own tuition."

Tears were flowing from my mother's eyes. She left the sink of dirty dishes and slowly sat back down in her chair at the kitchen table.

"May God help her," she said quietly.

"Ethel, we had better leave her alone."

In the fall of 1955 I moved into the first and only brand new dormitory for women at the University of Virginia.

The University of Virginia. 1955-1957

History of Women

I enrolled in the University of Virginia August 1955 when there were few women students and, they, overall, were not welcome. Today it's a coed institution, and no one thinks about it one way or the other. This great University was founded by Thomas Jefferson in 1819 after his dissatisfaction with William and Mary. I was proud to be admitted and I'm proud to have graduated. This section describes some of my experiences as I remember them.

At the time I entered, the "U" was referred to as a Gentleman's University or Mr. Jefferson's University. When it was founded the educational leaders of the day believed that women's education should be oriented toward the domestic. Although the University had a charter to open in 1816, classes did not begin until 1825. The later opening was due to the fact that that Mr. Jefferson could not find any professors in the United States that had the credentials to teach to Mr. Jefferson's standards. Jefferson found it necessary to travel to Europe in order to convince some intellectuals to move to America to teach at U. Va.

Even though I was admitted in 1955 a recent publication of the University of Virginia Magazine (Spring 2001) refers to the 1970's as the most notable historical marker for women. In 1969 the Board of Visitors voted to lift all restrictions regarding the admission of women when, in 1970, 450 undergraduate women arrived. Not until 1970 was the University considered officially a

coed institution. That was fifteen years *after* my admission. Times changed.

There was, of course, no mention of my enrollment in 1955 in any historical documents.. The only reason I was accepted was that University of Virginia taught course work that couldn't be obtained in any other higher institution in the state. My major was in speech correction, a recently approved program in the Department of Speech Correction.

In hindsight I do believe that the 1950's treatment of women at the "U" was intended to give me the feeling that men were more valued at Virginia. But that did not even occur to me at the time.

Dean Roberta Hollingsworth Gwathmey

When I made the unusual decision to leave William and Mary (itself with an illustrious history) I visited the University of Virginia. My appointment was with Dean Gwathmey who was the first Academic Dean of Women at the University. My appointment was in March when, as luck would have it, it snowed in Charlottesville. My boyfriend, Jim, and I had maintained our long-distance relationship. Since I had no car Jim drove through the rain to William and Mary, then returned through sleet and finally snow in order to deliver me to Dean Gwathmey's office. Her office on the Lawn was almost hidden. I passed an ivy covered serpentine wall where her office was tucked away in a small dwelling. There was no signage suggesting anyone important worked within the walls. The Dean of Women did not have the status of the Dean of Men. Her duties were to focus on qualities of leadership, integrity and social poise for women. Men were considered the academic scholars.

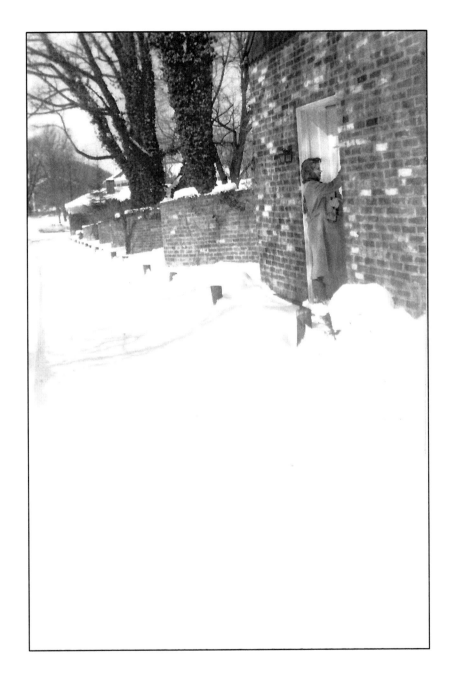

The knock at Dean Gwathmey's door.

I must have intuited even then that my life was taking a different path when I approached her door. Before I knocked on the door I asked Jim to take my picture. When that door opened it changed my life in a direction that could never have been imagined. I was, for the first time in my life, making an adult decision that had not already been predicted for me.

Dean Gwathmey greeted me warmly. I introduced her to Jim and we agreed that when I had completed my visit, I would walk to meet him at the library where he would be studying for his own mid-term examinations. She seemed genuinely interested in who I was and what my interest was in entering the University of Virginia. She informed me of the curriculum in the Department of Speech Correction (now referred to as Speech/Language Pathology).

By the late afternoon the sun was still shining and the sidewalks were clear as Dean Gwathmey and I walked through the snowy campus. The more we talked about the program in speech language pathology the more exhilarated I became. I felt I was breathing air that was more refreshing than any breath I had ever taken. There was a welcoming, intellectual atmosphere I never knew could be possible for me.

My decision was made. I got "the papers" to take back to William and Mary. Before Jim and I had our evening dinner date, he drove me by for a look at Mary Munford Hall, the women's dorm. It was new ... not old, old, old ... and it was beautiful.

Mary Munford

I had never heard of Mary Munford. Just who was this woman that had a building named for her at an all-male university? I discovered that in 1952 Mary Munford Dormitory was built with the purpose of housing 104 women, and two housemothers. In 1910 Mary-Cooke Branch Munford tried to establish a co-ordinate women's college that could share U.Va.'s resources by maintaining separate learning environments for the sexes. That was voted down in the Virginia General Assembly.

Mary Munford (1865-1938) was a woman whose own mother did not allow her to attend college because there was no need for a woman to have an education. Her mother told her she was put on earth to marry, have children, and support her husband. However, Ms. Munford continued to support education for women and also worked to support race relations during her era. She felt that minorities should also be free and well educated and she served on the Board of Trustees at Fisk University. I am honored that I was able to follow the path that she set for me and other women. I continue to be grateful to her for changing her part of the world and I have attempted to adopt her values in my own life.

Mary Munford Hall

I entered the University of Virginia in the fall of 1955. I still didn't have a car and this time both Jim and my parents helped me move. When Mamma saw Mary Munford Hall for the first time, she was exceedingly pleased. The Dean of Women, herself, met us and met my parents.

The new three-story dormitory was beautiful. The well-appointed living rooms were decorated with Virginia antiques and portraits of the men and women who founded the state of Virginia. There were smaller rooms for a few people to gather. The polished silver tea service helped to remind us that tea was served every Wednesday afternoon. We would be taught to pour sitting down with elbows at our sides. Women students were required to wear nylon stockings and dress shoes at tea-time as well as when we walked up and down, up and down, and down and up the hills to get to class.

The dorm rooms even smelled new, with "modern" furniture, nice desks and book-cases. There was a new mattress for each of the single beds for my roommate and me. A laundry room and "pressing room" were located on each floor along with a public phone booth at the end of each hall. Pure luxury. (*No cell phones then!*)

It must be stated that although my parents were against my transferring to a predominately male school, they were favorably impressed with my living conditions. My mother was assured that women were honored, respected, and would get a good education. She was actually delighted at what she saw and how we were welcomed!

Jim

This part of my story would not be complete without my giving all of the credit for my transfer to my boyfriend Jim (class of 57). He belonged to a great fraternity, was a football player, and intelligent. He loved me and I loved him. In fact, if my parents had not agreed to continue to pay my tuition at the University, my plan was to marry Jim, get a secretarial position, and figure out how to finance my own education. As time passed it was clear that marriage was not best for either of us; we broke up which was exceeding traumatic; and that is another story that will never be written.

I continued to see Jim at five year intervals in Arlington, Virginia, at our Washington-Lee High School Reunions. He was a successful man with a beautiful loving wife.

Mr. Jefferson's University

When I attended the University of Virginia there were over 10,000 men and 200 women. Most of the undergraduate women were studying to be medical technologists or speech therapists. I was assigned a roommate, Bobbie Van Dyke from Marion, Virginia who was studying to be a teacher. She was almost six feet tall and I am five feet two inches. We looked like "Mutt and Jeff" walking along together. Our new boyfriends, Will and Gaylord, became good friends and we had great fun on double dates. We especially enjoyed hiking and picnicking in the Virginia Mountains and enjoyed the colorful fall leaves and then, in spring, to see the rhododendron bloom.

Left: Will, Paul, Gaylord Right: Betty Jo, Barbara, Bobbie

(Bobbie wanted to marry a man taller than she was. When she went to the library her research revealed that the tallest men in the United States lived in Arizona. After she graduated she got a teaching position in Tucson. Soon after she married Marvin Quinn, an Arizona football player who was six feet five inches! They produced two tall children who became swimming champions!)

We worshiped each Sunday at the University of Virginia Chapel.

Discrimination

Male antagonism toward women was rampant. After Jim and I broke up I thought that getting a date would be quite easy. But, no! Young women arrived at the campus every week-end to room in women's boarding houses near Rugby Road. There were literally hundreds of women from Hollins, Sweetbriar, Mary Washington, Randolph Macon, and Longwood Colleges. The men students would go to the boarding houses to attend parties or to take the girls to the fraternity houses to drink and party! I actually spent week-ends in my own dorm with no date! Imagine!

Even though I felt alone and isolated on some days, Mr. Jefferson's University was a breath of fresh air for me. The teaching methods were different from those at William and Mary. Our courses were stimulating. My professors were amazing. I actually felt pride wearing my heels and nylon stockings to class whenever I walked the beautiful grounds.

Each morning I prepared my own breakfast in the little kitchen located down the hall at Mary Munford. I was in class by 8:00 in the morning after which I would work in the Speech and Hearing Clinic at least four hours in the afternoon, providing therapy for people who had communication disorders. Supper was always in the University Cafeteria, a restaurant on the Corner.

After the evening meal I went directly to the library to study until 11:00, after which I would spend an hour or more with Jim. I could not believe there was no curfew. I could stay out as late as I wanted. The first few weeks I would come into the dorm as late as 2:00 AM. After about four weeks of this I was so exhausted I could hardly drag myself to class in the morning. So I began to work regular hours and go to bed at a more reasonable time.

The Dress Code

University of Virginia had a dress code that required all men to wear coats and ties to class and women dresses or skirts, heels

and stockings. I left the dormitory early each morning to attend class, work in the speech and hearing clinic every afternoon, and walk to the cafeteria at night. My feet got tired and my legs ached. But I did it with no complaints. I had pushed so hard to be admitted to Virginia, I would have not have whined about anything.

Mister Jefferson

All students referred to Thomas Jefferson as Mr. Jefferson. Our professors were addressed as "Mister" as opposed to Dr. or Professor (as was required at William and Mary). The campus was called "the lawn" or "the Grounds." One was not to speak indiscriminately to groups of students gathered on campus; you spoke only if you knew someone. The Yearbook was called "Corks and Curls;" *cork* meaning one who is unprepared for class and *curl* meaning one who is prepared. And the University is still referred to as the Academical Village.

The Honor Code

The most memorable part of the University was the Honor Code, similar to the one at William and Mary. I have been a student and a faculty member at numerous Universities but I have never been a part of an Honor Code that was accepted so totally by the student body as at University of Virginia.

As most codes state: A student will neither lie, cheat, steal, nor fail to report an offense. And if a student was found guilty of any of the above, he was expelled from school. I have never been in a more honest, safe environment. Students could and would leave their books, satchels and papers on the steps of the classroom building to run an errand. Bicycles were *never* locked in their stands. And students would, indeed, report one another if there was an honor violation.

On one occasion when I was eating at Buddy's restaurant, a student put a set of salt and pepper shakers in his pocket and

prepared to leave the restaurant. My date approached him and said "I will report you if you do not put them back." The would-be thief placed them back on the table and left the restaurant. Every week or two the student newspaper, *The Cavalier Daily*, would report that a student had been dismissed from the University for stealing or cheating and he would be named. That was a shameful experience that no one wanted to endure.

Students also reported any classroom cheating to their professors or to the Honor Council. Amazing. I wonder if that is still going on today.

(The University of Virginia Magazine, Summer 2013, reported a student vote that amended the honor code due to student apathy in reporting violations.)

Social Life

Don't Act Surprised

The social mores at the University of Virginia were quite different from any that I had ever seen or heard of. The consumption of alcohol was excessive; fraternities were the backbone of social life and there was more overt sexuality than I had ever seen. There was a large mongrel dog named "Nasty" that would lap up beer until he could barely walk; then someone would call the dog to the top of a hill in front of a fraternity house, throw an object for the dog to retrieve, and actually roar with laughter as the dog sailed (literally flew) into the air, landed with a thud on the ground, staggered around, located the thrown object, and slowly returned to the top of the hill. I knew that was wrong but I said nothing; and that remains one of my regrets in life.

Before I transferred to the University I attended two of the Easter's weekends...which were reported to be the most fabulous events of the national college scene. In spring 1954 I left W-M in a car with six of my girlfriends in the middle of Hurricane Hazel. We were determined to get to Charlottesville. Our dorm mother wanted to prohibit our leaving but we had our permission slips from our parents and we left. We were the only car we saw on the road. Tree limbs were hitting the car; we detoured around Richmond because a steeple had blown off a church.

We safely arrived at Mrs. Goodlow's house with the other women who were there to enjoy the festivities. I had never seen a diaphragm contraceptive until one of the women in our rooming

house told us about it. She took it on every date and showed us how it worked.

The week-ends were "wild." On one occasion the University of Virginia parties were described in a national magazine to inform the public what was going on at the Virginia tax payer's University. One week-end a student rode his little red sports car the length of the lawn, up the steps and crashed into the Rotunda at the base of Thomas Jefferson's statue. We all rushed from the dance to the lawn to see that event. I said, "Whoa, that student's in a heap of trouble." But when I found out who it was, I was wrong. It seems that he had some "family connections" that I was not privy to. The "Easter's" week-ends finally got so out-of-hand they were banned by the University in 1982.

Teaching Methods

From my first day at U.Va. I felt I had been freed. From what? I still don't know.

After Thomas Jefferson attended William and Mary, he later went to Charlottesville to establish another university with the purpose of changing the methods of teaching. And they **were** different. At William and Mary the English classes would select three of Shakespeare's plays, and we would learn every line of the plays; or dissect each paragraph of two novels or every line of a few poems. At Mr. Jefferson's University we would read ten of Shakespeare's plays; or 100 English poems; or six novels. Then the professors would draw conclusions on what was happening in that day and how the literature was influencing behavior of the times. I thrived on this method of teaching. I loved to read; to analyze; and to express my opinion.

I entered the Department of Speech Correction in Cabell Hall where I went to class in the morning; worked in the speech and hearing clinic in the afternoon, and studied at night. Drs. Mullendore, Burr, and Khuri were brilliant, interesting, and demanded excellence. Most of my classmates were graduate students and I was competing on their level.

Sex Discrimination

From the day I entered the University I personally never really felt much antagonism from the male students. I was treated politely although I didn't make any lasting friends. The only time I was asked *not* to attend class was when I enrolled in Abnormal Psychology (today called Alternate Life Styles!) and we finally got to the part about homosexuality, bestiality and sexual fetishes.

"Miss Whitten, you really should stay in your dormitory for the next two weeks. We will be studying sexual fetishes and this material will be too rough for you. I prefer that you not attend. You will not be responsible for learning any of this information for future quizzes."

"Oh, thank you, Professor McCurry, but I definitely plan to attend. I have always wondered what those people do."

Of course, this, above all other, was the part of the class I wanted to attend. I attended. I cringed. I was stunned to hear about sexual deviates. I wished that I had not attended. But I did find out what two men did when they were together; and what two women did when they were together; as well as the interest some people had in animals. Furthermore, I was amazed at the interest some people had in shoes.

My attendance in the psychology class angered several of the male students. The men in the class reported the class was not as much fun as in other years. I was extremely embarrassed to be hearing about all of the deviations I did not even know existed, i.e. types of male and female homosexuality, bestiality, and shoe fetishes. But I continued attending until the end.

The Lonesome Gal

My interest in speech and drama heightened when I met a fellow student in one of my classes who worked at the University radio station. He wanted to start a nightly program from 11:00 until midnight called "The Lonesome Gal." I was offered the job

of "the gal" where I would play records and talk in a southern sultry voice to the male listeners. I agreed and got paid for the job!

The director of the radio station picked me up at Mary Munford, drove me to the station, and brought me home after the show. Students were trying to discover my identity. I covered my face with a scarf when I was whisked out of the radio station for the dash to the dorm.

Guys would call into the program asking for advice on how to treat women or for other advice on their love life. They might be in mourning over their having received a "Dear John" letter. And I played, "Love me Tender (Elvis), Que Sera Sera (Doris Day), Heart Break Hotel (Elvis again), My Prayer (the Platters!), Picnic (Kim Novak); and for a change of pace, "See Ya Later, Alligator" or "Blue Suede Shoes." It was really a great show, and I enjoyed making the money. But I couldn't continue the show and keep my grades up, so I resigned.

THE PERSIAN PRINCE

After Jim and I broke up, I had some difficulty getting a date. Some of his fraternity brothers felt that I had "done Jim wrong" and suggested to other students that they not date me. I had "hurt" a brother, and I deserved to be punished.

One evening I had a date with a fellow student who had been invited to a private party in Farmington, a prestigious area just outside the city limits of Charlottesville. I accepted. The party house was a mansion with numerous rooms and party space around the swimming pool. I was walking around feeling out of place when across the pool I spotted one of the most handsome men I had ever seen. I asked someone who he was and the answer was "the Persian Prince."

It was rumored he was from Persia (wherever that was), that his father was the king of some foreign country and he was at the University to play football. Hmmmmm. I approached him, introduced myself, and we talked for several minutes. He asked me where I lived (in the dorm) and if I was "involved" (I wasn't), and would I consider going out with him the next evening (I would).

At the end of the evening I went flying into the dorm to tell my girlfriends that I had a date with a Prince. We were all in a "dither." What would I wear?

A dress? No, a sweater and skirt.

Shoes? Your highest heels, he's tall!

What earrings? The ones with the diamond chips!

Hair? Yes, in a ponytail!

Lipstick? Revlon's Fire and Ice!

Arrival time? Seven o'clock!

Whew!

When it was about time for the Prince to pick me up, the girls in the dorm went downstairs to casually play cards, or study, or loiter!

Seven o'clock. No prince.

Seven thirty. No prince.

Eight o'clock. No prince.

Eight thirty. No prince.

He never arrived. I never saw him again … except when he was on the football field.

A Proposal

One evening I got a call from Maynard Ashburn, a student who worked in the registrar's office. I'd met him when I was in

the office for some reason or other. We spoke briefly. I left. That afternoon he called for a date.

I had one date with Maynard. He told me he had looked up my grades, checked on the type of parents and family I was from. He thought I was pretty and would fit perfectly into his family. He wanted to marry me. He then told me that his wealthy father owned three cotton mills in the south. He invited me to visit his parents' home the next week end and if they approved we would marry. I would be expected to have three children at a minimum! I thought he was teasing me at first. He was not. I thanked him and told him I would not be meeting his family that week-end…or any other. I never heard from him again, but I have wondered who took the bait!

The Student Council Election

The School of Education was the only door women were permitted to enter. That School had its own Student Council and in Spring 1956 officers were to be elected.

An announcement was made in the *Cavalier Daily* newspaper that any student who wanted to run for office should report to Cabell Hall that evening at 7:00 There were two political parties at U.Va. and I showed up at one of the party meetings. I asked several friends who lived in the women's dorm to join me. There was not one woman in Mary Munford Hall with a shred of interest in participating in Student Government. I went alone. When I arrived the men were stunned. They had already selected the students who would run for the four offices (President, Vice President, Secretary Treasurer, and Historian).When I walked into the meeting, it got quiet. I was trembling inside. I put my shaking hands in my pockets and tried to appear confident.

James Watlington said, "Who are you?"

"Betty Jo Whitten."

"We have already selected the slate of officers; there are no spaces for you."

"But I am here to run for president!"

James patiently explained to me that he had been at the University for four years already. He wanted to run and deserved to run. Furthermore, there would be no women on the ballot.

I said, "There are 200 women in Mary Munford Hall waiting to hear how this comes out."

(In truth, there was not a single woman that knew I was there; and they would not have been interested if they had known).

"If you do not put me on the ballot, I will run for president as an independent and I will win. Or you can put me on your party ballot in some other position and I will not run for President"

The men looked at one another. They looked at me. Then James said, "Will you run for Historian?"

"Yes" I said. And I did. I got some posters with my picture on them and plastered them over the campus. Our party won which means I won! I am not sure about this, but I might have been the first woman student to serve on the Education Student Council at the University of Virginia. That was in 1956.

Plans for the Future

A few months after I entered the University of Virginia I met J. Gaylord May, a handsome doctoral student in Mathematics. We dated throughout my Junior and Senior years. In 1956 I spent my last summer at home living with my parents and working in my daddy's office in the office of the National Rehabilitation Association. Each summer week-end I would ride a Trailways bus to Charlottesville where I stayed in Mrs. Goodloe's house and dated Gaylord. By the end of the summer the bus driver would let me out one block from my house rather than ride another eight miles to the bus station. And daddy was always in his car reading a book, waiting for me to come home.

The social life in Charlottesville was great for Gaylord and me. We ate hamburgers at Buddy's restaurant, went to The Corner to eat at the University Cafeteria or browse in Mincer's Pipe Shop.

We danced every week-end at Frye Springs ("See Ya' Later, Alligator, Stay off my Blue Suede Shoes!"); went to football games (the most losses in the history of the University); enjoyed springtime picnics to see the laurel bloom in the mountains; ate clam chowder at the Sunset Lodge on Sundays and splurged at Pantops Restaurant or Carroll's Tea room on special occasions. And I continue to feel emotional when I return to the grounds and see the beauty of the Lawn, the Rotunda, Cabell Hall, and the University Chapel where I went to church every Sunday.

The Lychnos Honor Society

I was a senior in 1956-1957 and that was the year that students were being tapped for academic fraternities. Women were not accepted into Phi Beta Kappa. Dean Gwathmey sponsored Lychnos, an honor society for women. Founded in 1930 for women it was intended to be comparable to the Raven Society which would not accept female members. When first founded in 1930 the University did not expect this to be an academic society, but instead it was to stress leadership, social poise and integrity.

Roberta Hollingsworth Gwathmey became the Dean of Women in 1934 and held the position until 1967, long after I graduated. She championed the rights of women students. She felt women had the right to live, study and socialize in their own spaces and campaigned for the construction of a women's dormitory, Mary Munford Hall. By the time I attended the University, Lychnos (the Greek word for lamp) recognized high standards of scholastic achievement leadership and intellectual activities among the women at the University. I was initiated in 1956. It still exists today.

A Career in Speech Therapy

In the 1950's speech therapy was a new profession. I always knew I would have a career serving handicapped children and/or

adults. Furthermore, I believed that the worst of all handicaps would be the inability to speak; to communicate; to socialize.

I absolutely loved going to class; my professors were intelligent and compassionate scholars. As soon as I got to class in Cabell Hall I was assigned a patient in the afternoon clinic. Her name was Ann. And when her speech improved I thought a true miracle had taken place. When I got to my dorm room, alone, I cried with joy. Thus, with Ann I began logging my 300 clinic hours required for speech pathology certification.

Most of my classmates were graduate students; but I was allowed to take the same classes. If I could do the work, I could stay in the program. I did the work and made A's. And there was no discrimination in that department. One of my professors Dr. Helen Burr, had gone to graduate school at UCLA. She was the smartest woman I had ever met and a great teacher. I had never met a woman with a Ph.D. I quickly decided that someday I would have one, too. She was a red-headed beauty, feminine, a mother to a small child, and had married a descendant of Aaron Burr of Virginia! We became friends later in my teaching career. When I taught a class I thought of her and tried to do what I thought she would have done to impart information to my students.

With graduation a few weeks away, my college days were almost over. The time had come for me to arrange employment after I graduated. I would be married after graduation and in the fall 1957 my husband and I would return to the University in order for him to complete his doctorate in Mathematics. I was looking forward to becoming a full time speech therapist.

It came to my attention that our Clinic was going to employ a speech therapist to work full time the following year. (Two part-time jobs were available that, together, would make one full time job.) The first job was to serve as a speech therapist at the U.Va. Speech and Hearing Clinic. If I were hired I would be diagnosing disorders, scheduling the therapy and providing some of the therapy myself.

The other part-time job was to be the first employee of a newly established organization, the Virginia Hearing Foundation. The job description was to (1) visit undergraduate colleges to recruit students into the field of speech therapy and (2) to go into communities to survey children in the schools to determine how many had speech and/or hearing disorders. The idea was to inform communities and train speech therapists to fill their needs. It was ground breaking.

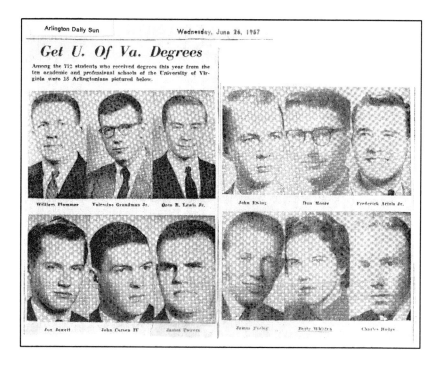

"Get U. of Va. Degrees" – Find the Woman!

It is hard to recognize today that speech and hearing services haven't always been in the schools. But they weren't.

That sounded like a great job for me. I applied for it and was selected for the position, and I got to drive the bran' new station wagon that "went with the job."

Graduation

I graduated from University of Virginia in 1957. (That was the year that William Faulkner arrived to teach at the University. Faulkner's family lived near my daddy's home in Mississippi.) I regret that I didn't attend my graduation ceremony. I didn't know anyone who was graduating; women were still not welcome at such ceremonies. I packed my belongings and went home to get married.

And today...imagine ... Dr. Teresa A. Sullivan has been appointed the first woman President of the University of Virginia. (2013) Amazing.

I am so glad I lived to see it.

Marriage - Expected after College Graduation

Today young women would not understand the marriage expectations required for those of us who "came of age" during the 1950's. I was told by friends, some family members, and complete strangers that I would never have a better opportunity to meet men and I had better "get one" before I graduated. I believe that was probably true on some counts. My systematic search for a husband began.

On my dorm room bulletin board I pinned a list of ten requirements I would want in a husband. In order to be a candidate for marriage the candidate must score ten out of ten.

(1) Must be from a "good family."

(2) Must be taller than I am. (Not a problem since I am five-two.)

(3) Must be handsome.

(4) Must be a good dancer.

(5) Must NOT drink alcohol.

(6) Must go to church...preferably Methodist.

(7) Must be at least as smart as I am; smarter would be better.

(8) Must have plans for the future.

(9) Must want to live in the south.

(10) Must love dogs.

The search began.

Each time I went on a date I managed to cover all of these topics. The score had to be 100% or there would be no second meeting. (The man I picked told me years later that he had never had a woman ask so many questions of him on the first date. He said he thought it was appealing because I wanted to talk about him and not myself!)

I can report to the reader that this man was hard to find. I studied in the medical school, law school and engineering school libraries. I arranged for a space in the Alderman Library where I could leave my books and then sit out on the front steps. I pretended to be taking a break from studying and chatted with the men as they walked through the doors. I attended the interdenominational protestant youth meetings in the University Chapel.

Each evening my roommate and I walked the four blocks to eat at the University Cafeteria on the Corner. Always sitting at a four-top table we waited and hoped that two men would join us. One night Gaylord May and Will Kingsbury joined us for dinner. We enjoyed our meeting and arranged to meet "same place, same time" the following evening. That very night Gaylord called for a date.

Our first date was rather confusing because we double dated with his identical twin brother, Graham. And I do mean identical!

We met in the dorm to play a few hands of bridge and then went out to a restaurant for coffee. When I hopped in the front seat to be with Gaylord, Graham said, "You are sitting next to the wrong boy. Your date is in the back seat."

"Oh, okay!" I was embarrassed when moving to the back seat. And I never got them mixed up again.

Gaylord scored ten out of ten on the check sheet. He was from a well-educated Union, South Carolina family. His father was a professor at Wofford College and his mother was a high school English teacher and author. The Phi Beta Kappa key hanging on his key chain took care of the smart part. Gaylord was working on his Ph.D. in Mathematics with the goal of teaching at a good southern University. He was a great dancer, a teetotaler, a Methodist and he had two dogs back home in Union.

Ten out of ten! I found one! Halleluiah!

I called Mamma and told her to start praying because she was always good at that! There was a big dance week-end on the horizon. I asked Mamma to make me a ballerina length dress of white lace.

"Put some seed pearls on the bodice so that Gaylord's subconscious thought will be 'wedding dress' when he sees me coming down those stairs at Mary Mumford Hall."

Mamma and I agreed we should not be too obvious, so she sewed a red velvet ribbon just under the bust line to meet in the back creating a large red velvet bow with streamers that flowed down the length of the dress. Red high-heeled shoes completed the outfit. The required crinoline petticoats would serve me well as I twirled on the dance floor.

The night of the dance my red velvet streamers were flying in the air. I had never felt prettier.

It worked…Mamma's sewing…the prayers…and seed pearls. Two weeks after the dance I received a Kappa Sig pin…pinned to Jesse Gaylord May.

The next time I went home I went around the house saying, "Betty Jo May. Betty Jo May. Betty Jo May." I was trying out the possibility of a new name.

Occasionally Daddy would say, "Or she may not!"

I always wondered when he did that if he was trying to tell me something. I still wonder.

Christmas 1956 things were moving fast. I rode the train to Spartanburg, SC, to visit Gaylord's parents who lived in near-by Union. When I got off the train he said, "I've got your Christmas present in my pocket!" He gave me my diamond engagement ring amidst the hustle and bustle of the train station.

While visiting his home we had time to enjoy the Christmas parties his friends gave and also to attend a wedding and the reception of one of his boyhood friends. Thus, my engagement was really announced at Jimmy Henson's wedding reception at the Union Country Club where I met Gaylord's friends and flashed my "third finger left hand."

Engaged! Christmas 1956

I called Mamma and Daddy to tell them the news that I was engaged.

"Mamma! Tell Daddy that we are going to have a wedding in Clarendon Methodist Church. Since I will be graduating on June 9 I think June 22 would be a good date."

"Call the church. Ask Dr. Robertson to marry us."

"We can shop for the dress during spring break…I think a long one don't' you?"

"I'll call Marjory, Bobbie, Dee, and Pat to be bridesmaids. Can you call the relatives in Memphis and Jackson to be sure they can put it on the calendar? Call the hotel to reserve some rooms for guests. Ohhhh, Mamma, I am so happy. I am the luckiest girl!"

"I've met a wonderful man. We are going to enjoy a long and happy life!"

The Wedding

Mamma and I were great wedding planners. We did, however, have a disagreement that was almost violent. She was angry and so was I. And it was over (believe it or not) whether to decorate the sanctuary with palms. We had agreed on white floral bouquets on either side of the sanctuary along with a center piece on the center altar. Mamma felt that we should also place palms beside the white flowers.

My position was that it would look "fakey" since we did not live in an area where palms grew. Mamma finally agreed. But she was displeased. I wonder why in the world I cared one way or the other. She had done so much for me and as the years passed I realized weddings are not about the bride and groom anyway… but about the families of those who were uniting. Oh, well. Too late now!

The wedding festivities began. The best men were chosen: Gaylord's father, Gordon May, was the Best Man. His twin brother Graham, friends Ray Woody and Henry Clark were the groomsmen. My Maid-of-Honor was Dee Alexander (my roommate at William and Mary); bridesmaids were Bobbie Van Dyke (my U. Va.

roommate); Marjory Helter (my best friend from home) and Patricia Baker (my friend and daughter of my mother's best friend.)

Christmas 1956 we sent one hundred invitations to my engagement party at the home of my parents in Arlington, Virginia. My engagement was announced in the papers. My parents always enjoyed entertaining and they were good at it! For this great event Mamma and her friends made most of the refreshments, and remained to assure that our guests enjoyed the evening. I wore the same white lace dress that Mamma made me the year before when we were scheming to get "Gaylord to the altar."

When I returned to Charlottesville to complete my senior year at Virginia my wedding festivities began with a surprise "Speech Correction Picnic" at Lake Renovia near Charlottesville. We ate hamburgers and the gift was a Proctor Toaster.

Then another surprise shower was held for sixteen guests at Mary Munford in the Gold Room. I never asked where they got the napkins and the white linen table cloth to place under the crystal punch bowl. Punch was served along with a little wedding cake with my and Gaylord's name on it.

When I walked into the U.Va. shower Mamma was sitting there among my friends. Daddy had driven her from Arlington all the way to Charlottesville. She looked beautiful, as usual, and was so happy for me and proud of what I had accomplished at U.Va. I believe that at that moment the two of us might have been silently remembering that sad day in the kitchen two years ago when I told her I was transferring from William and Mary to attend the University of Virginia.

I did not attend my graduation but instead went home to Arlington in June 1957. On June 13 Pat Baker's mother held a shower for twenty of my friends and rolled the wedding gifts in on a decorated tea cart!

On June 14 Mrs. Collins (and Mamma and Daddy's "Cousin's Club") hosted a shower for forty-six women. A door was decorated with wedding bells and gifts placed around the bells.

On June 15, (just one week before the wedding) Marjory honored me with a shower with Dee as her co-hostess. Guests

were the other bridesmaids and Janie and Helen who poured the punch at the wedding reception.

With all of the celebrating I still found the time to purchase beautiful lingerie... (a different night gown for each night of the honeymoon) and to get my appointment with the doctor to assure I was healthy, and had contraception. When I saw that diaphragm I could not believe it. But I practiced when I got home and by "the night" I could discretely place it where it belonged.

June 19 Gaylord and I honored our attendants at an informal gathering on the outdoor slate patio of Mamma and Daddy's home. We sat around late into the evening laughing, talking, and knowing there would never be another time just like this. I gave my bridesmaids' sterling silver spoons in their silver patterns. Gaylord gave the men shoe trees...imagine!

On June 21, the night before my wedding, Mamma and Daddy hosted the rehearsal dinner at our home in the back yard garden. Thirty guests (friends and family members) attended and were served by Mamma's friends and one maid hired for the entire day. Daddy's perfectly manicured yard was lush with green grass. Lilies of various colors and pink fairy roses were blooming in the garden and serving as centerpieces for each outside table. Mamma had sewn each of the white organdy table cloths trimmed with pale green for each of the eight tables. In addition, on June 21 another of Mamma's prayers was answered in the affirmative. The weather was perfect.

Mamma and her friends did all of the cooking for the rehearsal dinner: turkey, ham, potato salad, green peas and carrots, stuffed celery, red apple rings, pickles and hot bread. Small frozen ice cream cakes were served as dessert.

That evening my soon-to-be in-laws brought us a "bowl of lettuce"...a sterling silver engraved bowl filled with green cash... enough to pay for our honeymoon...and more!

I really do not, 'til this day, know how mamma organized all of this and never got impatient or panicky. She was a wonderful hostess and Mother-of-the-Bride throughout.

Daddy was uncharacteristically quiet during most of the festivities.

Mr. and Mrs. Elton Barber Whitten

request the honor of your presence

at the marriage of their daughter

Betty Jo

to

Mr. Jesse Gaylord May

on Saturday, the twenty-second of June

at four o'clock in the afternoon

Clarendon Methodist Church

Arlington, Virginia

Reception
immediately following the ceremony

The Wedding Day June 22, 1957

The weather was beautiful…hot but not humid. The bridesmaids and photographer gathered at my home to pose for the first of many pictures. When we arrived at the church Dr. Wigent was already playing his organ recital. Yes, the same Dr. Wigent who was my Junior Choir Director all through my growing-up years. The same Dr. Wigent on whom we changed the words of a beautiful spiritual religious song during choir rehearsal.

(I still do regret that!)

For our wedding he played Lohengrin Prelude to Act I, Wagner; Ich Lile Dich, Grieg; Serenades, Schubert; Truii me, Wagner; Ave Maria, Bach; Wir Hat En Haus Bildet, Trod; Sonata in C Sharp Minor, Beethoven; Paris Angelicas', Frank; two hymns, Jesu Joy of Man's Desiring, Bach. After mother was seated Betty Jo Booker Schellenburg sang Wedding Song, Heinrich Schutz.

Dr. Wigent literally pulled out all the stops as he played Lohengrin's Wedding March. Daddy and I walked down the aisle…I holding tightly to his arm. Then Dr. Williamson performed the rituals just before Betty Jo Booker sang the Lord's Prayer by Malotte.

Finally…finally…I was a married woman. Mr. and Mrs. Gaylord May dashed for the door to Mendelsohn's Wedding March. A fabulous wedding!

The reception was in the Clarendon Methodist Church social hall with a forty pound wedding cake on a lace table cloth flanked by silver punch bowls, mints and nuts. Helen and Janie poured the punch with their elbows tucked in next to their sides. Mamma's Sunday School Class served the guests as Mrs. Dieffenbach cut

the cake that was surrounded with more of the tiny pink fairy roses from Daddy's garden. The flowers from the sanctuary were carried downstairs to enhance the space for the receiving line.

There were three hundred guests attending. We were especially pleased that Aunt Hermie, Aunt Lib and Wanda came from Memphis. Gaylord's Aunt Mary Jeanette and Cousin Jeanne Christopher made the trip from Union, SC We received about three hundred and fifty wedding gifts.

The wedding and engagement announcements appeared in the following newspapers: Arlington Virginia Sun; Union Daily Times; Clarion Ledger and State Times, Jackson, MS; Taylorsville Signal; Spartanburg Herald Journal; State Columbia, SC; Wofford College Alumni News.

After the wedding we dashed off on our honeymoon in our 1955 Chevrolet convertible…headed for Ogunquit Maine. The tin cans clunked and clattered in the street; crepe paper was flapping in the wind; our friends were applauding and shouting good wishes. And our car disappeared.

Daddy walked over to Mamma in time to see tears streaming down her cheeks.

"Did she remember to pack her bathing suit?"

Daddy smiled when he said, **"Ethel, leave her alone."**

" Just Ethel and Me....and Betty makes three!"

"The Bride"

Epilogue

So there it is. The end of this story is the beginning of another. The girl did, indeed, have a career as a speech pathologist and learning disabilities specialist that focused on improving the lives of infants, children, and adults with communication disorders. She earned her M.A. and Ph.D. degrees enabling her to teach on the faculties of Wake Forest University and Winston-Salem State University where she was awarded the rank of professor emerita following her retirement. In addition, she served as adjunct professor at six other colleges or Universities. The girl became a wife, mother, mother-in-law, and grandmother.

The author taught more than twenty university courses, presented at more than one hundred professional meetings, published over twenty-five articles, and has been active in more than ten professional associations, including the North Carolina Speech Hearing Language Association and the American Speech and Hearing Association.

Her next book will describe her triumphs and struggles as she worked on behalf of women, minorities and disadvantaged children to assure they find their rightful place in society.

Stay tuned!

The end of this story is the beginning of the next.

CPSIA information can be obtained at www.ICGtesting.com
Printed in the USA
LVOW08s1036241014

410338LV00002B/381/P